KINETIC GOLF

KINETIC GOLF

PICTURE THE GAME LIKE NEVER BEFORE

NICK BRADLEY

Foreword by Butch Harmon

Abrams, New York

CONTENTS

IMAGES OF SWINGS

THE CLUB, THE ARMS, AND THE HANDS

IMAGES OF MOTIVATIONS, ATTITUDES, AND AFFIRMATIONS

Foreword

BY BUTCH HARMON

Nick Bradley is one of the world's bright new teaching stars. Among the many things I admire about Nick is the way he dares to depart from the accepted norm of golf instruction. He has new and refreshing ways of getting his message across to the reader or audience that immediately hook them into the learning process.

Butch Harmon is ranked No. 1 Instructor in the world by *Golf Digest*.

I first met Nick on Tour during the 2006 season, when he managed the coaching of PGA Tour golfer Justin Rose. At the time, Justin was certainly not playing to his potential and had fallen to a career low of 123rd in the world rankings. Within just twenty months, Justin climbed to a career high of sixth in the rankings and won the 2007 European Tour Order of Merit. Quite a turnaround! Such a dramatic change in Justin's game can be greatly attributed to Nick's ability to communicate the correct information in a very digestible way.

In this new book of his, you will see an enthusiasm and a new approach to teaching delivered via amazing imagery and a common-sense text. I know that, like myself, you will really learn a lot from Nick's latest work.

Introduction

On Christmas Day of 1980, when I was ten years old, I was walking past a room with a TV playing and happened on a scene from the James Bond movie *Goldfinger*. In it, Bond was driving a 1964 silver Aston Martin and an Asian assailant was holding a gun on him. I stopped to see how Bond would deal with this deadly threat. The camera panned swiftly back and forth between Bond's face and his hand on the gearshift, then froze on his hand. Using his thumb, he flicked the end of the handle upward, revealing a bright red button, which he pressed. This opened a section of the roof and vertically ejected the killer.

This scene gave me a love of dramatic and dynamic images that became an important part of my life and eventually manifested itself in my golf instruction. Why, I reasoned, couldn't golf instruction be as visually stimulating as that famous scene in *Goldfinger*? Why couldn't it actually stimulate and inspire golfers to "live up to" an image they had seen? How many men in their thirties and forties have walked around hotels and airports imagining that they were the great James Bond on a secret mission? The answer, of course, is millions. A powerful and indelible icon encourages people to emulate its example.

Golf instruction should be the same. It should encourage you to fit into an image and try to sense that "feel" for yourself. Truly inspired learning—the wish to develop and grow—is most effectively generated by a source that operates at a higher than ordinary level. At its best, education is inseparable from entertainment—they are one.

In *Kinetic Golf*, you will see images that I have successfully used with top players during major championships. "The Ball Has Gone with the Wind," for example, shows an image of me exhaling and literally blowing the ball powerfully down the fairway. The idea for it came from the 2007 Masters Tournament, in which I had Justin Rose inhale (generating a beta wave in the brain) and then exhale in the pattern he wanted the ball flight to follow. It was a pretty successful process, leading to a fifth-place finish for him that year. You will also see an image from the swing bible I created for him, which led to his record-breaking year winning the 2007 European Tour Order of Merit in just twelve counting events. From 2009 to 2011, I consulted for Kevin Chappell, taking him from zero status as a professional to winning on the Nationwide Tour and breaking two Tour records. He went on to finish third in the U.S. Open that year. The "Firing

the Right Knee" image was a critical tool for Kevin during this period, since he showed a lot of potential if he could only develop better dynamic balance during his swing.

Kinetic Golf is a valuable tool for any golfer wanting to get to the essence of what playing golf is all about. In my previous book, *The 7 Laws of the Golf Swing*, I taught you how to build the Ferrari. In this book I teach you how to drive it. No question, mechanics have to be in place, and that, dear reader, happens in the pit lane (practice ground). This book is about driving your car on the track, letting go, and allowing your brain to swim in pictures and feelings.

I'd like to give special thanks to good friend and artist Lee John Rouse. Without Lee and our unique working relationship, this project would not have been the success it is. Lee, thank you so much. Thanks also to Laura Macfadyen and Marco D'Uva and the team at Paperhat FTP. Much credit goes to photographer Keith Jacobs, whose patience during the various shoots (and with me) was legendary. Thank you, Keith. I'd like to thank James Ridyard and Justin Padgen for their input with the ball flight data involved—these guys are the best in their field. I'd also like to thank the staff at the Tobacco Road Golf Club

in North Carolina. This stunning piece of course architecture by the sorely missed Mike Strantz provided the backdrop for many of the shots.

My wish is for this book to help you play your best golf through the tools with which the greatest golf has always been played. These tools are the visual and the feeling. To have a golfing inventory of shot-feel possibilities that you can call upon is an accomplishment Tour professionals around the world have mastered. This book encourages you to move away from the narrow internal focus that makes lifeless statues of weekend golfers and tournament professionals alike and into a focus that is more out there, more external.

This book doesn't have *all* the answers, but it does give you *all* the clues you need to play the game extremely well.

Enjoy your golf—enjoy your life!

Sunset Beach, North Carolina, 2013

IMAGES OF
SHOTS

The Big Drive I

HANG BACK AND FIRE!

There will be occasions when you receive that glowing green light to open your shoulders and hit it hard! To be able to tee the ball nice and high, dial in the launch angle with your spine, and then send it on one of those low-spin, high-launch bombers is a great asset. The key is to get behind the ball twice: once at address, and then at impact. This is when you hang back and fire!

Take a good look at the image. Anytime you get the spine moving away from the target like this, you create huge potential for a powerful ascending blow. Notice I used the word *ascending*. Since the spine is moving back, the low point of the swing (where the left arm and shaft reach their maximum radius) will be slightly behind the ball. Therefore, this feeling of hanging back is totally acceptable when you want to throw caution to the wind and bomb it out there!

So the key is to take your time with your backswing, to gather, store, and fully wind against a stable lower body. Look at the image here: When you sense the clubhead is near delivery, give your spine a nudge in the direction opposite to the target. Look at the way the shaft and the spine match. This shows that the shaft has been fully released into the back of the ball, thus squaring up the clubface. You see, you can hit a golf ball at 100 mph with a feather and it won't go very far; you can hit the same golf ball at 100 mph with a brick and it will go a mile! So having that mass from which to release the shaft is the vital ingredient to a big hit.

In my years of coaching I have never seen a long driver of the ball who is not behind the ball at the time of impact. The trick to hanging back and firing is in the way the technique creates more leverage for you and, thus, more applied power. Unlike other swing moves, we can actually get the shaft to load twice in the downswing. "Loading the shaft" may be a new concept to you, so I'll explain. Loading the shaft is merely what happens when great force is applied from the handle of the club through to the shaft, and then ultimately into the clubhead. The same loading (bend) can be seen with a fly fishing rod in the change of direction during the cast. With the "hang back and fire" technique you can load the shaft twice: once as you nudge a little backward in the downswing, and then again at impact into the ball.

Wait for that green light, and then give that ball some serious launch!

The Big Drive II

FACE IT: NO SHORT, POKEY SWING HITS IT ANYWHERE

To me, this image conjures up so many great things about long, straight driving. Essentially, though, it gives you a great prompt for when to stop the backswing and start the downswing of that intentional big hit.

The only guys who hit the ball vast distances with short swings are those who are blessed with fast-twitch muscle fiber. You know those guys—they seem to move at the speed of light. Bruce Lee comes to mind, with his famous one-inch punch! But more on that later . . .

Those of us who have a more ordinary blend of average mass and average muscle twitch need to maximize them and have physics on our side. We need to make sure that the

clubhead has enough airspace in which to cre-
ate momentum and, ultimately, speed. Even
the ThrustSSC, the fastest car on Earth, needs
a one-mile track to get up to 760 mph! This is
verified! And you are demanding that the club-
head swing at 100 mph through about twelve
feet in just over a second! Well, the good news
is that it can be done—*if* you give yourself the
time to do it.

Another great feature of this image
that you can use on the course is that there
appears to be enough time to catch my reflec-
tion in the clubhead; there is obviously
enough time for a classy change of direction.
Nothing can kill the potential for power like
a snatched and tension-dominated swing. It
destroys *any* possibility of leverage and lag on
the way down. With any of the great players I
have observed over the years, the long hitters
have always had that one-*and*-two rhythm
to their swing. Therefore, my image really
assists in giving you that settling sensation
during the transition between backswing and
downswing.

So when the time comes for you to
unleash a drive with that little more to it, work
from this image. It will give you the time to
coil your body, give the clubhead the arc to
travel and accelerate within, and promote a
smooth but strong change of direction. Jack
Nicklaus, probably the longest and straightest
professional golfer in the modern era, had one
thought that served him well throughout his
career: "Complete the backswing."

Thanks, Jack.

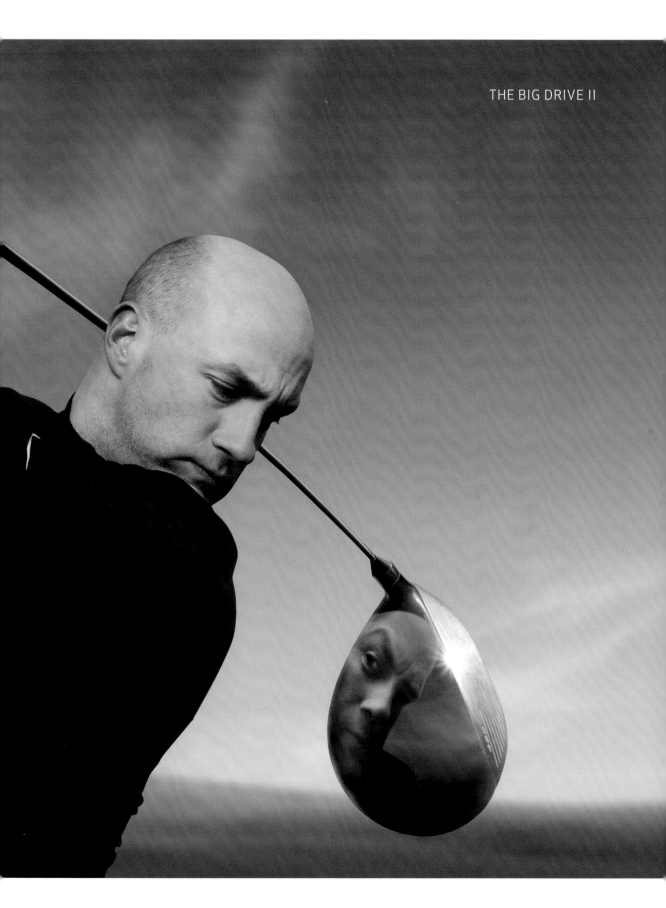

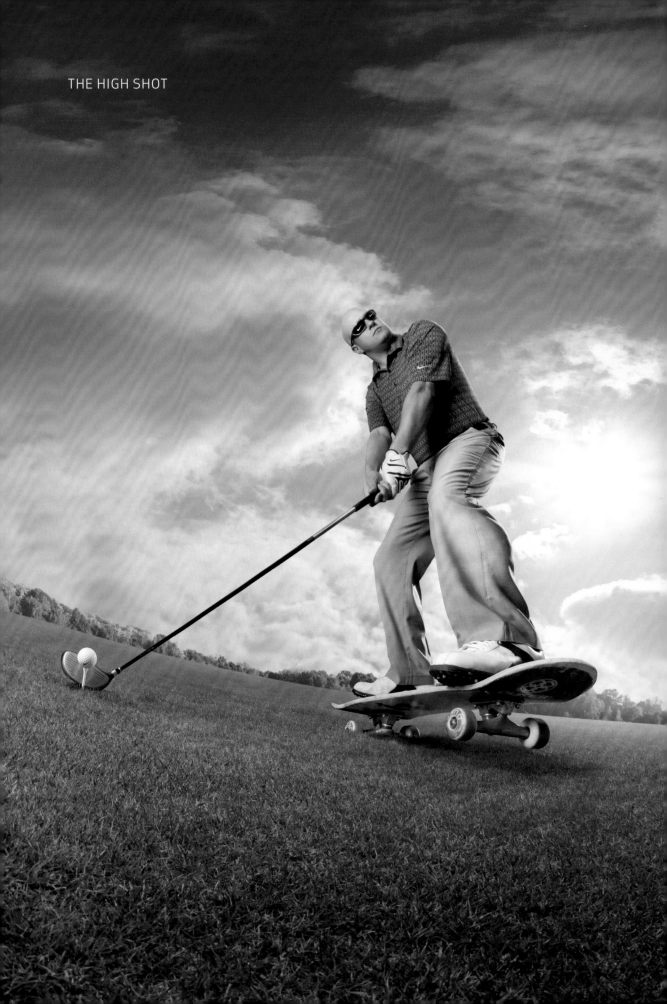

The High Shot

SHRINK FOR LOFTY GOALS

There are times when it can be really advantageous to pop the ball a little higher than normal from the tee box. I'm primarily thinking of downwind drives (riding the wind) or shots into par threes where you want to get the ball just behind a guarded front-placed pin. So much of golf is how you dial in what you want at the address position; the rest is how well you get back there or re-create it at impact. For this high tee shot, we essentially guarantee the loft on the club through impact for as long as possible and promote a slightly shallower angle of attack.

As funny as the image looks, it really does convey your setup geometry in attempting to hoist the ball up a little higher. Look at how my right side looks smaller and lower in comparison to my left. Also, the handle of the club will be leaning a little away from the target; this subtle adjustment in the setup presets the feeling of loft through the ball and is a feeling you ultimately need to have in playing a high shot.

Obvious sensations will happen when you fit yourself into this image. Your weight will be a little more right-sided; as you look at the target, it will seem that your eyes swivel underneath it, looking from a low position to a high one. The clubface will be set back a little, providing loft, and there will be an added sense of cup in the left wrist because of that adjustment.

This shot also has the classic "use your eyes and pick your target" aspect to it. The skateboard you see under my feet gives you a great start in visualizing this shot. Hindsight is a great thing in golf, but "flightsight" is better! So really run your eyes up and down your intended trajectory and then ultimately lock in to the apex (the highest point) of the ball flight. If you can hold that apex (almost in the mind's third eye) as you swing, you will unconsciously gravitate to hitting the ball at that spot on the higher wind thermal.

The Low Shot

DIVING PLANES: PLANELY BODY LANGUAGE

When I look at this image of the low shot, I always think about the kids I have taught and how they instinctively conjure the right positions for the shot ahead. Sometimes the power of description and suggestion is enough for the body. That, in essence, is what this book is all about—visual autosuggestion. The text in this case is merely support for the image; it is not the instruction in itself. I also think of great players like Seve Ballesteros. He got his body to fit the shot. So did Jack Nicklaus and Tiger Woods—golfing chameleons, if you will!

To play great shots, you definitely need to ask great questions: "What do I need to feel to get the ball to act this way? What does the clubface need to do? Where would my body need to be positioned to create that flight? What would my speed feel like?" Fortunately, kids don't intellectualize these questions in this way; they speed-dial in to an image-feel directory and then organize themselves accordingly. As adults, we don't lose this ability; it just gets masked by words, or sometimes we simply cannot be bothered to go through the act of obtaining the feel ourselves.

There are two main references you want to take from this image, and one overall feel. If you want the ball to go low, guess what?

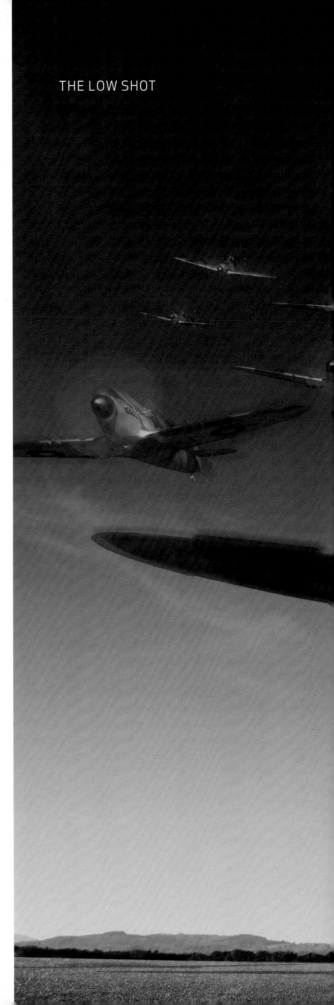

You have to feel low, especially in the follow-through. So observe how my chest and, indeed, my spine angle through the shot are lower to the ground than they would ordinarily be. This helps us trap or cover the ball. And observe the exit angle of the shaft; it is also low as it mirrors the low, chasing angle of the body. The overall feeling I would give you for this low shot would be similar to skimming a stone low on the water's surface, crouching down, and staying still as the arm extends low down the line.

This image offers a pretty good incentive for staying low and quiet through this particular shot. Lee Trevino's swing comes to mind—he was a master of controlling his ball trajectory through wind, with that low impact and finish of his. So the next time you want to hit a lower-flighted ball, make some smooth swings imitating and feeling how you would do it if a child had asked you to show him or her. I bet you wouldn't look too far removed from my plane image on the opposite page!

Occupying the Mind

MORE WILL BE LESS

I would wager much gold that when you have played your worst golf, your mind has been very, very busy! When the mind is busy with words flowing around your brain, playing good golf is almost impossible. Why is this? During this state of verbal onslaught, you are consciously aware of a great many things, such as noise, visual distractions, and of course your old buddy the ego chattering away in the background! We have all been there, usually when no balance is found between too much golf and too little.

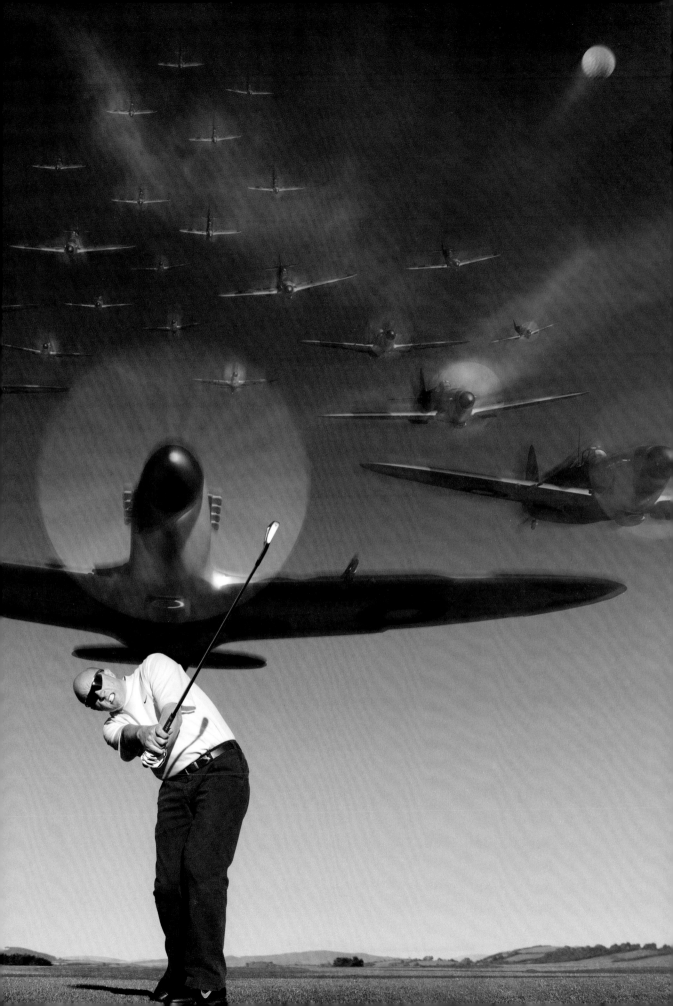

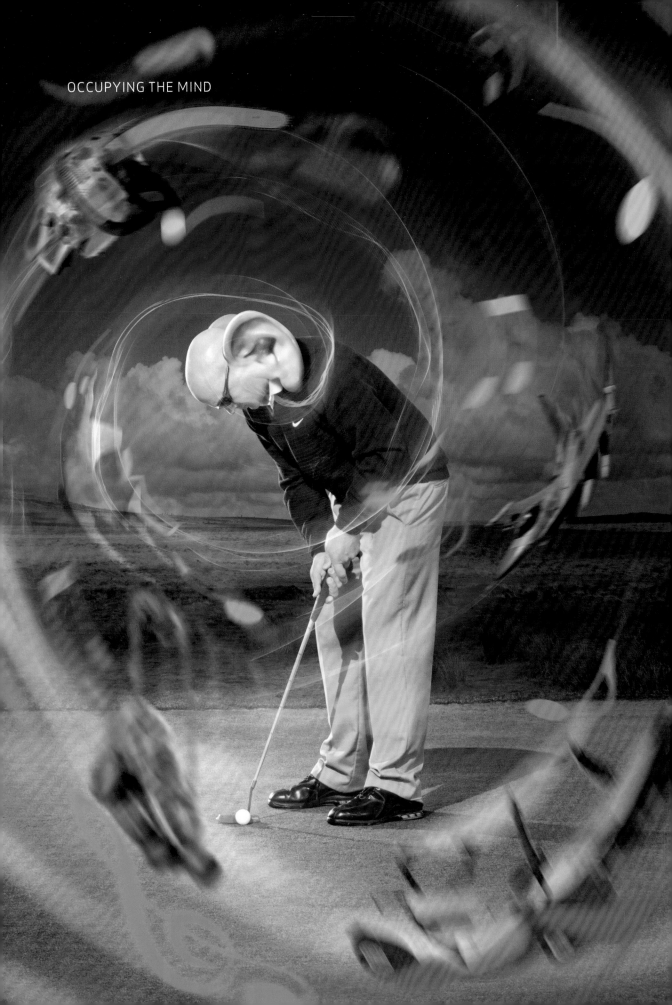

You also see this awareness distraction happening at Tour level. A player will be over a shot and quite legitimately will glance up and nod disapprovingly at a cameraman or fan in the crowd. I say "legitimately" because there are times when the mind is waiting for that little something to react to, something that normally wouldn't even register on the radar. I like to think of this as the black dot on the white page: Your mind, ready for just one little thing, zeroes in on the smallest blemish. So how do we cultivate the right level of awareness or, even better still, tune out when there is the possibility of distraction?

The knack to this is the white page, not the black dot. The next time you are on your putting green, grab three balls and start to make your way around, putting from hole to hole. As you start putting, place your awareness, most notably your hearing, all around you—as though you are casually listening to *everything* rather than intently waiting for *something*. All of a sudden you will be able to hear that plane above, cars driving in and out of the club, people chattering, greenkeepers mowing, and birds tweeting! So no single thing acts as the black dot on the page or has the chance to dominate, since your awareness is too general and broad to pick out one particular distraction. I really want you to notice, too, how the chattering, the incessant gibbering, starts to subside and fade out as your personal radar focuses wide and external rather than narrow and internal. It's amazing how quiet you become when you achieve this effect. A great analogy is being in a dark room with a flashlight. This is how your awareness *can* work; it can uncontrollably dart around and light up little objects, if only for a brief second, as it searches for the next point of interest or distraction. Or you can flick on the bulb above the whole room and take in everything to the point where no one thing steals the limelight.

Transfer this new awareness state to your wedge play, your medium- to long-iron play, and eventually to the golf course. Distractions will be a thing of the past, and you'll have the ability to make loud noises on the golf course with your quiet mind. So starting with the putting green, use this image anytime you want to enter your own little world.

Verbalizing the Shot

There have been many routines and rituals suggested in golf over the years by psychologists who couldn't make an honest claim that they themselves had broken 100 on a course. I personally have witnessed several Tour players' careers end as a result of their becoming overly busy with useless minutiae that supposedly enhance their thinking processes before, during, and after the ball had been hit. Believe me, everybody, when I tell you that the essence of a great pre-shot routine has never changed since the days when Old Tom Morris spanked his baffy around St. Andrews.

Lack of clarity or intent before a golf shot has been hit is disastrous; it's rather like being a rudderless ship! Let me once and for all give you a pre-shot routine that will lock in numbers one and two of the essential three-step pattern you must use to give yourself the best chance of shot-making success. But I warn you, these steps are so advanced, they may go way over your head and confuse you! Ready?

1 Visualize

2 Verbalize

3 Execute

The image you see here is your starting block. There is no better way to be able to resonate with your intention than by using your imagination *and* verbalizing the result you'd like at the same time. You cannot escape from clarity if you carry out these first two steps, unless you introduce something else into the equation. When you verbalize something, you strengthen it; it's like an unwritten contract between your mind and your body that has them in agreement before the shot has been hit. I say "before the shot has been hit" for a reason. If you genuinely want to know how well your technique is performing, program your desired outcome to a finite detail, leaving no stone unturned. Once this has been determined, go ahead and hit the shot. The result that will follow (ball behavior) is based purely on your technical ability. You see, it's tough to blame a pre-shot routine when you have covered all bases; the ritual I give you here not only programs your mind for success but brutally reveals the inadequacies in your technique.

I understand that some of you are not visual people. I also understand that there are some of you who have very little swing feel to go on (maybe you should go to your pro and get some relevant feels), but I will say this with 100 percent conviction: You need clarity and intention before action.

When we look at Jack Nicklaus or Tiger Woods, we can see that whole package in action. Jack is incredibly methodical and analytical in his approach to shot making, yet interestingly the one thing he has told us to do time and again is to "go to the movies." Tiger, like the late Seve Ballesteros before him, only truly comes alive and hits amazing shots when he is in trouble on the golf course and his mind is literally forced into imagination mode. For the record, Tiger used to be like Jack.

The feeling aspect to this routine can also be described as rehearsal. How many times have you played a poor shot, dropped another ball, and then proceeded to flush it straight at the pin or down the fairway? This phenomenon happens all the time, so the question is—why?

The body is not stupid. Think of those magic magnets that claim to redistribute the energy flow and equalize your balance. The guy demonstrating it says, "Okay, I'm going to push you now, and I want you to do your best to keep upright!" So the guy gives you a shove, and guess what? You stumble and lose your balance. Out come the magic magnets and on your wrist they go. "Okay," he says again, "same thing, try to keep your balance." So he shoves you again, but this time you part with $9.99, you hold your position, and you are now in possession of a magnetic bracelet that cures everything from vertigo to Aunt Mildred's bunions.

Folks, wake up and smell the coffee. After the first poor shot you hit in golf, the body will go into a self-correction mode where, to some degree, a better pass is made at the ball the second time around.

So in a way we can allow the body to have a glimpse at hindsight through the act of rehearsal. We can give it a chance to say, "The balance on that practice swing was terrible, let's go again." You have seen your intention, you have verbalized your intention, and lastly you have physically rehearsed your intention—it's now time to step up to the ball and execute. To some, this may seem like a lengthy process, but for the good player this happens within split seconds of arriving at the ball.

Visualize your intention. . . . Verbalize the unwritten contract. . . . Rehearse and . . . *execute.*

A FADE
FROM THE TREE

Fading I

STATIC FADE: DOMINANT BODY FADING

There is no great science behind this image, but it does create the feelings to make the science of a fade work for you while you are over the ball. Before you start to blend and marry into what you see here, remember that in terms of setup sequencing, the face of the club is your first consideration. Ensure that the face is roughly pointing at your intended launch direction of the ball.

First of all, let's look at the equilibrium of a setup from this view. You can clearly see how the green (right) side of my body has grown into this dominant position—my right-hand grip is weak and on top, that shoulder and that entire side of my body is feeling forward (toward you the reader) and feels significantly higher than the other side of my body (which feels out of the way and low). Much of the shape component has now been dealt with, since these are all mainly path-influencing feels and sensations. I want you to hard-wire one aspect of this setup, though. Please make sure the face is dialed into your starting point first, leaving you to work your body into the form you see before you.

The image is one of my favorites because it is not in any way benign or passive. This guy *will* move the ball from left to right and trap the ball nicely with his torso. The extreme drawer (the ball moves right to left) or hooker of the ball should also fuse into this image. If you have always struggled to start the ball left, feel on top of the shot at impact, or have never seen the ball peel off correctly in its flight, then I would wager that the right side of your body is tucked down and under the left side,

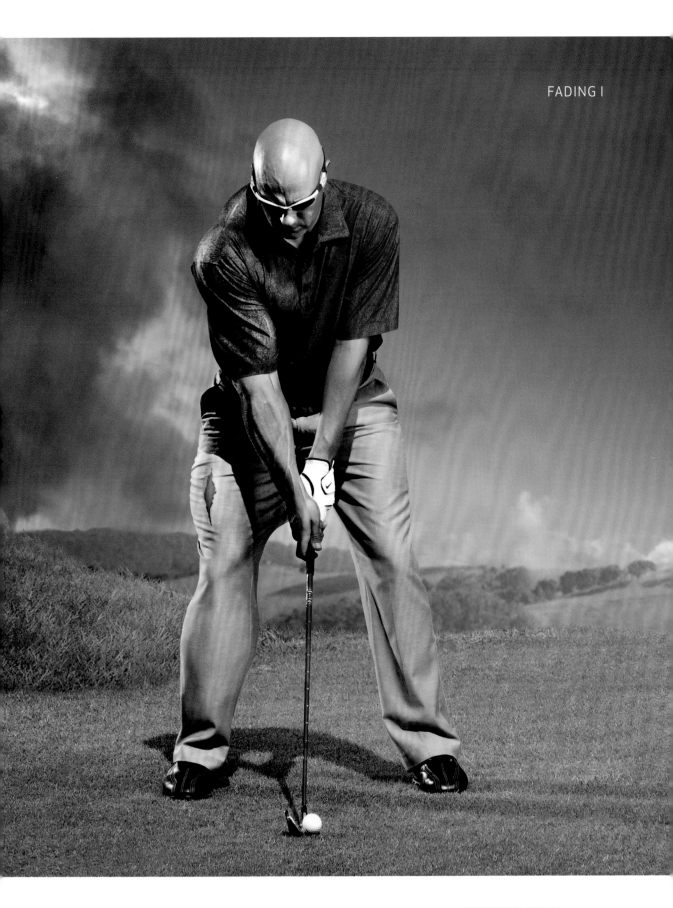

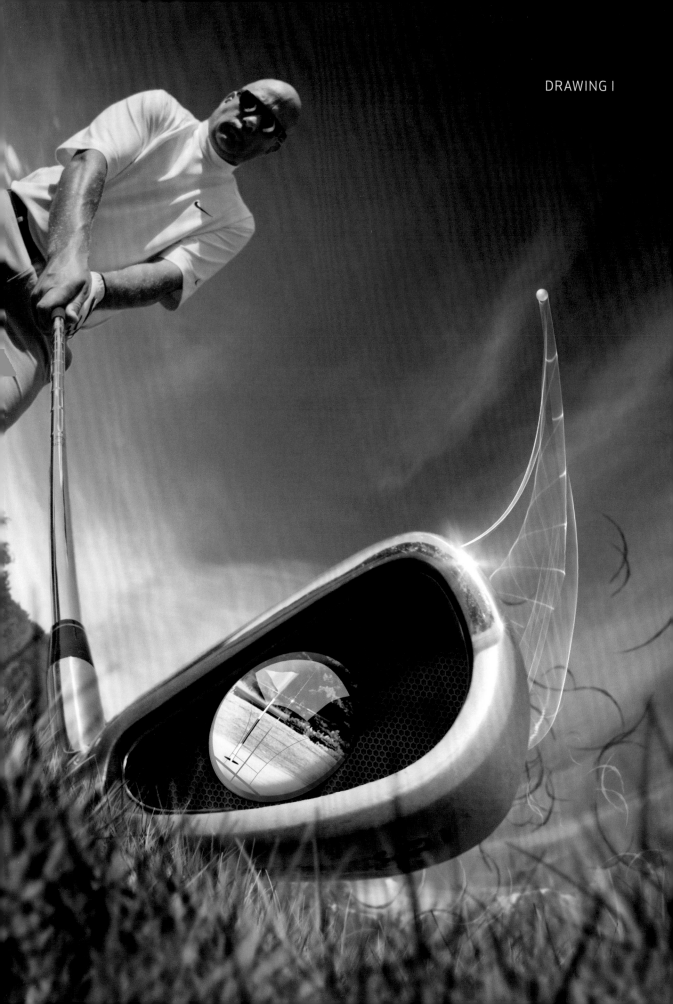

promoting a huge inside-to-outside swing path and poor angle of attack.

Marry into this image to create a fade, and get the bulk of your work done in the setup position.

Drawing I

STATIC DRAWING: DRAWING ON YOUR SETUP

The ability to shape and curve the ball in the air is a huge advantage. No golf course is linear, and no two greens are really the same when you take into consideration wind, slope, and other variables. The static draw relies heavily on the components of the setup being perfectly dialed in at the address. It's this premise that the image before you depicts.

One of the first lessons I learned, when I was nineteen and caddying on the European Tour, was that if the initial starting point or starting line of the ball wasn't somewhat guaranteeable for my pro, then it was going to be a tough day for him. With a consistent starting line, however, it really doesn't matter how much curveball you hit, since you can always plan on this foreseeable movement of the ball.

The image before you shows the crosshairs of the club to the right of the flagstick, since a true draw would always start to the right of its final destination. Please be meticulous about this pre-shot ballistic as you take your stance over the ball; this is the first domino that falls in a chain reaction, and if you don't get it right, your chances of success are small. In yesteryear, the clubface was placed at the *final* destination and the body at the starting line. You can now start to appreciate why shot making was such an inexact science, and why the old pros had such great hand action. Why wouldn't you aim the clubhead at the starting point of your shot—it seems so obvious, yes? You wouldn't point a bow and arrow ten feet right of the target and expect it to take off to the target no matter how you adjusted your body, would you?

While the draw is an attractive shot and indeed allows many planes and angles, the clubface, and the arc to dial in to one another, it can all go horribly wrong if the correct calibration is not adhered to. Believe me, the last thing you need in golf is a ball that starts left and continues to curve left through the air, yet this is what happens when a) the clubface is looking at the target to begin with and not to the right of it, and b) the golfer thinks, "Ah! To draw the ball, I must be like the old pros and incorporate hand action through impact, twisting the clubhead to the left."

All you have to do to apply the spin needed to draw the ball left is to create a very small conflict between the clubface aim and the path the clubhead is traveling. This path needs to exceed the clubface aim by traveling farther right than the clubface itself (remember, the clubface is already slightly right of the target). This is where the term *push draw* is used, since an accurate feel to cultivate is one of pushing the clubhead a little right of the starting line itself (where the clubhead is pointing).

My advice on perfecting the static draw is first to start small by clipping some half shots with a 7-iron from a tee. Make sure you fully understand and become competent in starting the ball on line (if you struggle with this, please check your grip and clubface activity during the swing). Second, sense the amount of push or rightness you need to feel to gain the right-to-left spin.

The Ball Has Gone with the Wind

SKETCH FOR JUSTIN ROSE
AT THE 2007 MASTERS

EXHALE

slow

BALL TO TARGET WITH
Flight

I have a sketch that I did for Justin Rose during our preparation for the 2007 Masters Tournament at Augusta National, in which he finished fifth. The sketch is of a golfer standing behind his ball, taking a deep breath, and then blowing the ball into its flight. There were two ball flights, in fact: one a low, piercing shot into a wind and the other a high, soft-landing fade. Augusta is such a theater of pictures—it's not surprising that Jack Nicklaus and Tiger Woods have prospered there, since they use the power of visualization probably better than anyone who has ever lived.

The distinction between the two opposing flights is significant, since each represents a different way to couple the intention of the shot with your breathing, and then finally to fully buy into the visual intention. Imagine, if

you will, a high, soft, floating fade, normally seen as a slower-moving ball as it reaches a higher arc. If you were to blow that ball into its flight, your exhaling breath would be long and slow, just like the profile of the shot itself. You would also be able to track your eyes ahead and upward at the same speed as your breath and the imagined ball. The flight would look similar to the initial climb a roller coaster makes before it begins its descent.

Now imagine a low bullet 5-iron into a stiff breeze. The outward breath that would represent the added speed and penetration of the ball flight would now be sharper and shorter, rather like a quick jab in boxing. Once again, your eyes can dart up to the flight at exactly the same time as the breath leaves your mouth. This breath is like blowing out a candle in one short blast!

One thing to remember about this little technique: Inhale deeply, whether the shot is fast and low or high and soft. Doing this will assist in settling you down and will deliver two lungfulls of oxygen to the brain.

We know that the brain works on different electrical impulses, which are called waves. The wave that is created through efficient and meaningful breathing is called the beta wave. In simple terms, when you are standing behind the ball creating your shot, this beta frequency opens up the correct channels within the brain to allow these pictures to get through. Beta waves are at their most potent when the body is still and quiet, so installing this breathing aspect while posed behind the ball is absolutely perfect.

There are several real benefits to this tee-shot technique. The most obvious is that it sucks the player's awareness straight back into the present moment; in taking that initial deep breath, you will center yourself and find focus on your shot naturally, rather than

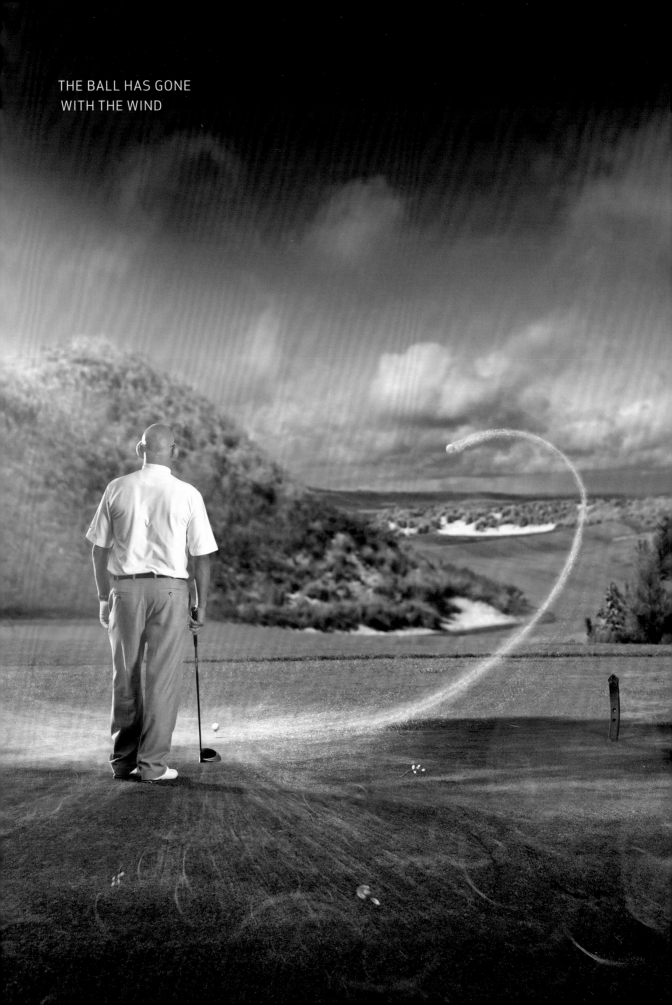

THE BALL HAS GONE
WITH THE WIND

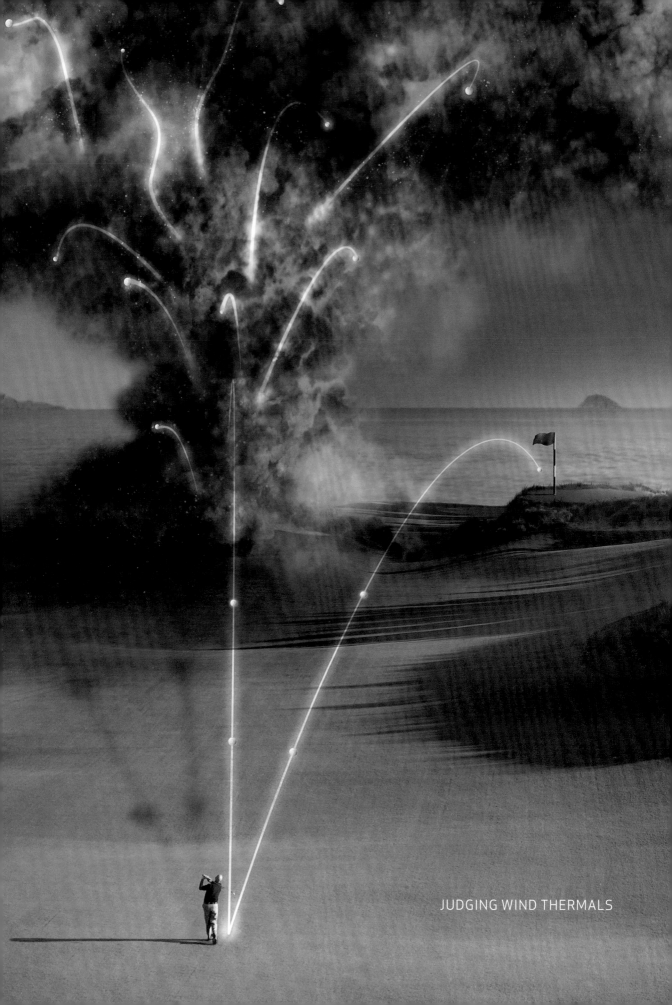

JUDGING WIND THERMALS

trying to find it. In blowing the ball away at certain speeds and in certain shapes, you see the ball flight in real time. It forces you to enter a process of shot realization in which a truer representation of what you are trying to achieve is met. Lastly, you will embark upon a process you can use for the rest of your life. This ultimate pre-shot routine has complete economical function and purpose; breathing the ball into its flight, whatever flight you choose, prepares you for shot success in every way possible.

Judging Wind Thermals

Firstly, this is an inexact science. It cracks me up sometimes to see Tour players chastise their caddies when a wind switch happens midflight. These players need a reality check, because until predictive wind equipment is allowed or even available, judging the wind is nothing more than amateur guesswork.

There are a couple of little tricks of the trade you can take to the course with you, though, to make this black art somewhat more exact when you play. Looking at rippling bodies of water for wind direction and approaching gusts is one well-used technique. Another is to hold your left arm up and point it toward the target as you throw a handful of grass up into the air with your right. This gives you a true north bearing to the flag from which you can clearly identify the wind direction relative to the hole. Lastly, make a little wind chart on your course planner that lets you know the prevailing winds on each hole. This takes some of the unknowns out of the equation.

This image is less about the direction of the wind than it is about the effects of altitude on it. Writing this reminds me of a funny story about an inexperienced American links golfer playing the intimidating Ballybunion course on the west coast of Ireland for the first time. As he approached the 7th hole, which runs along the coast, the wind dramatically started to rise to an alarming crescendo. He proceeded to tee the ball up very high; the professional who was playing with him thought it was somewhat a tactical error, but politely said nothing. The gentleman from across the pond gave the ball an almighty whack, and both golfers watched in amazement as the ball took off, rose to about thirty feet in the air, and then started coming back at them. Needless to say, it didn't make it past the ladies' tees. The pro turned to him and inquired, "Can I ask you why you teed the ball so high?" The golfer looked at him and in all seriousness said that he was trying to hit it "over the wind."

It's important to look at the mushroom cloud in this image. The higher the ball goes, the more volatile wind conditions become. When you also consider that by the time the ball reaches its apex, its maximum velocity has been spent and it will start to slow down— the effect of the wind will be dramatically magnified. When these factors are combined, you get this mushroom cloud effect where the ball can literally peel off and float away on a gust or a thermal.

The inexact science of judging wind I mentioned earlier is further qualified when you consider that pilots flying 80,200-pound 737s have to watch factors such as wind shear and sudden gusts while landing these jet aircraft. Now compute the effect of that same wind on a silly little golf ball!

The rule of thumb here is simple. To avoid the mushroom cloud effect of a golf ball in the wind, keep it low by dropping down a club (from a 6 to a 5, for example) and swinging easier, thus taking the climb out of the shot. I

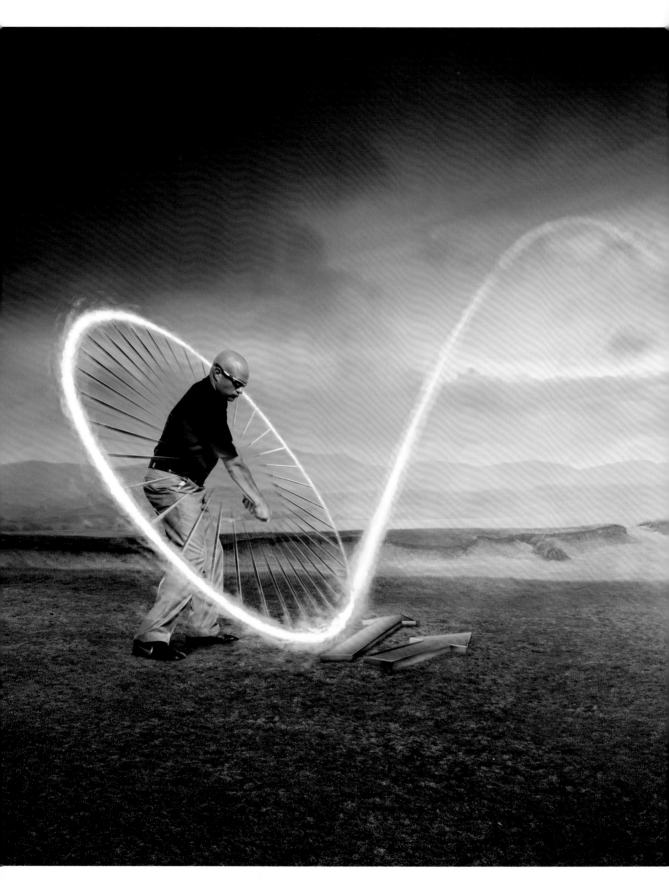

FADING II

spent three great years playing golf in Ireland and saw some amazing wind players. All of them demonstrated this final piece of advice in regard to playing in the wind: Grip down the club to where at least an inch of the top of the club is exposed above the glove hand. *Down* seems to be the operative word here in regard to wind play:

1. Drop DOWN at least one club.

2. Grip DOWN the handle at least one inch.

3. Keep your speed DOWN during the swing.

FROM THE FAIRWAY

Fading II:

FADING FIRE

Fading I: Static Fade (see pp. 24–25) really addressed the feeling and imagery to be gained standing over the ball; much of it was setup. Fading II: Fading Fire is more of an image to work from so that you can gain the overall feel of a fade shot through the ball. I have always advocated and encouraged adding what I call "layers" onto shots, meaning: If one practice swing or rehearsal of a shot gives you 35 percent of the feel you need to sense the shot accurately, then go ahead and take a snapshot of that feeling a couple of times. This is like giving the golf swing and the shot ahead a sense of hindsight! As I mentioned in Verbalizing the Shot: How many times have you hit a poor shot, dropped another ball down, and then gone on to play the next shot well? We have all done this at some

point, haven't we? The reason the second shot turned out better is that your feel for the shot and your vision for the shot became more refined through experience. Hindsight helped! The number of practice swings you need to develop a feel is quite individual—one good one is obviously better than three halfhearted attempts, but there is no set number. In my first book, *The 7 Laws of the Golf Swing*, Law 7 talks about the need to "fill up the bottle"; I stress the need to cover all the bases to exorcise any doubt in your pre-shot routine. Part of this is gaining that snapshot of the feel in the last moment before you address the ball.

The great value of this image is the awareness you will gain in sensing the clubhead during the downswing. Ultimately the snapshot feel for anything of this nature should be directed at the clubhead, since this is the brush painting the ball into its flight. You can see clearly that the clubhead is guiding the ring of fire across the ball, introducing the left-to-right spin for the shot ahead.

Other feelings come to you when you promote this fading action through the ball. As you paint this path of fire, you will sense your body unconsciously rotating and turning through the shot with less lateral slide, and your left heel will catch your weight a little more aggressively. Your left arm will want to fold and crease into your chest and stay there well into the follow-through. This should be encouraged, since it indicates that the armswing has blended nicely with the body turn and worked slightly left through the ball, as the path of fire suggests. More than anything, gaining the degree of the sensation needed will come down to how much you register this when you practice. Both this image and Drawing II (see p. 38) were created for the "feel players," those who are kinesthetically able to sense the face of the club to a high degree.

Practice this subtle feeling through the ball, have the clubhead work this path of fire across the ball, and you'll start to gain a real sense of creating this fading ball flight by being in touch with your golfing paintbrush.

Fading III
THE STINGER FADE

This photo was taken on the 16th hole at the marvelous Tobacco Road Golf Club in North Carolina. I tweaked the original picture a little to marry into this stinger fade theme, and I am glad I did; the result is one of my favorite images.

Tiger Woods has been an incredibly successful exponent of this shot over the years, particularly when his overly debated golf swing was not in full flight and he needed something safe to sizzle down the fairways. Tiger loves this shot because it gives him (especially in recent times) glimpses and feels of how he'd like his regular swing to perform. The stinger fade gives Tiger that slight across path (minus), that on top of the ball feel (angle of attack), and the left-to-right ball flight he knows he can win majors with. Fortunately for Tiger, to feel this stinger fade is a huge departure from his normal go-to swing, which is why he can play it so well. The very fact that it's a radical feel gives him some tangible bodily milestones to shoot for during the swing, and with it permission to fully commit himself to the shot ahead. No further evidence would be needed to demonstrate this poor-play antidote for Tiger than his transition from the 2012 Arnold Palmer Invitational at Bay Hill, which he won, to his poor play at the Masters a few weeks later. Bay Hill, a course that's essentially

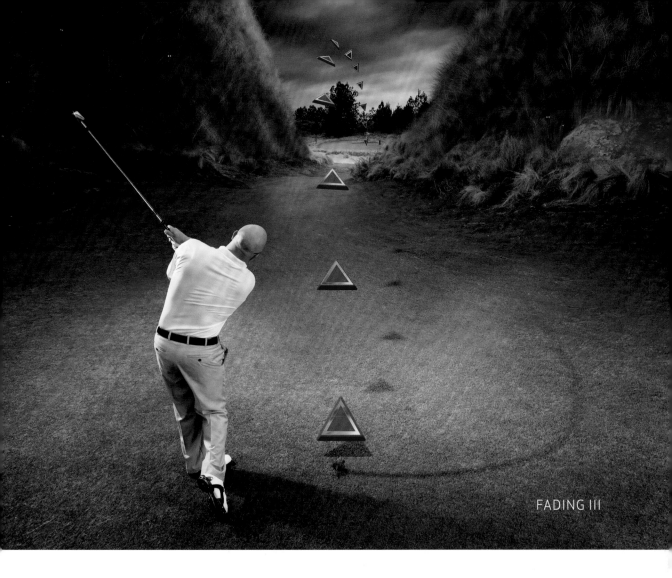

flatter than the landing strip on an aircraft carrier, could accept these stinger shots. However, Augusta National, a course that demands trajectory control as much as directional control, was too much for his game, in poor shape as it was, to withstand. A one-dimensional approach will work on a one-dimensional course, but alas not Augusta National, which during tournament week is almost a four-dimensional experience for the competitors!

The key to this shot from either the fairway or the tee box is to be found in its technical requirements and the feelings you need to generate while performing it. The most obvious trait of the stinger fade is its trajectory. To play this well, the dynamic loft probably needs to come down to 10 degrees (at impact)

to get that boring flight the stinger has; assuming you play this with a 4-iron (standard 24 degrees of static loft at address), the shaft or handle of the club needs to lean around 10 degrees forward as the ball is being struck. For the mathematicians out there wondering where the other 4 degrees of de-lofting occurs—that dynamic launch of 10 degrees is found when the attack into the back of the ball becomes -4 degrees (down).

Just by the science you can tell that this gives a real "squeeze the ball into the turf" sensation when the ball is struck. The squeeze occurs because the base of the plane (bottom of the arc) would need to be roughly 7 degrees left of your target line (this is significantly forward, which is why Tiger loves this on top

and forward sensation that is so contrary to his recent pattern). At the risk of repeating myself: Encourage the sternum or breastbone to hang on or even, in this instance, nudge a little forward of the ball position with the chest slightly open at address to preset these stinger ingredients!

In many ways I regret having to write about the numbers needed to pull off certain shots in this book. Numbers to me have always been cold and unfriendly (even at school!), yet for the purpose of explanation it was necessary to prove that there is science and geometry behind every shot hit, followed by the human element.

Take your time in learning the stinger fade. Start off using these sensations with the relatively friendly 7-iron and then build up to the longer clubs, which will be the ones you ultimately use. Follow the ground rules for shaping the ball and in no time you will have a highly effective go-to shot, whether you are swinging well or not.

Feeling a Fade

AIM THE FACE AND FEEL THE FADE

I believe Christopher Columbus's life was in danger several times after he started to publicly announce that he thought the world was not flat. People scoffed at the idea that humans could take a space rocket to the moon

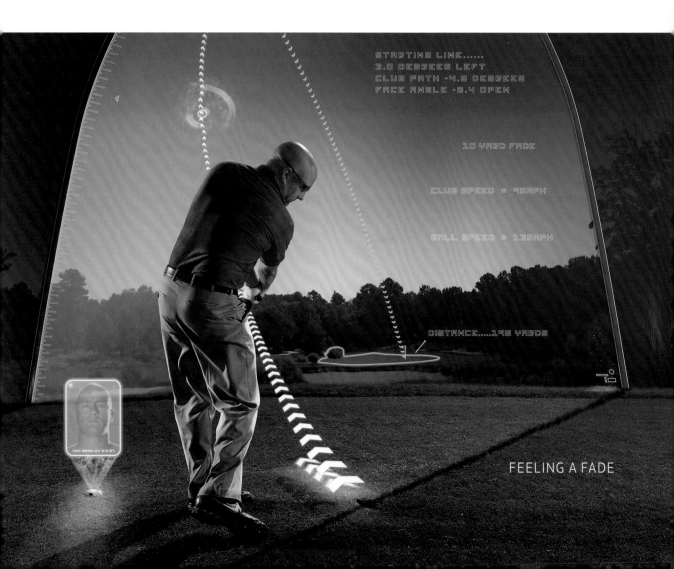

STARTING LINE......
3.0 DEGREES LEFT
CLUB PATH -4.8 DEGREES
FACE ANGLE -2.4 OPEN

10 YARD FADE

CLUB SPEED = 95MPH

BALL SPEED = 130MPH

DISTANCE.....195 YARDS

and bring back soil samples. Dick Rowe, a Decca Records executive, said, "Guitar groups are on the way out," when turning down the Beatles in the early 1960s.

These are just a few examples of situations where huge paradigm shifts had to follow in the wake of success and history. In golf, the latest shift occurred when what some of us had long suspected was recently confirmed by the TrackMan launch monitor.

For many years, one of my first instructional heroes, John Jacobs, popularized the idea that the initial starting direction of the ball was instigated by the path of the club through impact. For example, if the divot pointed to the right of the target when you examined it after you had played a shot, it was logical thinking that the club's path had "pushed" the ball in that direction. The same with a shot pulled left—divot left, path left—and that alone generated the conclusion that the path had sent the ball in that direction.

When I conducted clinics across Britain in the late 1990s on behalf of the PGA, I coined a phrase that many of the pros disagreed with at the time, owing to their indoctrination in the old ball flight laws. That term was *clubface override*. I explained that the face would beat the path every time when it came to the starting direction of the ball. To demonstrate this, I merely took a sand wedge and started bouncing the ball on the face, as every assistant pro in the world can do. I asked the pros to note how I could alter the path drastically by sliding the face of the club this way and that, and yet the ball would still fly vertically upward. Then I started to tweak the face angle a little by closing and opening it as I bounced the ball in the air. What was obvious to the pros from watching this simple trick was the importance and significance of face over path.

Our image shows me hitting a 195-yard 4-iron with a 10-yard fade (a ball that curves left to right in the air for a right-hander). For this shot to happen effectively, these qualities have to be present:

- The ball must start left of the target (a fade starts left!) by about 3 degrees.

- My yardage is about 195 yards, and I am banking on about 10 yards of curve to fade the ball into the flag.

- In this case, the path must be left of the target line by approximately 4.8 degrees with the face open 2.4 degrees to that path. It is within these parameters that we substantially create that left-facing starting line and the curvature of the fade.

The older belief in creating movement on the ball by having the clubface on your finishing point and your body aligned at your starting line resulted in many, many extreme setups—which often caused the famous double cross or, in the case of a fade, blew the ball miles to the right of the target.

If I were to convey a feeling for this shot, it would without doubt be to permit you to feel the path more than the face, for one simple reason: During the swing, it is far easier to feel the path than it is a face moving at 103 mph, which is what you would need to pull this shot off.

This brings us back to the beginning. Why did the pros believe that "the path sent it and the face bent it"? The explanation is very simple. They felt the path more than they ever did the face. And we still do. Aim the face—and feel the fade.

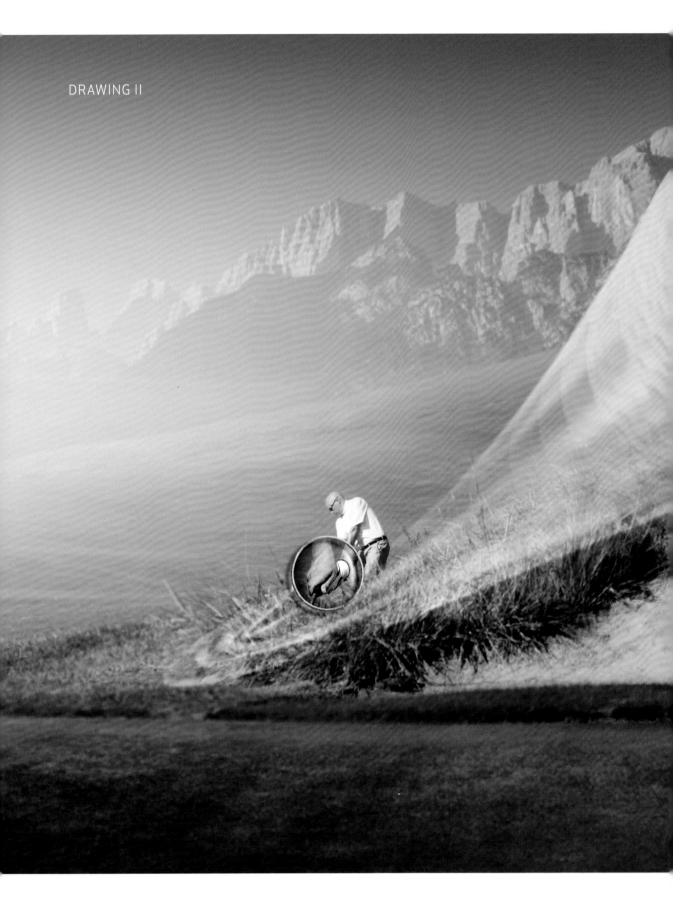

KINETIC GOLF

Drawing II
FEELING A DRAW

Don't get me wrong, I love to see a player of mine drawing the ball, but it has always been a love/hate ball flight for me, mainly owing to the amateur's obsession with it. If I had a dollar for every time an amateur swung the club 15 degrees right, followed by the clubface shutting down and twisting through impact to create the draw, I'd be a rich man. Such extreme feels come with a long-term myopic focus on obtaining this holy grail of ball flight, which frankly is very damaging.

The shift I'd like to achieve with the many wannabe drawers out there is to eradicate the overuse of the hands—or even the thought of using them at all—to create a draw (a ball that moves from right of the target and then drops down next to it). For the good player, it seems that a controlled draw is mostly performed when the planes of the body, the planes of the swing (forearm rotation), and the face within the arc are all gelling together and working as one combination that unlocks a passive face/path relationship. In contrast, the amateur often tries to cheat the hard work that it takes to create this uniformity of swing by slashing his/her hands into the ball at the last minute to turn the face over and close it. In probability of success, this is akin to picking this week's lottery numbers, to be completely honest. There is a far better way to feel a draw, one based on geometry and hard science.

In this instance I want to draw the ball about 12 yards in the air (not extreme) and carry it around 220 yards. Technically, I would need to start this guy 3 degrees right of the target to do it at a club speed of 100 mph. Now, read carefully, because here is

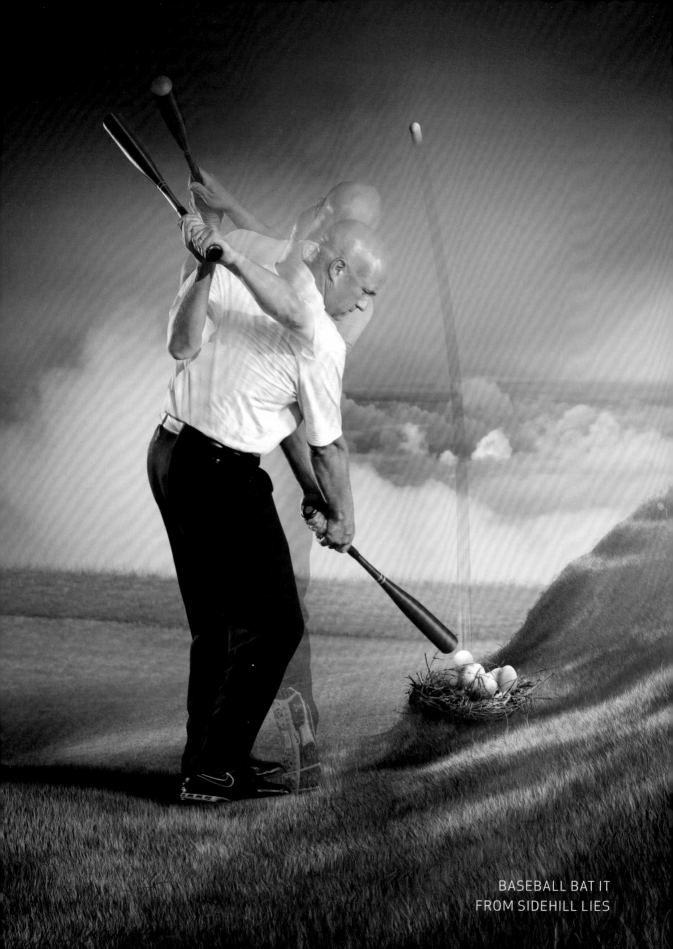

BASEBALL BAT IT
FROM SIDEHILL LIES

the technical data, followed by your feel! The path of this shot (which *was* famously thought of as the gun barrel of the ball!) would need to be 4.5 degrees to the right of your target line. The clubface at impact, relative to that 4.5-degree path (going right), would need to be only 2.5 degrees closed to that path for the shot to come off in its purest form. However, do not get bogged down with these numerical equations. I, as an extremely visual person, almost feel sick trying to calculate the science behind each and every shot. In my career as an instructor, my only business is to create the great golf swings that automatically fall into these number patterns. If I were to chase the numbers first while building out swings, it wouldn't be too long before I was selling hot dogs. Build the swing and the numbers will follow.

So your feeling is a simple one. You should strive to set the clubface on the very point at which you want the ball to start. After this moment your feel should be directed into the sensation of pushing to the right, which creates the drawing you desire. No independent hand action is ever employed through the ball; this is a simple act of aiming the face (right) and the body (slightly farther right) and committing the swing to a pushing or a slight rightness of feel through the ball.

For the good golfer: Your goal is to create your draw through the assembly of a swing that blends the plane, the face, and the arc of the swing together. For the amateur: Don't try to cheat the system. Good swings produce good shots; that is the fact. What is a good swing? It lends itself to a clubhead, swing path, and angle of attack that can repeat and that scribe a predictable ball flight for you that can work on most golf courses.

Build and the draw will come. Employ busy hands and it all becomes a little messy.

Baseball Bat It from Sidehill Lies

I love this image for so many reasons, but mainly because it is accurate to the feelings needed to play this shot. Slicers love the uphill sidehill lie; it's their dream for the club to feel shallow, late, and behind them! But for the rest of us, there are some essential imagery and guidelines for playing this challenging situation. When we talk about the subject of gradients in the next couple of pages, it is worth noting that any lie you face has to be negotiated and not argued with, because we are talking about the big ball here—Earth!

We will get into the subject of acceptance in more detail a little later, but it is paramount that your attitude, when faced with a non-perfect scenario, is excitement for the challenge and not despondence about it. This is what golf is all about: successfully dealing with the imperfect. Choose to see this as a test of your creativity and planning, and you will instantly approach a difficult situation with a more forward-thinking attitude—you will surprise yourself! As you will see, indifferent lies in golf become relatively straightforward with the right imagery and concept; it's all about being a chameleon, blending in with your surroundings, and knowing what to expect with the ball flight.

You will instinctively want to brace yourself against the slope with your weight displacement, so you will subtly go toward the balls of your feet. Alongside this, your posture will be a little more vertical than usual as it combats gravity and the tendency to sink toward the heels. The real trick, though, is with your arm positioning. Since the ball is higher than the ground and your toes, the

shaft and your right arm plane must reflect this adjustment by feeling higher at the address—hence the baseball analogy.

To hit a baseball at roughly chest height, you wouldn't have your hands and the bat positioned by your crotch or your shins; similarly, a golf ball at knee height wouldn't warrant holding the handle of the club or your hands too low either. The moral of this lesson, therefore, is to have the hands and the shaft up enough to be almost at ball level. In doing this, we have the plane of the club and the arms as near to the ball's height as we can, which will just make life easier!

This shot requires an around-your-body feel just like the image you see on the previous page. This is why the uphill sidehill lie feels good for slicers—the arm swing and the body motion link, match, and blend together so much better than in their regular swings. The old image of picking the head from a daisy is also a great way to think about this shot; it's that level feeling through the shot that provides us with the best key to good contact—you wouldn't want to smash the eggs in the nest, now would you? So always try to pick the ball clean from this lie.

Lastly: The ball always goes in the direction of the slope—the bigger the slope, the larger the axis shift imparted to the ball. Factor this curvature in and hit that home run into the middle of the green.

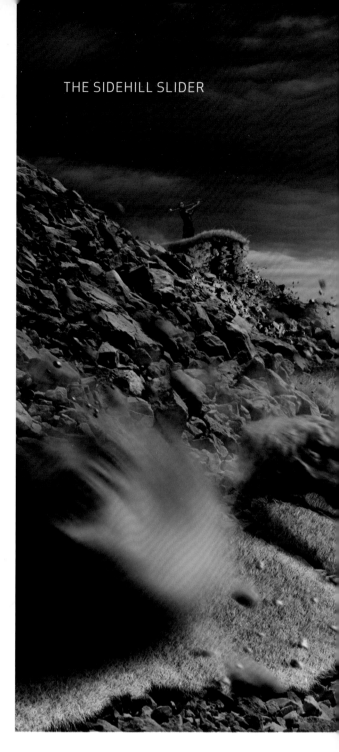

THE SIDEHILL SLIDER

The Sidehill Slider

I suppose in golf it's only possible to have the same shot twice from tee boxes, since finding the exact same location on a fairway is unlikely. Unless you believe in those crazy fables of Ben Hogan playing golf in the afternoon from the same divots he was supposed to have taken in the morning, you will almost certainly find a different lie every time you play even the same hole over and over again.

The downhill sidehill lie, like the one you see here, is not a friend to most weekend golfers, since the majority of them hit the ball to the right anyway. When a ball goes right the clubface is open—but why should such a lie

exacerbate this openness of the face and bleed the ball right even for good players?

The real answer lies in the body's inability to rotate into a great impact position, shift weight, and dynamically stack through impact and beyond. The trouble manifests itself because the slope encourages the weight to remain too toeward immediately from address position. The double jeopardy in this situation arises because the inertia of the club will throw your balance even more down the slope and further stifle all the qualities of a great impact position. But how does this affect the clubface?

During a golf swing there are linear forces (straight lines in a direction of motion)

and there are circular forces (rotations and planes). Because the weight is aggressively toeward owing to the slope, the golfer's ability to rotate into his left heel and clear the chest, thus squaring the face up through impact, is impeded. This is why the clubface points right.

The image here gives you a couple of great setup feels to counter that effect on the ball. Firstly, look at the way my heels are digging into the slope with the added sensation of my toes curling upward. This gives the torso a fighting chance of getting to its left side and opening out through impact.

Secondly, look at the magnifying glass on my grip. See how I have "gripped long" on the club, which allows my rump to squat a little more. Gripping it long gives me the ability to sense my weight a little more toward the heel without having to change the club in my hands.

Lastly, note my aim; it is parallel left of the flagstick itself, thus preparing for the inevitable right-flighted ball at impact. The key here is really to make a good aggressive move to your left side during your downswing and commit to turning into your left heel through the shot.

It's not good to fight Mother Nature in these situations—it's far better to appease her!

The Downhill Shot

The downhill shot is not an attractive one for many reasons. It's so hard on the golf swing technically that it sometimes leads to a volatile reaction in the ball flight. What you can expect when facing this kind of downhill gradient is a low bullet, and as you have probably already guessed, this is not the ideal profile for accessing any pin location. Most golfers will just have to accept this unfriendly ball flight

and plan ahead. The advanced golfer can conjure up a compromise using an exaggerated blend of swing path and clubface activity.

What is step one in playing this shot successfully? Well, it's imperative that you blend with Mother Earth and morph into the slope ahead of you. To do this, you must go against your natural balance reactions. The trick is to get your body perpendicular to the slope itself, as though there were no slope at all! Why is this important? Because your first and natural reaction will be to lean on your back foot to stop the sensation of falling down the hill. In essence, you will want to counterbalance, but if you do, you will find yourself hitting way behind the ball, since the low point of your arc will naturally follow where you place your weight, either at address or at impact.

Therefore, you must blend with the slope, and when you do this your weight will feel left-sided. The next aspect to factor in is the ball position. Keep in mind that the slope will keep trying to shove you down the hill, and this feeling will be exacerbated by the fact that, in the swing itself, you will be generating forces that want to push you farther down the hill as you dynamically move forward. As you can see in the picture, the impact position is toward the back of my stance, which more than anything promotes a "ball first" probability. Remember that the slope will want you to hang back (on your right foot) to counterbalance this downhill force. So make sure you place the ball, at the very worst, in the middle of your stance.

Naturally, the hands will lead the golf club through impact, and this is to be promoted (in fact, it is one of the few occasions when I *would* promote an exaggerated shaft-lean feel), since one thing we seriously need with this shot is a sharper than normal angle of attack. To summarize to this point:

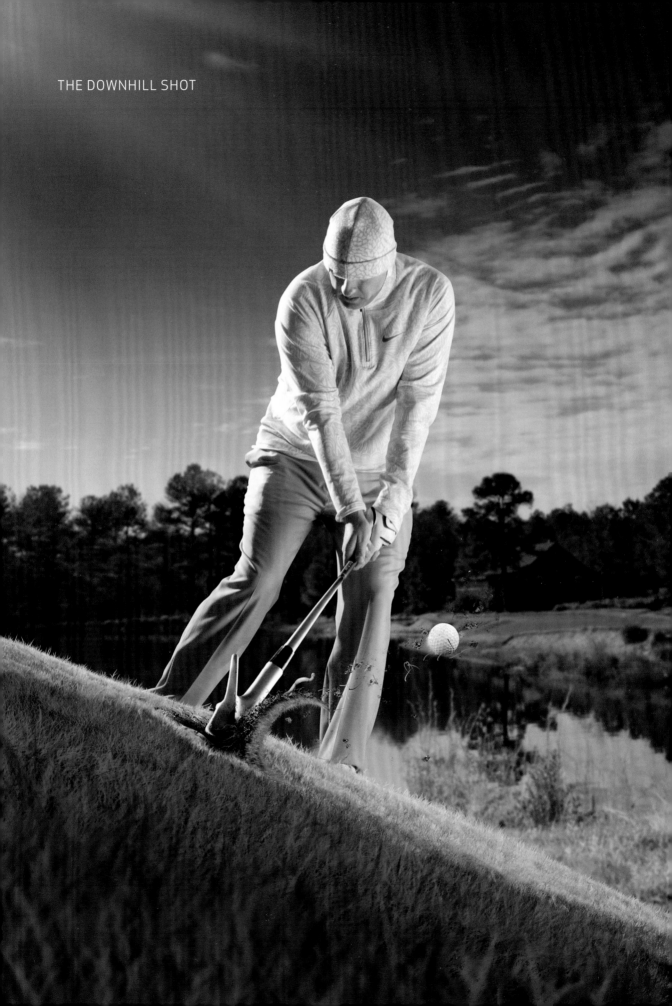

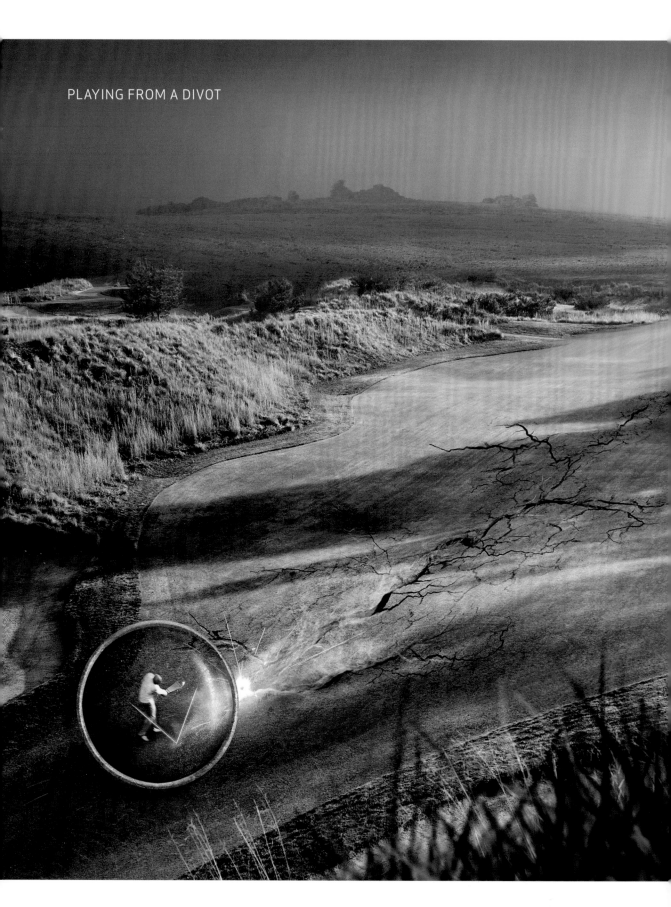

PLAYING FROM A DIVOT

1. Blend with the slope; become perpendicular to it, meaning weight, spine, and sternum forward.

2. Place the ball toward the back or middle of your stance.

3. Sense at address and at impact that your hands lead the clubhead all the way.

Lastly, as uncomfortable as it may feel in your follow-through, you must keep moving forward. The ball will come out like a bullet, so plan ahead. Take a more lofted club and make plenty of practice shots before you engage. And please, please, please, keep your energy moving forward during the shot—no hanging back!

Playing from a Divot

"EARTH-SHATTERING" DIVOT PLAY

The purist in me reasons that a shot finding the fairway should be entitled to a perfect lie— not in regard to any slopes I may find, but just in finding a decent, manicured lie in which I can do what I want with the ball. The realist in me, however, knows the facts. It is possible to hit a great tee shot where the ball finds a collection of divots large enough to span a small island; this occurrence is unfortunate but not unfair. It is just the nature of golf, and you should accept it as such—what else can you do? Finding a divot is not the end of the world. Look at any Tour event and you will see that, with the proper execution, a decent shot can still be played—so don't lose heart in this situation; accept it and then carry on!

The vital ingredient in playing the ball from a divot is the correct angle of attack. This shot, usually sitting down in a trough of flaky turf or sand, needs to be compressed from this lie; anything other than a downward attack will result in a duff. Like many shots in golf, the concept of "how to" in negotiating certain situations is *the* most important factor in attaining success, since you then have the ability to build an accurate technique around it. In essence, hitting this shot from a divot is very similar to a punch shot, inasmuch as the technique follows the same trapping and downward motion.

Positioning the body—more specifically the top of the sternum and the shoulders—unlocks a key combination for striking the ball well from this lie. Your sternum (or breast-bone) must be, at worst, level with the ball or slightly ahead of it as you take your stance. To make this positioning slightly easier, move the ball slightly back in your stance; you will find that the sternum will now want to hang over the ball's position a little more easily. Why is the sternum position so important to the strike? Since the sternum represents the body's center of balance from the face-on per-spective, having it on or slightly ahead of the ball virtually ensures we always contact the ball first. Moving on from this, your next feel is with your shoulder alignment. Anytime the ball is struck well with an iron, the shoulders are slightly open to the target line at the time of impact; when you combine this quality with the breastbone aligned over the ball, you will always strike the ball first. So what we really try to do with the address position of this shot is to re-create a great impact position. One more little feel to gain over the ball: Allow the right knee to fire inward slightly toward the left, thus shifting a slight amount of weight forward.

The image itself gives you the concept and DNA of the type of contact and the result you want, as the earth shatters out in front of the ball. The cracked riverbed extending away from the ball came to me while I was visiting California, and it immediately struck me as a great metaphor for a particular sort of ball/turf contact.

The Fairway Bunker

DON'T CRACK THE EGG, BECAUSE YOU MIGHT LOSE MORE THAN A SHOT!

This image was born out of learning that Jack Nicklaus attributed his fantastic fairway bunker play to the wide, sweeping arc of his golf swing, which enabled him to pick the ball cleanly from the sand. Picking the ball clean is not the only way to play a fairway bunker shot. For example, if the sand is a little wet or seems compact, you can take the option of punch-ing it out, almost in the same way you would play a ball from a divot. It goes without saying that your first consideration is the bunker's lip height. Don't let your heart rule your head here—get it out!

When there is an element of looseness in the sand, through being either flaky or powdery, picking the ball is best, so with this in mind the depth of your contact is all-important. The T. rex is a bit of fun, but what *is* important to focus on and imagine is the egg underneath the sand, since this will have your mind in the right place throughout the swing. Tricks of the trade with this shot include look-ing at the top of the ball (to achieve a clean strike) and standing taller at the address

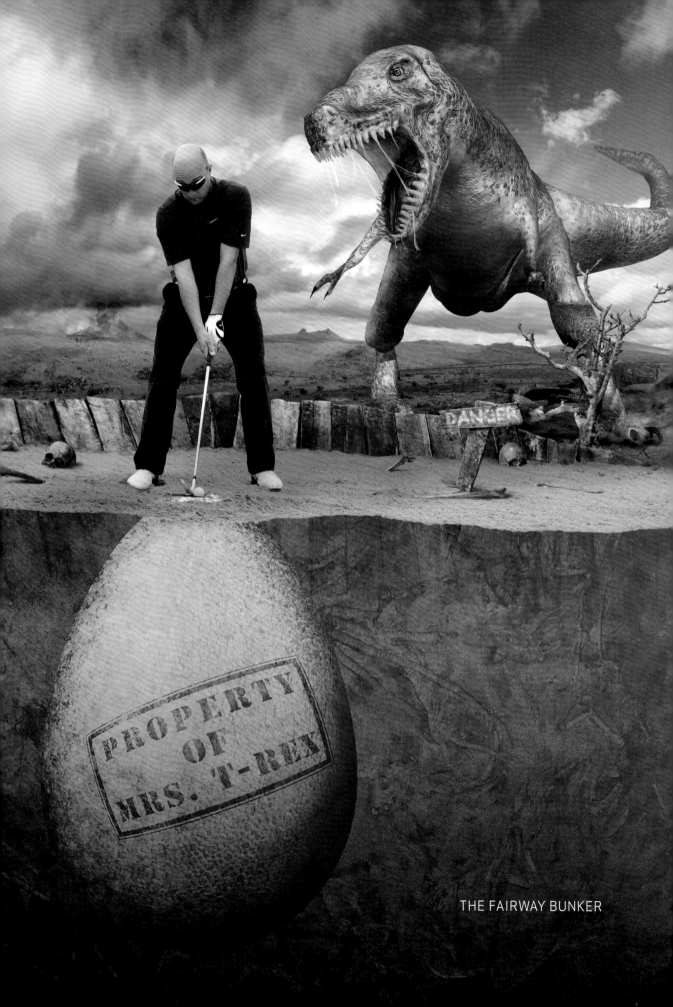

PROPERTY OF MRS. T-REX

DANGER

THE FAIRWAY BUNKER

YOUR SHOT-MAKING MENU

position. These are both effective keys to focus on, but the real trick lies in what Jack had going for him!

Look at the image on page 49 and note how the shaft hovers at 90 degrees. Well, if we were to replace it exactly at that position during impact, the shot would be pretty successful—you can see how clean the strike would be. There is no forward lean in the shaft. In fact, if you study the image, you can see that my hands are marginally *behind* the ball at address, thus assisting the pick. Jack's advantage can be found in the way he had very little wrist cock in the backswing—he didn't have too much to replace on the way down in re-creating that functional address position. So in making your backswing, feel as little as 50 percent of your normal wrist set or cock, and your clubhead will pass through the impact zone on a nice, sweeping, shallow angle of attack.

Use the information above and the image on page 49 to play these shots. Most of all, catch that ball clean—your life depends on it!

Your Shot-making Menu

À LA CARTE YOUR WAY TO THE SHOTS YOU CHOOSE

One of the challenges we find in golf is to try to play the right shot at the right time. Dr. Bob Rotella has popularized the phrase "conservative strategy, cocky swing" in his teachings for years now, yet even at Tour level I often see players taking on a 3-in-10 shot rather than an 8-in-10 shot. The 3-in-10 shot creates two outcomes both physically and mentally.

Physically, it induces tension through the mere fact of your facing a more difficult shot. It can also strain your present technique to the point of breaking it down. Believe it or not, there are some shots that you are simply not capable of playing! You have just been baited and conned by your ego. We will go into this a little later, but suffice it to say that your ego loves the glory shot! Done enough times, the glory shot or the 3-in-10 will fatigue you and mentally wear you down.

Wouldn't it be great if you had a simple formula—a menu, if you will—that you could refer to every time you faced an approach shot into a green? What I provide you with here is a shot-making menu as old as St. Andrews itself, one that has been proved time and time again to give you that 8-in-10 shot. Do with it what you will; like life, golf is a yes-or-no question. You can use this and eat away at those ego decisions, or you can let them eat you up.

Golf is basically a numbers game. "Really!" I hear you say. "Tell us something else we don't know, Bradley!" Well, I know we have to record our scores, but in terms of shot making, it's quite interesting to look at some hard facts. Imagine standing in the middle of a fairway; out ahead of you lies a green with the pin situated on the right side. If you take the width of the green as 100 percent, to shoot straight at the flag would mean that you only work with roughly 25 percent of the total hitting area. With the usual hazards they place next to such pin placements, you are asking for trouble. In the Holy Grail Shot-making Bible, you would hit the ball starting in the middle of the green and let it fall to the right; in doing this, you would now be playing with 50 to 60 percent of the hitting area available to you. If you plan your attack this way, your margin for error is greater and your physical and mental tension

is reduced; if you pull the ball, you will be on the left side of the green. If you hit it straight, you will find the middle of the green. And if you fade it as you intend to, you will have a pretty good chance for birdie.

The Third Eye of the Mind

I believe that the best players in the world have the ability to stack the odds of success in golf very much in their favor. They stack these odds in preparation—physiologically and spiritually—so well that they create a certainty and a confidence that will see them through the heat of battle right to the end. The only time a good player will generally speak negatively about his game is when his preparation

has been poor in one of these aspects. Having taught some of the best players in the world, I can say that any aspiring coach needs to understand the importance of process and preparation more than anything else he learns or teaches in his career.

From the player's perspective, the preparation the instructor or mentor recommends must culminate in one result and one result only: to be totally into the target while standing over the ball. This is utopia in golf; this is when you know you have arrived (albeit for only a short time) at that moment when the stars have aligned, your numbers have come in, and the ducks are swimming in a row. If your instructor gets you to this point, dish out the medals, compliments, and percentage bonuses, because he has done an amazing job.

This image gives you the perfect out-of-mind awareness sensation you can achieve when you are totally into your target. Even

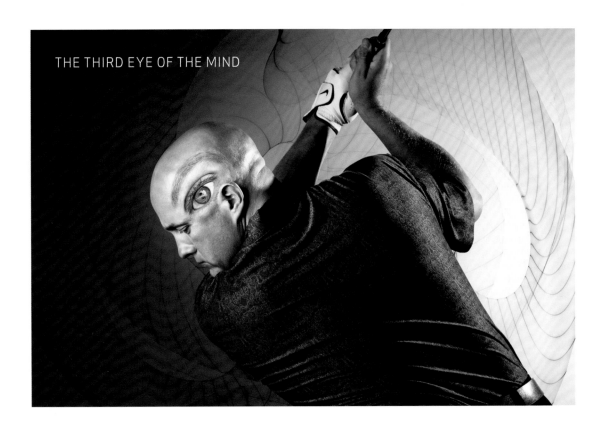

THE THIRD EYE OF THE MIND

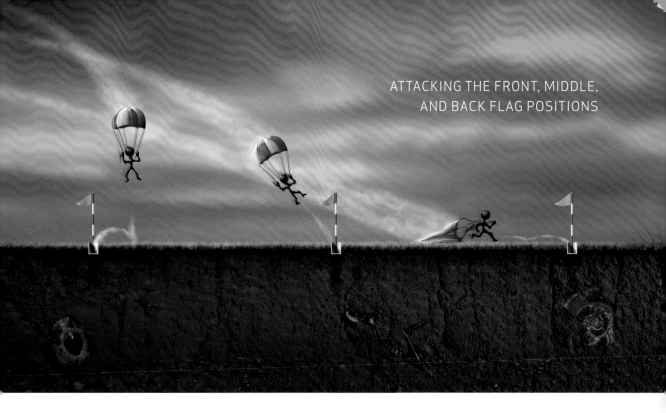

though you are looking at the ball during the swing, it can be hugely beneficial to place your mind's eye out there on the target as you go through your motion. When you consider that the mind has to be somewhere, having it directed at the target isn't a bad starting point. Start this sensation off with your short game. Hit some pitch shots with your third eye directed at the target, and then hold it there during your actual swing—it will liberate your motion and quiet any chatter or busyness that may be going on.

Attacking the Front, Middle, and Back Flag Positions

Stepping into the mind of the course designer, we must consider what he would do relative to the green from its front (normally guarded,

because most players fall short) to the middle and the back. Is there a way we can flight the ball in to these pin positions that gives us the best chance of getting it close, but without introducing any hazardous elements?

Statistically, a high shot coming in for a back pin will always come up short and then possibly screw and spin back farther down the green. Conversely, a ball coming in low will never work for a front pin! So attacking a pin at the back will be more successful if the shot comes in a little lower and chases up the green. Alternatively, the front pin will be better negotiated with a higher, aggressive shot to the middle, leading to that chance of the ball sucking back.

Look at this image and copy the shot-approach menu: It will really take the guess-work out of what shot to hit and where!

From the Rough I

PLAYING WITH A CADDY NAMED EGO?

Once again, an ego-driven mistake in which a player's heart tries to rule his head. The reality of the situation is this: To become the best player you can be, you must enter the world of the course designer. "What was he thinking when he placed that bunker there? Why does the green always look diagonally at me, and why do I always come up short on this approach?" Think about it. A golf course was essentially designed on a drawing board, computer, and sketchbook, and each was used in a controlled environment in which the designer had all the time in the world to create his master plan. He wouldn't have designed it while trying to whack a ball around a mud field with a pad and pen in hand. No, he quietly planned and schemed his torturous topography just for you!

Owing to the time constraints under which we play golf, we are often forced into rushed decisions. So as you arrive at your ball, up pops this little window of time in your brain in which to make the right decision as your ball sits in its uncomfortable situation. Unfortunately, this small window is just wide enough to let your ego suggest the quickest route out in its attempt to save time and face. Gone is any rational awareness, calculated decision, or strategy. You walk up to the ball with no picture, no feeling, and no plan, and guess what—double bogey.

Out does not necessarily mean forward! As you face a situation like the one in this image, just take fifteen seconds longer to decide what is really your best strategy. Fifteen seconds seems like a decade when you are standing by your golf bag or cart, but your playing partners won't mind one bit. If

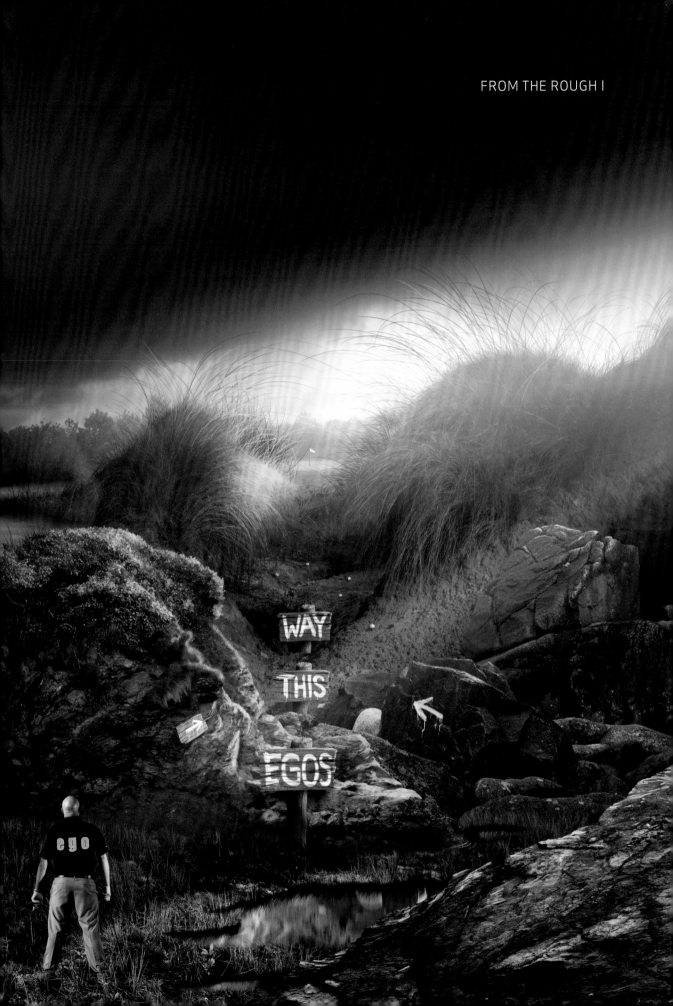

DON'T CLOWN AROUND
WITH SUCKER PINS!

anything, they will be quietly impressed with the decision you have taken and the control you have shown in wedging a ball back in play. I believe that anyone anytime can make a bogey simply through a poor shot, but anytime you see a double or triple on the card, you know there has been a mental error as well.

I can understand the glory shot when you are one down playing the last hole—you have no option. But when you do have options and time, choose the shot that will create a par chance or a clean bogey. Just ask the question: "What would the designer have me do here and now in this situation?"

Think like a strategist—don't play to your ego!

Don't Clown Around with Sucker Pins!

There are two things that, quite frankly, always act to the detriment of the golfer: the ego and adrenaline. Granted, a little adrenaline can be an asset, as it assists focus and indicates that you have entered a competitive environment and are ready to be challenged. Too much, however, and your thinking and nervous system will suffer.

I have a saying when I coach college players and professionals alike: "If I offered you eighteen greens every round, you'd take it, right? So why shoot for pins?" The usual reply comes in the form of a lightbulb appearing above their heads and, indeed, even a sigh of relief, as if to say, "Thank God—it's okay to not shoot at the pins and still be a man!"

Get your thinking back to the course designers. They are the masters of intrigue and illusion. In fact, if you were to create a mission statement for course designers, it would read something like, "To excite and tempt players into making mistakes through beauty and illusion."

There are times, for example, when you may face a shot of 150 yards into a green like the one you see here—pin cut tight to the edge, bunker guarding it, and no room to play with. From this perspective (the camera shot), you can plainly see it would be suicide to take the pin on—even with a wedge. However, from the fairway we get a different impression. Standing next to the ball, we believe that there is plenty of room to land the ball between the bunker and the pin, because that is *what we are seeing!* The ball has to right-correct, so let's go for it!

If you follow your instincts, you will play your next shot from that trap with very little hope of getting it up and down; you just fell for one of the oldest design tricks in the book. The designer deliberately placed a bunker that is proportionately much bigger than the green itself. Then add into the equation that the pin may be slightly shorter than some of the other pins on the course, and you have a shot that seems a lot farther than it actually is. Standing in the fairway, the pin looks so far behind the bunker that you mistakenly believe you have at least fifteen yards to play with. This is a very basic example of the way in which what you see is not always real.

In this situation, and indeed in 99 percent of on-course scenarios, you must play the yardage! Because your feelings are more powerful to you than a bunch of numbers on the yardage chart, the temptation is to go with what you feel. What you feel and what is real can be worlds apart in golf. So in ending: There will be plenty of clown pins during a round of golf, but always start an important round by asking yourself, "If I were offered eighteen greens now, would I take them?" You bet you would, so—don't be a clown!

From the Rough II

BECOME THE ROUGH DIVA WITH AN EXTRA LEVER

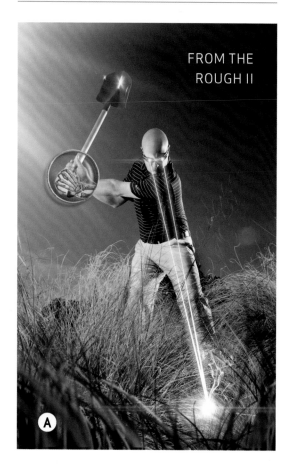

FROM THE ROUGH II

A

When in the rough, we have all heard the expression "Just chop it out," indicating that the ball is sitting in rough so thick, you have to resign yourself to zero chance of positively advancing the shot. Some golfers are just plain useless at escaping from rough situations: The clubface tends to enter the grass so flatly it gets caught up and snagged, and the ball barely gets airborne. Assuming that you have not been too ambitious with your club selection, advancing the ball poorly from the rough is generally a technical issue, with a little bit of physical incapability owing to the situation thrown in. This image was created when I lived in Ireland, playing great courses like Waterville and Ballybunion, where the cabbage can be punishing. Years later, it has become a great weapon in teaching players to deal with the roughs they encounter during U.S. Opens. Irrespective of your physical prowess, this image can really work for you.

The key word here is *leverage*, and how much you can get of it. For the golfer who never gets the ball *up*, the club's angle of attack is never steep enough to stun the ball from its buried lie. To be successful in this situation, you must descend on the ball. Typically, golf instruction has always focused on keeping your weight forward and cocking your wrists, which can work well in normal situations, but what happens when the ball is really nestled down in the thick stuff?

What you see in these images is the conventional way to play a rough shot (left), and the supercharged way (opposite). The conventional way creates just one lever, which works well some of the time. To really sting the ball out with some oomph, though, look at the second image, the one with the chain saw! The technical change is that I have allowed my left elbow to bend, and in doing so created a second lever to the wrists. You can see that its angle is much sharper in and out of the shot, which in turn produces that stinging pinch attack we need.

The amazing feel you get from this is one of softness in the backswing as the elbow joint closes up and slightly bends, then accelerated delivery as the same elbow joint straightens and plummets the clubhead into the grass. This shot really is a useful piece of armament when you haven't hit your straightest drive! All power to the elbow!

Into the Wind

TO HIT THE BALL LOW, AHEAD THE STERNUM MUST GO

In *The 7 Laws of the Golf Swing*, I introduced a new, more reliable concept of ball position, which has now been accepted as the norm. I always felt that something was missing from the standard approach to ball position, which was: Move the ball forward in the stance to hit the ball high, and move it back to hit the ball low. Like many other golfers and fellow pros, I always seemed to struggle with either divot patterns being too deep or no divot at all. The spin was adverse, too. For example, shoving the ball back in the stance always produced huge divots and tons of spin, so the intent of hitting a low, penetrating shot into the wind was gone when the ball took on its low-launch, high-spin characteristics.

Moving the ball position around in the stance must be complemented by the correct positioning of the right foot and the sternum. It's very simple, really, since you don't actually create different trajectories by moving the ball around—you accomplish it by adjusting the sternum in relation to the ball. So if you want to hit the ball lower, simply move your sternum to a point that is at least on top of the ball.

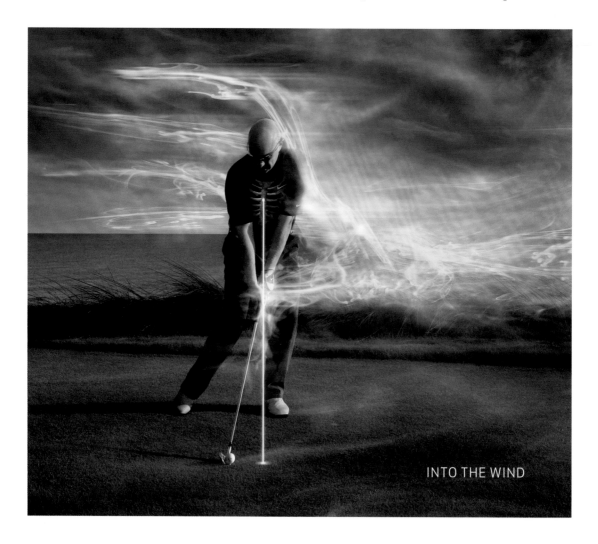

INTO THE WIND

You will also automatically feel that your right foot wants to narrow in on the left at this stage.

Have you moved the ball in relation to the left foot to do this? The answer is no! It still maintains its position at the low point of the arc, so the divot pattern retains its normal depth. The good news about this is that you will create a lower flight by trapping and covering the ball more effectively with the body, rather than attacking it steeply from the ball back position.

In a picture—it's all here for you on the opposite page!—you can clearly see how I have hung my breastbone over the ball, encouraging coverage of the ball with the chest. There has been no cliché instruction like "hands pushed ahead" or "weight forward," since this setup has no extremes. Less is more in regard to your club selection. The rule of thumb is this: The harder you hit a ball, the more backspin it is likely to have and the higher the ball will go. So choose a club that will get you to the target yardage with just a three-quarter swing. This is a great example in golf of the "less is more" philosophy working for you!

Controlling Your Ball Downwind

A downwind shot can be one of the more difficult shots to judge. The difficulty is in the degree of accuracy you have over your distance control. With a wind that's into your face or coming from the right or the left, you can judge the effect quite accurately because it's all out in front of you. But when a wind is behind you, it's almost like a blind spin where the effect can be, or seem to be, somewhat unknown. But this shot shouldn't pose many problems directionally as long as your basic alignment is fairly neutral.

To get the vision clear in your mind, I first need to explain something. When a ball is hit well, blending good speed and a full release of the face (that is, presenting the proper loft of the club back at impact), it will generally apex anywhere from 26 to 30 yards in the air. In a perfect world this would be the same for all clubs—you actually see that at PGA Tour level quite frequently. Typically, though, the average amateur will hit his short irons way higher than his long irons, since there is often too little clubhead speed to spin the long irons high enough into the air, gaining that apex yardage.

In a downwind situation, this poses two interesting ball flight patterns for most people. Firstly, when the short irons do climb high downwind, they will carry farther than in a normal situation. Secondly, medium to long irons will get knocked out of the sky, nose-diving short of your intended landing area. It's why planes never land downwind—too little speed, and they would lose height very quickly; too much height, and they would never get down in time! So the key to the downwind shot is the perfect compromise: not high, not low. You must really work hard on two things to pull this shot off successfully. Number 1: Work on where you see the ball landing and running out to the final target. Number 2: See the trajectory you ideally want for Number 1 to happen. Look at the image on the next two pages to gain a visual understanding of the conditions you will experience. The key is to merely "chip" the ball with the wind and have it travel at the same speed as the wind. This is not the reality, of course, but it does generate the correct pictures and feelings.

So now you can appreciate that to have the ball under control downwind, you should really try to match the speed of the ball with the speed of the wind.

The Crosswind Hold

I tend to agree with the idea that, from the tee box, you should generally utilize a crosswind to gain more distance. However, when a crosswind is present on an approach shot, the wind can be utilized once again, but in a different way. A wall of wind is your ally when a pin-seeking iron shot is needed, since, when understood, it will give greater clarity to the shot you face. The crosswind hold allows you to work the ball against an invisible wall along which you can slide the ball down to land softly right next to the pin.

Let's not get complicated about the technique involved in order to play this shot. For a right-hander with the wind off the right, you are simply playing a static fade against it. For the right-hander with the wind off the left, you are playing a static draw. No manipulation, no funny follow-throughs, nothing confusing.

I love the image here. I first shot my preliminary images for this book at the wonderful European Club in County Wicklow, Ireland. My first intention was to depict this wall of wind like the side of a billiard table, with a ball bouncing off it. The other way I had in mind was to have a huge mattress that the ball gently skipped and bounced slowly along, eventually grinding to a halt and dropping vertically down to the pin. I settled on the picture you see here, which features the spiraling whirlwinds on the right flank of the hole buffeting the ball back over the green's surface.

There's also a reason I prefer the static shot-making setup for these shots as opposed to the feeling way to play them. The one thing you don't want to do on these shots is to double-cross yourself. In a nutshell, to double-cross yourself, you wouldn't have the face aimed correctly at address in the

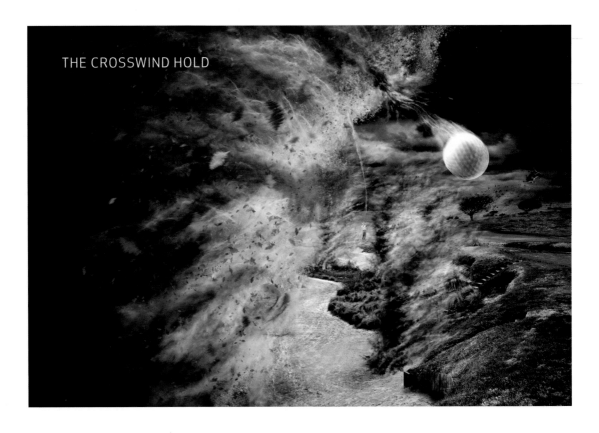

THE CROSSWIND HOLD

The Pain of Rain

first instance. Take the image, for example: It would have been disastrous had I had the clubface aimed at where you see the golf ball in the picture, since I would have introduced the possibility of missing the wind altogether or underestimating it, which 90 percent of amateurs do! By aiming *too* straight, like this, the temptation now is to "push" the ball into the wind, making up for the "gap" the initial poor clubface aim created. In pushing the clubhead away from us, we introduce a right-to-left spin on a ball that will start too straight, then spins right to left *and* rides the very wind we are trying to hit *against*! This isn't double-crossing, it's triple jeopardy! Such triple-crosses would go *with* the wind and unfortunately finish a mile from your intended target. So when you use a holdup shot, don't focus too much on the path of the club. Instead, ensure that the face is pointed *into* the wind you want to work against and swing normally. Do this right and you'll never be "gone with the wind"!

Originally from London and having lived in Ireland for three years in the mid 1990s, I can tell you that I have had my fair share of rain on the golf course! It's not a pleasant situation, granted, but it is an integral part of the game. If you are playing a friendly game with nothing on the line, it's an easy option to take shelter in the clubhouse with some lunch and a drink. If, however, there is something on the line—like a grudge match, a lofty bet, or even a professional situation—you had better have an attitude and a strategy that gives you an edge in the wetness. I'll give you an example. In wet and often windy conditions, the easiest thing in the world is to resign yourself to the elements, throw in the towel, and demonstrate little in the way of effort. You do, however, have a choice: You can instead decide that, although it is raining, you will be the last to throw in the towel—and, by the way, the tougher it gets, the tougher you will be. What's

the worst that can happen? You'll be in the clubhouse in three hours, you'll get dry, and you'll survive. So the next time it starts to rain cats and dogs, think about the other members of your group or the rest of the field; they will mentally have started to quit as soon as the first drop hit the deck. Raise your focus and your efforts in the rain, and maintain perspective. You'll be glad you did!

In terms of strategy, the picture on the previous page gives you a few tricks of the trade. The spokes of an umbrella provide a perfect wash line from which to hang objects such as gloves and towels. These objects are now easy to reach, pull off, and use when needed. You will find this simple ploy much easier than delving into rain-jacket pockets. Your wet hand would inevitably make the pocket wetter and, in the instance of finding a glove, make it more sticky and damp. Use the umbrella as a metaphor, too. I wanted to create an image in which it seemed that I was in my own little bubble of concentration, where no one could infiltrate and upset the resilient attitude I was conjuring up to deal with the inclement conditions. In fact, it's not a bad metaphor in any conditions to have an imaginary shelter over your head keeping out external distractions.

Lastly, Justin Rose, then a student of mine, played with five-time Open champion Tom Watson in the 2008 Open Championship at Royal Birkdale. This was a thrill for us both, since Tom represents everything that is great in a player and a champion. The first two days at Birkdale were very unpleasant, with 25-mph winds, sometimes gusting to 35 mph, as the order of the week. A challenge for anyone! What amazed me about Watson during those first two days was that even in the driving rain he limited the amount of time he used his umbrella. While I saw other players (even those using the wash-line tip) clumsily juggling among putting gloves on, drying grips, and attempting to keep the towel dry, Watson merely "walked the rain," placing his glove hand in his pocket when not playing a shot. It was a simple yet highly effective demonstration from this seasoned campaigner, who from tee to green that week easily held his own with the young golfing studs. Yes, the rain is a pain, but with the right attitude and some simple strategies, you can become the bad-weather maestro!

Put the Ball into the Hole

I remember watching Jack Nicklaus give a putting clinic at the London Golf Club in which he said that he never really tried to *stroke* the ball into the hole, but rather *put* the ball into the hole. This was an interesting insight into a golfer who has held more clutch putts to win championships than any other golfer in history. If the putter could talk to the ball in the

PUT THE BALL INTO THE HOLE

case of Jack's stroke, it would be saying, "You have no choice! You are going in!" (A)

I never wanted to play golf as my life's work. I always had an affinity for teaching and mentoring. However, when I first turned professional, I played in tournaments around London as part of my PGA training. And even to this day, one three-foot putt I missed burns into my soul. I was playing the beautiful St. George's Hill course in Weybridge, Surrey, on a dank and dingy winter day, with the rain coming down sideways on some of the holes. I made the turn at one over par, doing my best in these crummy playing conditions. I made par on my 10th hole (I had started on the back nine), and into the teeth of the wind I hit a driver from the tee and a driver onto the front of the green to the 11th. Sensing a par would be more like a birdie, I lag-putted up to about three feet from the hole. What happened from this point on would reframe not only the way I approached short putts but also the way I have instructed anyone since. Thinking all the

tough work was done, I stood over this short little shot and simply fell into a stupor, my mind on the result and not the process. After standing over the ball for fifteen or twenty seconds, I jerked the putterhead back and made a pass at the ball that was weaker than a kitten. Then I watched in disbelief as a three-foot putt was left six inches short and right!

Had I had Jack's philosophy working for me that day, I would have been far more assertive, and from that moment on I knew I would never botch a short putt like that again by being so rigid and non-flowing.

Image A conveys the conviction the putterhead must feel to *put* the ball in the hole and not "dolly" it in there (B). As you develop as a golfer, you will soon discover that even the shorter shots need to be played with conviction. This applies to chip shots, sand shots, and even delicate chips. No golfer I instruct is allowed to be tentative over these short shots—either you take control of them or they will sabotage your mind. PGA Tour and

European Tour careers have been destroyed by these small and innocent-seeming shots.

Never freeze over the ball as I did. Once you are convinced that you have the face of the putter looking directly at your target, take one final look, let your eyes come back to the ball, and then make your stroke. Any time between ticking the "target box" and pulling the trigger is danger time, a horrible void before action that can allow the mind to wander and the body to tighten.

Don't *stroke* your ball into the hole. *Put* it in the hole. As Yoda in *Star Wars* once said, "Do or do not—there is no try!"

The Crosswind Ride

There's probably not another golf shot like the crosswind ride, in which the moment the ball leaves the clubface, you relinquish all control to the elements. Once the ball is up in the air, you really hope that the breeze you *thought* was present continues to be present for the duration of the shot. The closest thing to this act of letting go would be a putt. Once the line and speed are calibrated in your mind's eye, all you can do is simply stroke the ball down that line and let the fall of the green do its thing! In both shots you turn over control to nature.

Good players tend to categorize wind in two ways. A wind that is behind them or directly into their faces will be termed a *club wind*, which means that they will take a club or two off the shot with a downwind scenario, or add a club or two when playing into the wind. When the wind is side-to-side, like in the image, good players will use a yardage or clockface system. Both of these examples are very practical, but the visual golfer will tend to like the clockface system more, since it will all be laid out in front of him. He will be able to see that clockface and determine that the wind is coming from the right at 2:30, slightly in from 11 o'clock, or hard off 3 o'clock. The yardage system, in which you stand down your target line and simply determine how many yards the wind will affect the ball's sideways motion, is likely to be the choice of the more analytical individual. If you adopt either of these methods the next time you play in a breeze, I'm sure it will help your judgment greatly.

There are always going to be slight variables in windy situations. The 2:30 wind I mentioned represents a wind that is from the right and slightly into you. Therefore, we have to factor in the sideways impact on the ball and possibly an extra club. There will be very few occasions when you face a simple and straightforward wind direction as in the four points of a compass. In these situations, you have to be versatile and blend the two methods of wind judgment together. The image shows a typical wind scenario. I hit a shot that flies relatively straight until it climbs into the thermal. At this point, the wind will really take effect, as the ball slowly starts to curve as it loses its forward momentum; like the last breaking foot of a putt, Mother Nature's influence will really accentuate the curvature toward the end of the ball's journey.

As usual, picturing the shot ahead is vital to success. If you use the pre-shot routine I taught you in The Ball Has Gone with the Wind (p. 28), you will find that you really buy into the shot ahead and gain a great sense of movement in your visualization. That is what you are really trying to accomplish here—a sufficiently accurate movie in your mind to enable you to select the correct club and shot for the situation. Experience obviously comes into it, but at least here you have the tools of the trade to experiment with and use.

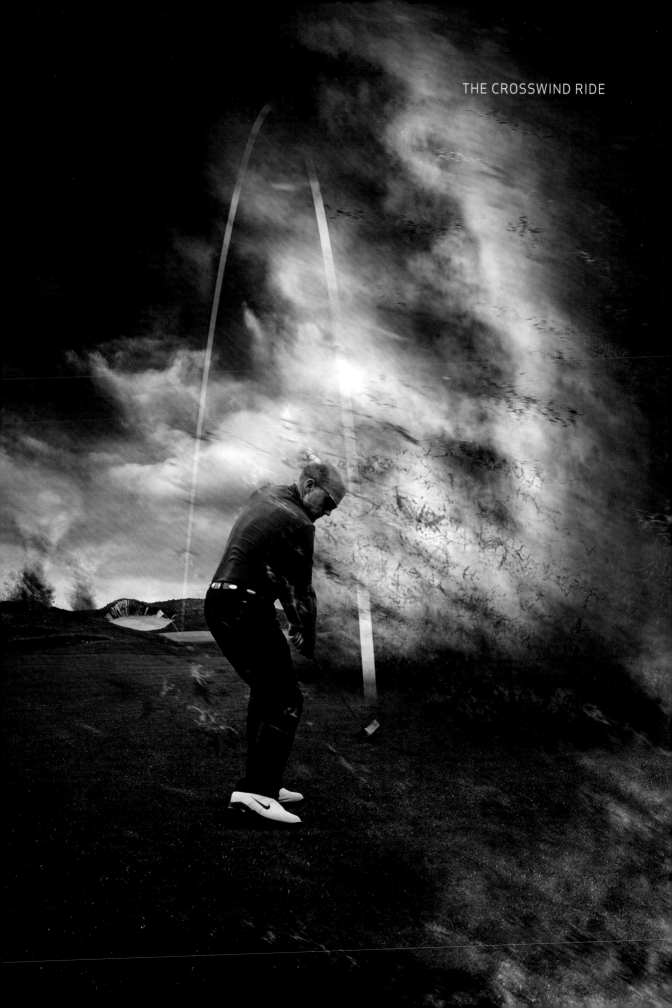

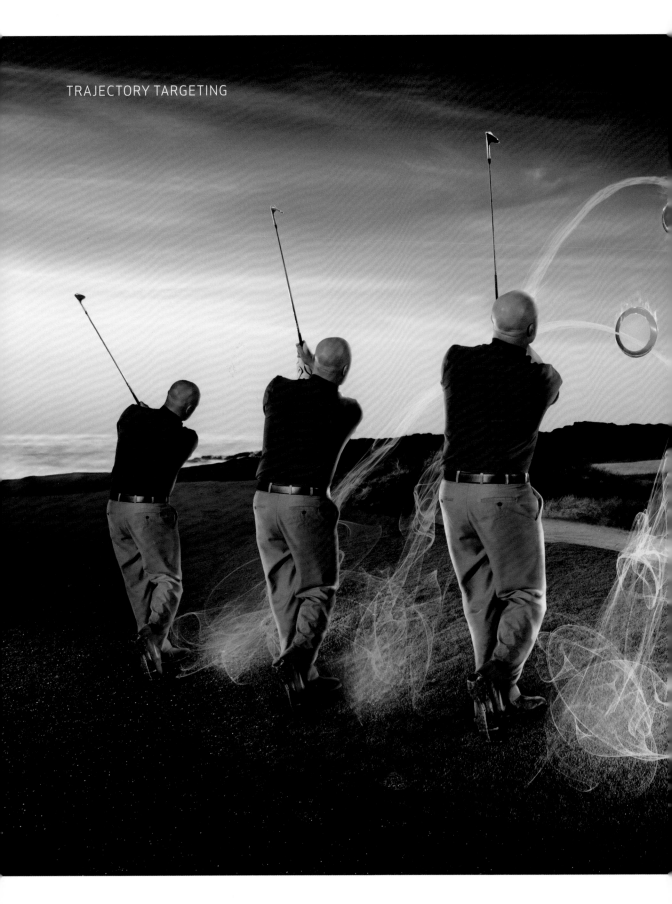

INTO THE GREEN

Trajectory Targeting

Ben Hogan was one of the first golfers to mention that his practice sessions started with first the trajectory of the ball in mind, followed by its direction. Hogan had a reason for this that was personal to his swing. He had a tendency to get narrow into his downswing, which was accentuated by the fact that he had double-jointed thumbs and an extremely kinetic golf swing. Angle of attack was Hogan's issue: If he kept the spin down on his ball, his distance control would be under wraps—which makes his one-time win at The Open Championship in Carnoustie in 1953 all the more remarkable.

One other note I want you to be aware of: There is really no such thing as sidespin on a golf ball! "What?" I hear you say. Yes, it's true, folks, sidespin is a myth. What actually happens when you see the ball curve in the air is a product of ball axis change. Imagine a spear going through the middle of the ball from north to south. If the spear was hit flush, bang in the middle, the ball would launch dead straight, as if it could go through the eye of a needle. This is rather like a rugby ball or an American football when it has been kicked perfectly straight and rotates end over end (backspin). However, when that spear has been hit on either side of the pole, its axis changes in a nanosecond, matching the angle of the clubface (shut or open). Once its axis has been altered—or, with luck, remained the same—the ball merely has backspin. A ball can *only* have backspin, or *total spin*, as we call it.

Trajectory targeting avoids what I call the "high, wide, and handsomes" or the "mushroom cloud effect." In both, you will witness

the ball ballooning high and sideways, just like the edges of that sinister puff of smoke after an atomic blast. When faced with a situation where you can knock one in from about 150 yards, it's better to send it in low if you can. Take the spin off and shoot it in low at the flag.

Take a look at the images on page 70. This is a visual cue for hitting those front, middle, and back pins simply by adjusting your follow-through position. Each pin needs a different angle of descent to maximize opportunity while quashing disaster. Part of knocking the ball close first involves your decisions about the height of the shot—its apex. The relationship between the hoops of fire and my swing can be seen in my right arm and club-shaft exit plane. Assuming that I'm using the same club here (which I am), you can vary the ball trajectory by simply working on your finish positions. The low hoop will need a shallow plane through the ball to keep the backspin down. Conversely, you can apply more backspin to a shot simply by finishing in a high, steeper exit plane. Work with these images when you want to take out the flag; low is the way to go. One last word: In throwing the ball in lower, it is always easier to go down a club to make a swing easier in these positions, since you will not be in danger of overworking your golf club.

Rocket Uphill Shots

Uphill shots produce some of the most bizarre ball flights imaginable, owing to various dynamic factors—yet I haven't met one golfer who doesn't like them, because of the high and floaty ball flight you inevitably get from this natural launch pad.

These images give you two accurate feel reference points: one as a backswing sensation (A), and the other as a through-swing directive (B). We must accept that for some golfers the idea of swinging into a balanced and fully released follow-through position is difficult enough when the ball is lying on a flat piece of turf. Golfers have two default responses when working on this position, which *doesn't* have to be merely the culmination of everything that has gone on before it. The first reaction I am likely to get after posing someone into a finish position will be along the lines of: "I feel very self-conscious that I am imitating a good golfer at the end of *his* swing and not mine." This response is merely an awareness of a new place to go during their golf swing and a slightly egoic dread that they could end up looking a lot better than the ball actually performs after they have hit it. To a large extent your finish position is the last chapter of a swing you have just written about, but it *is* within your ability to influence many aspects of your technique through its function.

Hitting an uphill shot is a little like trying to push a car uphill. It's relatively easy to push any car forward when there is little or no gradient to the ground and, like the golf swing itself, if you give it a little momentum and dynamic motion on a flat surface, its energy forward will be largely perpetual. Place a golfer on a slope like the one you see here and he or she will have to work twice as hard to get into a regular finish position. So what do these images teach us?

The image on the left portrays the need to store, wind up, and torque into the right leg during your backswing. More specifically, you must never allow it to breach the outside of the right foot, which in this instance would be disastrous. The same can be said for the head and spine since, if allowed to shift to the back of the ball during the

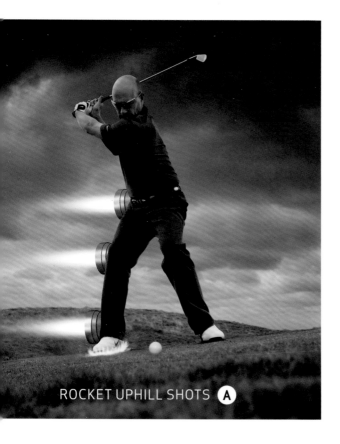

ROCKET UPHILL SHOTS **A**

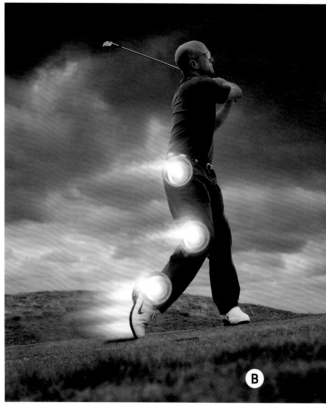

B

backswing, the chances of returning to the address position and beyond are greatly jeopardized. Your main goal, just as the image suggests, is to prepare the right leg for its role on the downswing—which is to shift and drive a sequence of events that sees your body weight travel up the slope, into the image you see on the right.

Specifically, your awareness during your backswing should be on creating a pressure into the ball of the right foot, thus trapping and harnessing this right-sided force. As you start down, your whole intention is to rotate hard (turn the trunk and chest through the ball) by pushing off from the right foot and committing the right knee to working into the left leg. In doing this you will have no choice but to work your center of gravity back up the slope and not hang back.

Just to end, here are a few basics I want you to bear in mind:

1. Move the ball up a little in your stance to encourage the base of the plane to work with the slope and your good intentions.

2. Tilt your body to blend with your natural surroundings. An easy way to do this is just to position your spine or sternum at 90 degrees to your surface.

3. In the event of your body not effectively turning through into a full finish, it's likely the ball will hook, owing to the influences of the slope on the clubface and swing path; because of this I would encourage you to at least see some draw and hook spin to your ball flight.

This shot is all about your preparation during the backswing, in which you need an aggressive commitment to your right side and follow-through to the very end.

The Two-Bounce Rule

As you might have guessed by now, I believe that the visual aspect of golf is the undisputed start of the shot-making process. From great sportsmen to the business leaders of our time, Victorian industrialists, and Surrealist artists—all had the ability to conjure up their own realities and desired outcomes before the events had happened. In a way, the movies that these people played in their minds were so indelible that they literally bought into the result in a form of self-hypnosis. Throughout the years, I have noticed a strange phenomenon occurring between the weight of the ball and gravity. It seems that on most pitches and chips, the ball takes two primary bounces before it settles into either a runout pattern or a checkup. Either way, the two primary bounces are present. This doesn't just happen with pitches and chips—the tendency is present on full shots, too!

It goes without saying that visualizing these two bounces from a drive can be a little pointless, since the landing area is so far away. This insight really comes into its own around the green, as you visualize the initial landing area and the resulting run-out toward the pin. As you can see from the image, a neat way to picture these primary bounces is in the way the ball would react if it were pitched onto a pond. The first bounce would be the most potent and would create the largest ripple. The second ripple would be less far-reaching as the ball's momentum slightly lessened. The third ripple or bounce would be almost unnoticeable to the eye as it settled and ran out toward the hole. Gravity has to take its toll as the ball gradually loses

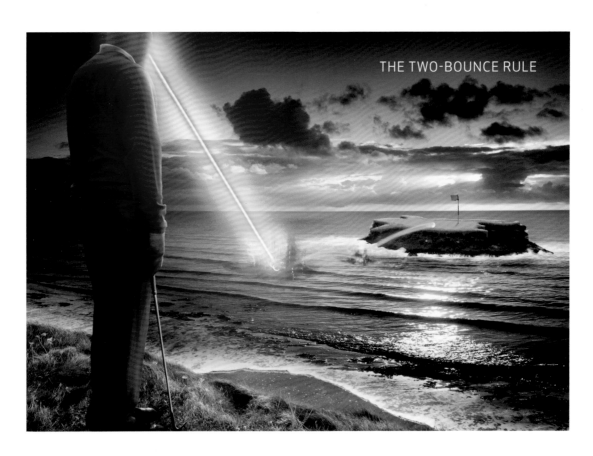

THE TWO-BOUNCE RULE

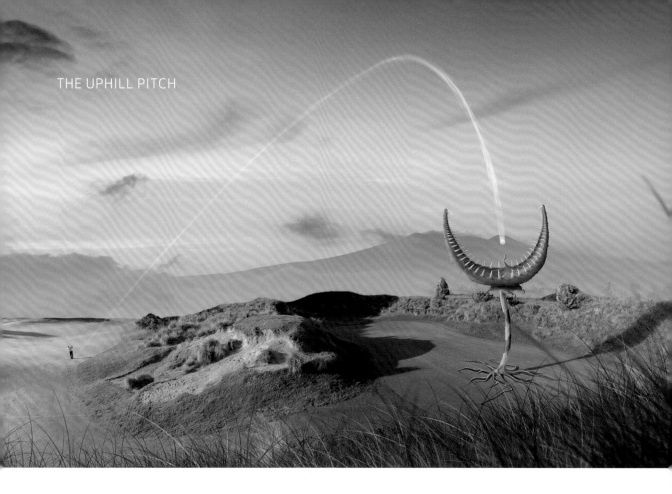

its energy, which is why on most shots gravity only needs two bounces from the ball to drag it back down to earth.

There will be occasions where you will want the ball to sit down a little quicker than usual or, conversely, run end-over-end up the length of a green. In both instances you can still expect two primary bounces, only with different actions at the end of the shot. Obviously, the surface of the green may be firm one day and soft the next, yet this ball/gravity pattern is still in effect—only to a greater or lesser degree.

I suggest you practice with a sand iron initially so that you have plenty of time to appreciate and observe the two-bounce rule. Throw a shot in high, or chip and run one low. The universal law of gravity can really help your chipping pictures!

The Uphill Pitch

I doubt I could have found a better location to shoot the uphill pitch than the 13th at Tobacco Road in North Carolina. Offering a selection of ways to get the job done, this par five demands a seriously good long approach (230 yards hoisted into the heavens) or the uphill semi-blind pitch you see here.

I think it was Christy O'Connor, Sr., who gave me the idea for this image. While at one of his innumerable clinics at Mount Juliet, Kilkenny, Ireland, in the mid 1990s, I always made time to watch Himself hit shots and relay great stories about his playing past. I distinctly remember Christy saying that the best way to play any shot uphill was to land the ball right on top of the flagstick.

Any shot uphill takes the gusto out of the ball from the distance-carried perspective,

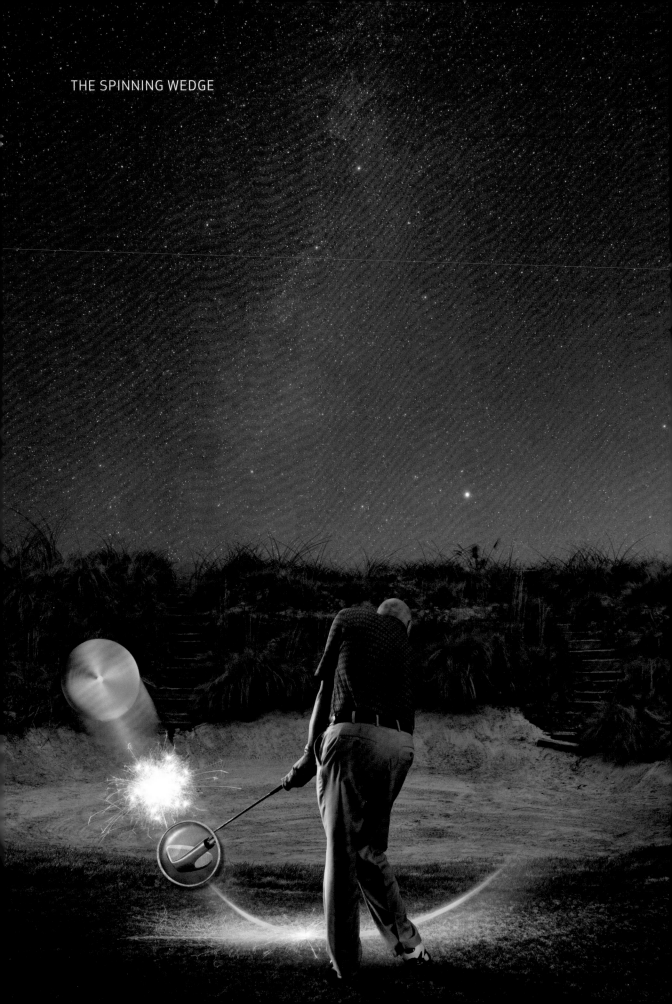

THE SPINNING WEDGE

since the land arrives quicker within the ball's flight. So the image I have created here is a perfect start for picturing any such shot. It's like a slam dunk: You are literally throwing the ball plumb into the middle of the hoop—or, in this case, into a Venus flytrap!

Another visual key to dial into here can be found in an earlier image. The trajectory targeting image with the fire hoops (p. 71) will really assist in your club selection, giving you an apex for the ball's journey. That image is designed to make sure that you play these shots aggressively and do not leave the ball short.

The Spinning Wedge

SPIN THE COVER, NOT THE CORE

Amateurs are obsessed with backspin. It reminds me of the Lee Trevino story about a lady asking the Merry Mex, "How do I get backspin with my 7-iron?" Lee Trevino, ever the public comedian, replied, "How far do you hit your 7-iron?" The woman replied, "Ninety yards," to which Lee countered, "Why do you want backspin, then?"

Backspin is basically a product of a well-struck shot, but what *is* a well-struck shot? For many years, producing backspin on a shot—especially a wedge shot—was associated with a wide-open stance, ball back, and banging down into the back of the ball, creating a pizza-style divot flying through the air. This was fine so long as you got the ball first and didn't break your wrists in the process. With that steep angle of attack, you would in all truth generate the same amount of spin, but the probability of a good strike lessens!

In my book, there is a much neater and more repeatable way to have the ball jacking back when you need it to. By banging into the core of the ball—imagine hitting an egg with a hammer but only focusing on striking the yolk—the clubhead itself essentially does not act as it's designed to, because the leading edge digs too much into the turf. The spin when a wedge shot is played like this is created from the sharp angle of attack of the clubhead. Wedges actually work best when the bounce on the sole of the club (the face slightly open) is used.

If you had a beach ball like the one in the image and you wanted to spin the colors as fast as possible, you wouldn't bang into its center as if you were throwing a jab into the middle of a punching bag. To have the colors rotate very quickly and blur, you would skim the underside of the ball with traction (the grooves and abrasion of the clubface itself) and speed. This technique also utilizes how the design of the wedge actually works, as you use the bounce to bruise the turf as opposed to digging at it.

An alternative image of the ball's cover spinning is the Catherine wheel firework, in which a circle of sparks keeps rotating.

Technically, you can see from the image that there is very little in the way of wrist set in the backswing. Remember, the pitch shot is one of the smallest and slowest swings you will make in golf. If you put too much hinge into the wrists during the backswing and combine this with having the ball excessively back in the stance, you will have neither the time nor the speed to return the shaft back to its starting 90-degree angle at address. The other technical advantage the minimal hinge provides is found in the shallow angle of attack to the ball. This not only rotates the ball's dimples like the blurring colors on the beach ball, but also uses most of the fifteen or so grooves on the face of the club during the shot.

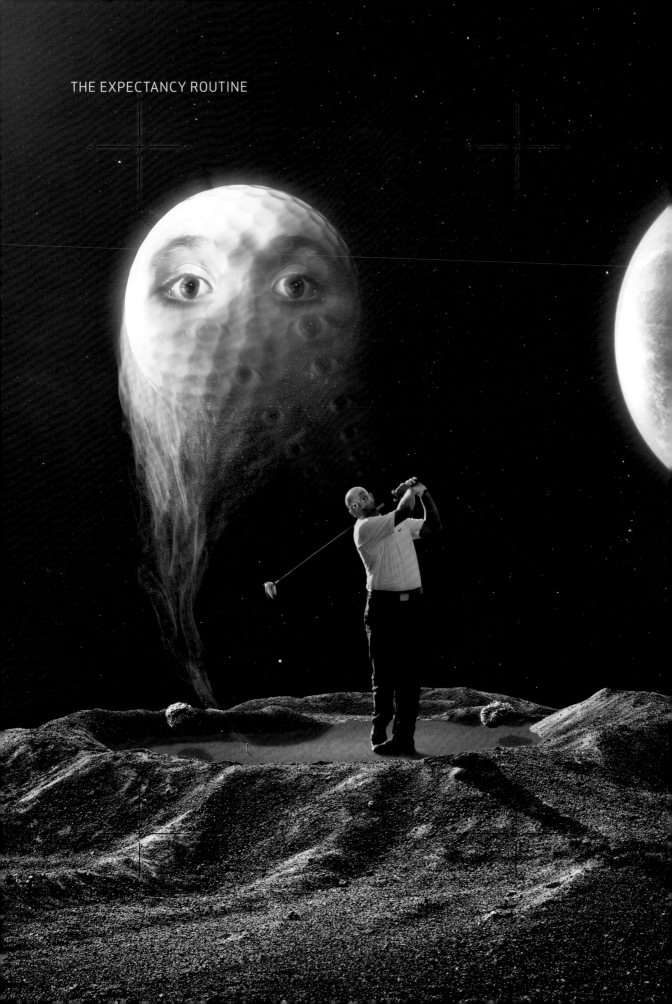

So take the time to visualize what you want the face of the club to be doing to produce this spinning wedge shot. Hinge less on the backswing, accelerate the club through the shot, and really zip that cover.

Spin the cover, not the core, baby!

The Expectancy Routine

HOW TO FRONT-LOAD YOUR MIND

I'm a great believer in using hindsight in golf. I call it "front-loading." Briefly, as you arrive at your ball, your mind should be like an unfilled bottle: empty, present, and waiting to take in information on the shot ahead. Filling the bottle up to the brim with the correct information, including visualization, feelings, and triggers, will definitely allow you to execute with full commitment.

I'm also a great believer in the metaphysical law of attraction: that man does, becomes, and gets what he thinks about all day. This is not limited to golf; it holds true in all sports. So the question is: How do we program this into our golf game? How do we give ourselves the very best possible chance of success in front-loading the mind? The expectancy routine holds the key:

The combination for hitting a great shot in golf has not changed in the past 300 years! First is a clear intent in the form of a picture. Jack Nicklaus calls this "going to the movies"; he first sees the ball's reaction upon hitting the green, then sees the ball flying in the air back at him, and finally sees himself swinging in the fashion that will produce the movie

he has just witnessed. Second is tapping or dialing in to the shot you have just pictured. Some players are kinesthetically advanced enough that a picture is sufficient for them to get the feel down the first time around during the actual swing. Others (in fact, most of us) would do well to have one practice swing or "swish" at the ball to give us a sense of what is needed. Third, and this is the by-product of the last two, is execution without interference. The expectancy routine uses the eyes, the two gods of great golf, in a way that galvanizes the routine above.

I want you getting familiar with this routine with nothing more than a 7-iron. Once you have seen your shot clearly in your mind's eye, stand parallel with the ball and swing, feeling the shot you have just seen. Really gain an acute sensation through your body of what it would feel like to hit that shot, even down to the ball clinking off the clubface to start its journey. It's like a kinesthetic snapshot of the event to come.

Now for the key! As you hit the follow-through position, allow your eyes to track the ball flight right up to its apex. But I want you to *really see it!* Lock your eyes into that apex position and wait just a second.

Address the ball in your normal fashion, settle, and then hit it. As you hit the ball, let your eyes lock on to the apex position again and expect to hit and see the ball on that pre-programmed flight. You will be amazed at what your swing and your subconscious can do when you give them an order. Don't just do this for tee shots; work it into every part of your game.

Now, look at the image again. Let your eyes be the ball's eyes!

AROUND THE GREEN

Bunker Shot Ballistics I

Before we start this section on bunker play, I'd like to tell you that my ideas on bunker play are a little different from the textbook information you already have. Keep your mind open to what I have to say in this segment, and I am sure you will start to see, feel, and experience the truth of what I tell you.

In times gone by, sand wedges were not built to the high specs and understanding that they are today. Bunker construction was also patchy, with the sand found in them often inconsistent and poorly maintained. These two factors led to a method of playing bunker shots that amounted to (at best) a controlled chop! We were constantly told to open up the stance, play the ball a little back, pick the club up with an aggressive wrist cock, and then wipe across, cutting under the ball through impact. This technique was a total by-product of crummy equipment and crummy sand.

Now things are different. The construction of modern bunkers cleverly replicates that of the natural bunkers found on the seaside golf courses of Great Britain and Ireland. Today's construction allows them to drain better, the base area is built deeply and more authentically, and maintenance by greens staff is on a daily basis. The sand can therefore be guesstimated more accurately when playing a shot in today's world of golf.

As the bunkers became uniformly consistent, the sand wedge underwent further evolutionary development. Darwin would have been proud. No more orange builder's sand, no more clumps of clay, no more unraked bunkers. Now we could develop an implement that

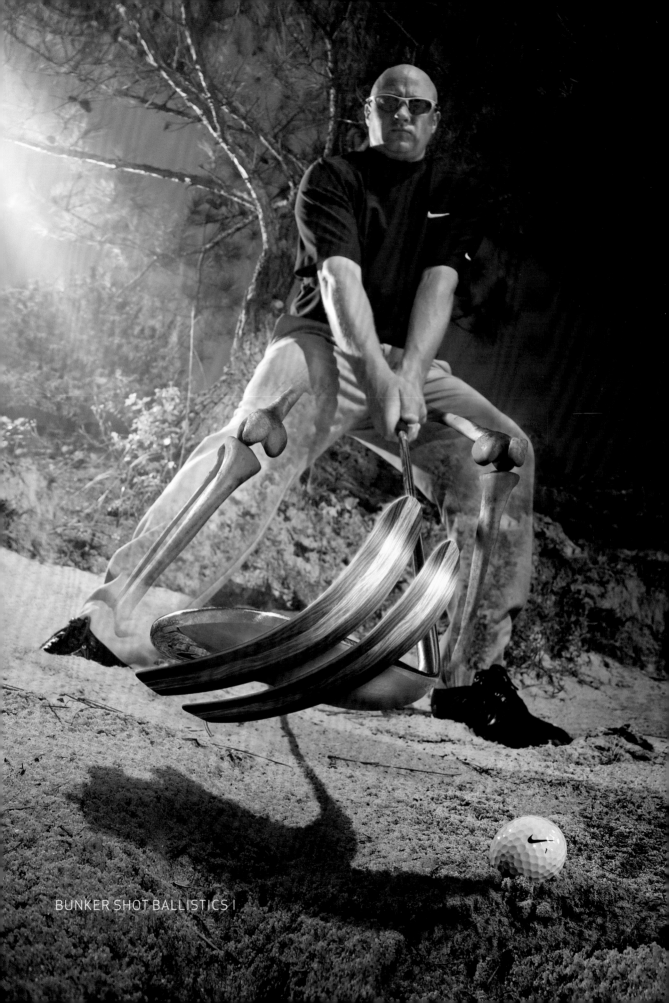

BUNKER SHOT BALLISTICS I

glided through sand like a hot knife through butter. All of a sudden it became much easier to escape from even the worst greenside bunkers. This was evident at the 2007 Memorial Tournament held at Muirfield Village in Ohio. Jack Nicklaus introduced a wider-pronged rake, which was used during the tournament to create more of a sand hazard for the players. The thinking, and rightly so, was to create a little more of a lottery feeling when your ball landed in a hazard, because bunkers are hazards, after all. The wider prongs produced a groove in the sand that your ball *might* roll into—or not.

So the bunkers changed, the equipment changed, yet one thing did not—bunker technique. Allow me to bring you up to speed.

First in view is the clubhead. It is evident here that the clubface is open. When the clubhead is presented like this, the bounce on the club will encourage just that—a bouncing, bruising contact with the turf or, in this case, the sand. So if you tend to dig or thin your shots in the sand, the first item on the agenda is to open the clubface a little and allow the bounce to work. When playing my best bunker shots, I envisage exactly what you see here, which is two skis on the sole of the club ready to skim, cut, and glide through the sand the ball is sitting on. It gives me permission to assertively thump the sand behind the ball with no fear of chunking the shot. As a guideline, I make sure the leading edge of the club is pointing just outside my left foot.

You can see that most of my weight is on my left side, which agrees with the most conventional thinking. However, the ball is positioned in the same spot for most regular shots: opposite the left armpit and at the bottom of the swing's natural arc. What you can't see here is where my feet are aimed—but I will go into that a little more in the next section.

The message in this image is: Learn to use the sand iron as it wants to be used. Open it up a little and allow the bounce of the club to work. Experiment with this; go into your practice bunker and take some practice swings with the face of the club square. Take note of the amount of sand (a huge amount, or none at all) you take and also the sound your strike makes. Then make some swings with the bounce open and you will feel and hear a totally different sound. Place 70 percent of your weight on your left side, anchoring your weight and strike point throughout the entire motion.

Bunker Shot Ballistics II

I want you to give up the notion that the clubhead in any bunker shot should be picked up on the outside and then sliced across the ball. I can think of one possible situation where that would be the right shot to play—yet even then there is a simpler, less risky way to execute a high, soft shot.

The first point you can draw from this image is the square to slightly shut stance. In conventional bunker wisdom, the stance must be aligned to the left of the target (open). Essentially, this was designed to deal with the fact that you would try to slide the club across the ball during impact. The contradiction to this can be found in the way that conventional bunker wisdom *again* wants you to place your weight predominantly on the left side. With your left foot pulled behind your right, it is almost impossible to do this, since you actually have no left side to lean on. If you do actually manage to put your weight onto your left foot while in an open position, your body positioning will adjust to the point where you lose any consistency in strike.

Try this in your living room, bedroom, or study: Take a stance with your left foot set in a slightly closed position (six inches ahead of your right foot) and place 70 percent of your weight onto it. It's actually very easy to do, and the feeling you get is a bracing sensation, as if your left thigh is set in stone. After you have done this, take an open stance with the left foot now drawn back behind the right. It will be apparent that the first way gives you the better sense of stability and support. You see, we don't need the weight transfer in the short game to deliver power; we need it to deliver consistency.

The stance is the subtle aspect of the image you see. The meat and potatoes can be found in the plane I'd like you to work on. Remember that in the last section I wrote about the advances in the design of the club's sole. The club now works in a non-digging fashion when the face of the club is slightly open; it bounces, splats, or thumps the sand under the ball. This advance in club design gives us permission to do away with the out-to-in swing path, paving the way for a much simpler, one-planed action.

As in the putting stroke, bunker play is at its best when the clubhead paints a very gentle crescent or an arc around the body. You can see and, indeed, practice this with the message the picture is giving you. By stretching your left arm out toward the ball, you simulate the one-planed shape of the short swing you need for this shot. I personally like to see the right arm and the shaft attempt to match one another at the address; repeating this sense that the right arm and the shaft are on the same plane greatly assists your over-the-ball visual of what you have to do during the shot. Unlike the full swing, where we actually want the left arm plane to rise slightly above the shoulders, the mini swing found in the short game works more closely to the plane of the

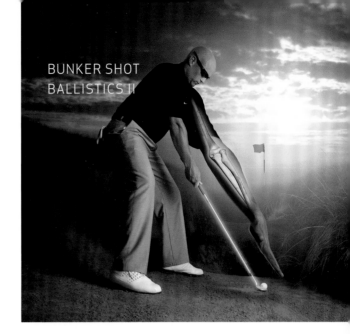

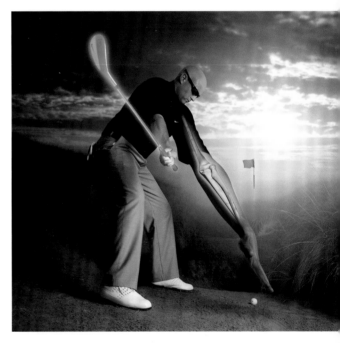

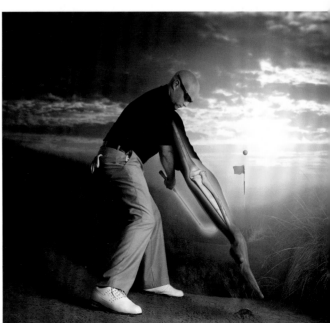

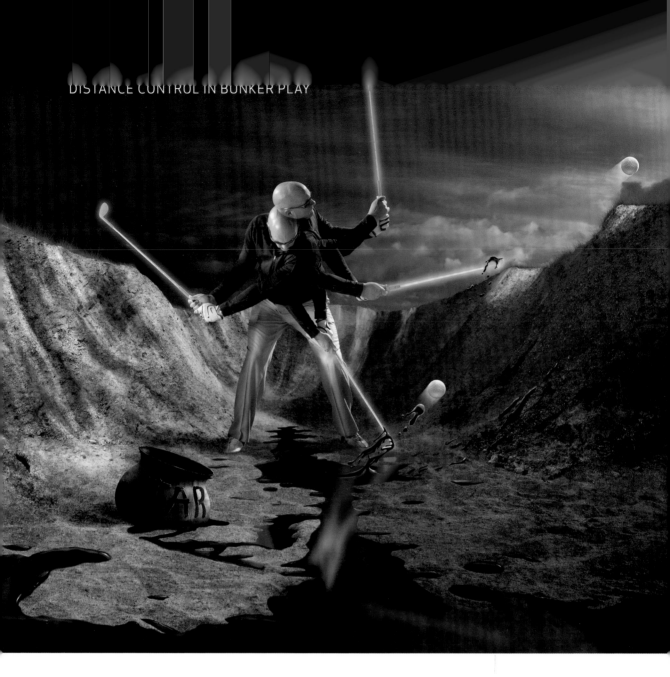

shoulders. When you imitate this image of me moving the club back and through on the same plane as the extended left arm, you will get a real sense of the shape the clubhead—and, indeed, the shaft—need, to follow.

Most bunker shots are best played with a shallow angle of attack. Notice how my center of gravity looks really low to the ground; you can see how squatty I look. This low center of gravity harnesses the club to move low and shallow throughout your motion and, combined with the right arm and shaft up, is a

consistent recipe for success. There are obviously bunker shots that need a slightly different angle of attack.

Because this setup is somewhat different from what you are used to, ease into the changes slowly. First, gradually begin to shuffle the stance into a squarer look. Next, shift the shaft upward and blend it with the right arm. Finally, work on that gentle arc around the body. With some practice you will hear a different sound to your shots and see more control as the ball lands on the green.

Distance Control in Bunker Play

The development of feel in the short game comes partly from your technique and partly from the way you use your bodily senses. Golfers with poor feel inevitably have too much going on in the way of motion. It would be like a telephone operator trying to decipher ten conversations at the same time—impossible to do effectively. However, listening to

one (or two at a maximum) would be workable. This is one of the ways feel is either heightened or diminished in the short game. This is true even with the professionals; feel can dissipate quickly if too many lines of communication are open.

The first aspect of bunker play feel is creating a constant. The constant in this case is the length of the backswing. For bunker shots of up to 30 yards, you should start to envisage and practice a nine o'clock backswing with your left arm, and remember—do not put too much hinge into your wrists. This is your constant. This is your first element to work everything else from and around. In the picture, I use a backswing that only goes to a nine o'clock position. By simply working on a constant backswing, your feel will have somewhere to go; it will start to act as your sensory true north. Even when you initially work on this aspect of your bunker technique, you will notice a smarter pattern to your strikes and a tighter ball grouping.

I want you to start off with three basic finish positions: short, medium, and long. From the nine o'clock backswing, the short follow-through *interrupts* the club's momentum. The medium length through swing sees to it that you *maintain* momentum, and the longer finish *increases* the club's momentum. If you follow this sequence on bunker play, you will immediately gain a different dimension to your distance control. All of a sudden you have a gauge, a method that makes perfect sense and, moreover, works!

When you have these three simple determiners of length down pat, you can experiment with different clubface positions. The two ends of the scale would be a short follow-through with a 60-degree club and the full follow-through with a 52-degree club; between these two parameters you have enough shots in the bag to handle most greenside bunker situations.

The pot of tar acts as the metaphor for momentum. The short position stops too short to shake off a clump of the sticky stuff. The long finish position, however, has the speed and momentum to fling off the majority of it. Armed with this newfound finesse, play some money games around the greenside trap with your buddies. It won't be pots of tar anymore, it will be pots of gold!

The Plugged Bunker

HOMAGE TO BRUCE LEE'S ONE-INCH PUNCH

Bruce Lee didn't know it, but he created a great way to play plugged bunker shots! The accepted theory—or, I should say, attitude—when faced with a plugged bunker shot is to shut the face down, jab behind into the sand, and plan for an almighty run out from the ball. You get the feeling that it is a hope-for-the-best situation. But what if you do need some degree of control on the ball? Is there a way you can perform a miracle shot with little risk? The answer is yes.

Bruce Lee's famous one-inch punch worked on the principle of delivering a short blast of energy in a small time frame and a confined space. It's a little like music. You can get long, drawn-out deep notes (energy sounded out over a long period of time) or short, sharp high notes (energy sounded in a very short blast). To perform this shot well, you have to get this concept into your mind: It's in and out—very quickly—as if you were sticking your hand (the clubface) into hot coals and out again.

The first step here is to take a really good look at the lie of the ball and visualize how you see it reacting on the green. Like all short-game technique, theory can only get you so far; you need to practice and thus positively experience it in action.

Now I want you to play the ball a hair farther back than you would a normal bunker shot. Instead of the accepted closed-face approach to bunker play, lay the club way open as it sits behind the ball, since the first part of getting this shot right is being able to really *smack that bounce* (the undersole of the club) into the sand behind the ball. Imagine a set of scales: The clubhead will plummet almost vertically onto the left scale pan, and in doing so will almost vertically pop up the right scale pan with the ball on it. This is exactly how this shot works: energy down—energy up.

Here's the real trick, though. Just as soon as the club has entered the sand, you must retract it. As I mentioned previously, it's like sticking your hand into hot coals and then out again—it has to be quick! When you do this, you apply that short, sharp burst of energy required to *pop* the ball out from its little hiding place. I'm not sure about a one-inch punch, but this technique delivers force in roughly the same way. The result is a higher ball flight from the bunker with very little spin; the only roll it will achieve on hitting the green will have come from the forward momentum gained through the stroke itself.

Like the majority of bunker shots, a little practice and experimentation on your part will go a long way toward performing this shot well. Experimentation allows you to learn the causes and effects of the various lies you can get in golf and their associated reactions, a skill well worth learning! When you get competent and have repeated this a few times, you will use it to great effect.

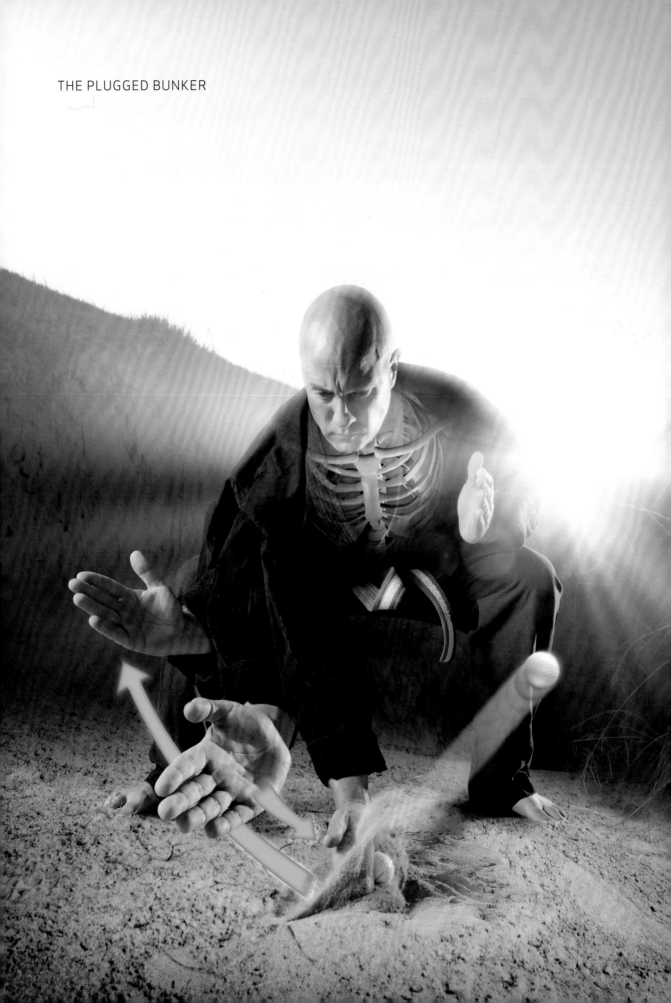

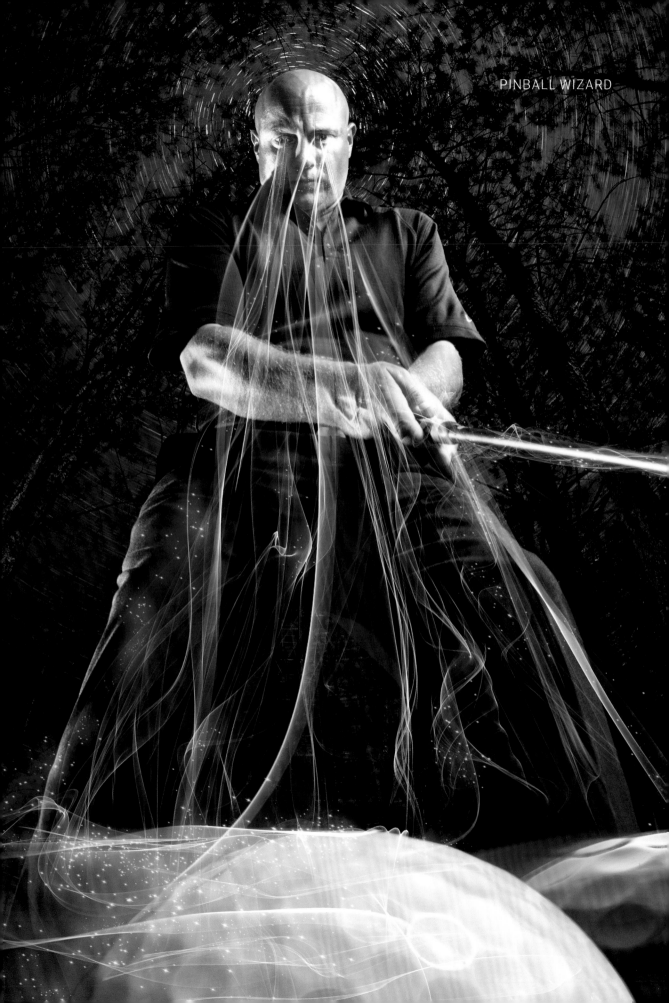

Pinball Wizard

"THAT DEAF, DUMB, AND BLIND KID SURE PLAYS A MEAN PINBALL": SENSORY PUTTING

I don't know how Pete Townshend of The Who came up with the lyrics for the 1969 hit, but he described the perfect "feel" putter. The song tells the story of the unfortunate Tommy Walker, whose abilities to see, hear, and speak have been stripped from him. Yet despite this, he compensates by developing an ability to *feel* beyond the normal scope of things. It's a known fact that most blind people have better hearing than fully sighted people.

Great putters optimize their sensory assets all of the time; the key for them, though, is to use those senses at the *right times*. While the eyes are the dominant sense for most of us most of the time, we can actually develop feel faster when they are left out of the equation. When I coach the short game, I first focus on technique, for without it, nothing feel-wise is going to be either authentic or repeatable. This is an absolute fact. So when your feel is deserting you, take a good look at your technique first.

The second aspect I believe in is that every shot played in the short game is a chance to develop layers on your feel; this is commonly known as finding your touch. Assuming that your technique is good, you now have the ability to store accurate feelings in your sensory memory. Start by hitting some putts—or indeed chips, if you wish—but as you do so, keep your eyes closed well after the strike has occurred. You will immediately gain more sensation through the act of doing this, simply because as one sense has shut down,

the others have become heightened. The thing to understand is that each time you do this (most effectively to alternating targets) you develop the relationship between *your senses*, the *weight of the club*, the *weight of the ball*, and *where the ball goes* as a result of those three elements. Your feelings and sensations now have the ability to marry together, which ultimately leads to touch and feel.

If you observe Eric Clapton ripping through a solo piece on his Strat, or Nigel Kennedy hitting the high notes on his Stradivarius, or even something simpler like someone rapidly typing on a keyboard to form sentences, you'll notice in each case that their eyes are not observing their handiwork. Their eyes are elsewhere. Clapton and Kennedy will normally have their eyes closed, not on the guitar or violin; the typist's eyes will be firmly fixed on the screen, not the keyboard. They are tuning in to their feel.

One last point: When you practice the art of not looking, your trust will initially be tested. You will want to peek at the results of your efforts, since you only trust what you can see, right? Well, the ball has gone by that stage anyway, so does peeking early benefit you in any way? The answer is no, so keep your head and your eyes quiet, and let your body and your memory feel the rest.

The Short Putt

DON'T BE THE GRIM REAPER; BE THE HAPPY ONE!

Missing short putts has a lot to do with where your mind is at that particular moment. Most short putts are not given enough attention and respect because in his mind the golfer feels

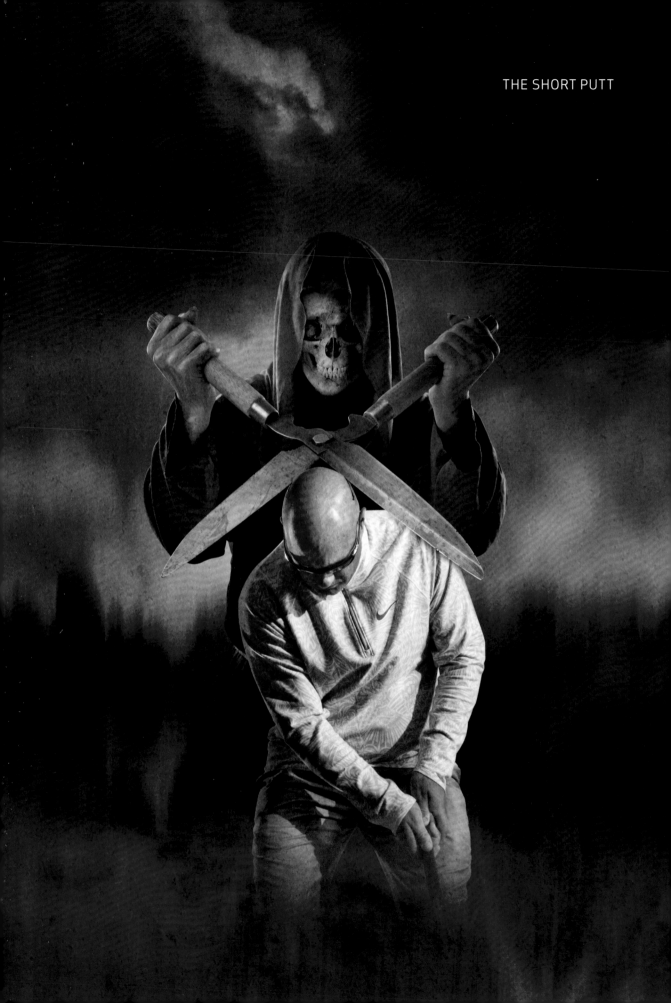

that his work has all been done in getting himself to this "gimme" range. I have some news for you: THERE ARE NO SUCH THINGS AS GIMMES! I personally detest the notion of giving putts, especially short ones, since they are the most mentally demanding. I believe that's why the gimme was invented: to avoid the sweat and pain these short putts can cause! So the next time someone says to you, "Pick it up," refuse nicely and finish it up. There's something good about knowing you have *really* finished a hole.

Whenever the mind wanders while you stand over one of these short putts, it will jump forward either to the result or to the next hole. This is an abandonment of process, and process is what golf is all about!

This is actually a very simple image with a very simple message: Keep your head in the right place before, during, and after the putt has gone. The consequences could mean you lose it in more ways than one!

Toe-to-Toe Putting

I've always liked the idea of using your own natural rhythm to create the mood of your full swing and putting stroke. I can't think of many players who had a racy temperament, a slow golf swing, and a slower putting stroke. It just doesn't happen, since your natural body rhythm will override any sense of consciously slowing yourself down. Your body rhythm is your body's speedometer. Golfers around the world are constantly trying to slow down or speed up their golf swings and putting strokes, yet it seems that with the passing of time they always return to rhythms that are notably *theirs*. Once you accept that you develop technique around your own natural rhythm, you will authentically start to improve all aspects of your golf. With better mechanics, the timing of your golf swing will improve. Fact!

I have rarely seen an amateur golfer display poor touch and control through a

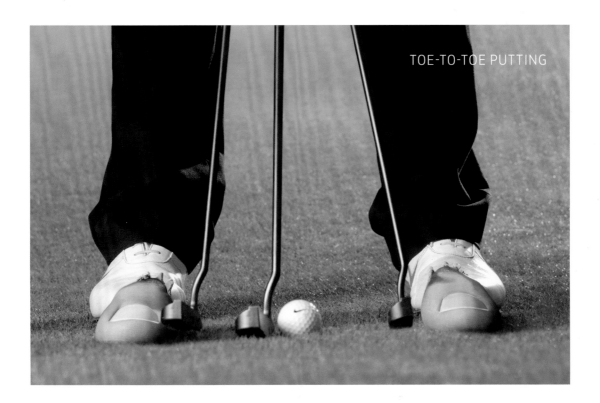

TOE-TO-TOE PUTTING

backswing that is too short; typically, the putterhead travels too far for the shot required. In most cases the golfer will decelerate through the ball, compensating for the overly long backswing, and when no compensation occurs, the ball careers past the hole. If you look at most finite motion—picking the strings of a guitar, typing on a keyboard, or even keyhole surgery—you don't see a long, heavy, and clumsy motion; you see an economical strike in which the feel is housed.

When feel and touch are starting to desert you on the course, look to the length of your stroke first. Use the width of your stance—in this case your toes—to act as a governor of motion through which discipline and order can be restored to your stroke. At the end of the day, feel is derived from discipline, and it is this discipline that allows the brain to sense motion, weight, and speed.

So the knack to using this image effectively is incredibly simple. If you face a short putt, take a narrow stance and let the toe-to-toe method calibrate this smaller stroke for you. With a medium-length putt, widen the stance to demonstrate that the putter needs more momentum to travel the greater distance, and widen farther still for the longest putts you

face. This straightforward approach has immediately disciplined many speed-challenged golfing students of mine . . . especially juniors!

The Hole of Time

Every putt has an entrance through which the ball can find the hole. Ultimately, there's no putt on any golf course that cannot be holed. How do we find this invisible trapdoor that opens when the right combination of speed and line is keyed in? The answer lies in the green reading.

Have you ever noticed how the last part of a long journey to an unfamiliar place is the most stressful (at least until satellite navigation)? That's because at that point, we're really venturing into the unknown. Every putt you face is a new journey (*without* satellite navigation!). Conversely, the journey back home is simple, because you know exactly where your final destination is. So doesn't it make sense when reading the green (or the map) to look at things first from the destination (the hole) to home (the ball), rather than guessing the route from the ball?

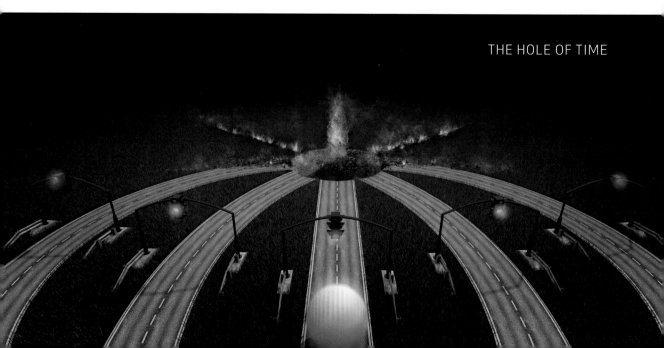

I mostly advocate taking the first read of any putt from behind the hole, looking back toward the ball. To me, it's imperative that you know what goes on around the hole before you even consider looking from the ball side. The route the ball takes to the hole is nothing more than a journey; it has a speed element and it has a directional element. Take the time to study the last twelve inches of your putt and the speed at which you see the ball falling in.

Once you have seen the door, start walking back to the ball, but with your eyes fixed on the point at which you see the ball entering. Your imagination can now legitimately go to work on finding the route to the hole, taking into consideration the breaks and the slopes. Such is the brilliance of the brain—you can run and rerun the movie in your mind until you get the speed and route of the ball to the door perfect.

Take a good look at the image, which nicely represents the speeds of the balls and the probable entrance points relative to those speeds. I have often used this with Tour players, telling them to view putts from the perspective of a traffic light system. Green means straight and firm, while red means one must die the ball in from the edge of the cup.

Remember, all shots in golf are merely educated guesswork and not science, but the more clues you can throw your imagination's way, the harder it will go to work for you.

The Flop Shot

HANDS BEHIND—HANDLE BEHIND

At the Bel-Air Country Club in Los Angeles, long-standing legendary professional Eddie Merrins, also known as the Little Pro, has a great philosophy in teaching golf. Eddie's credo is to learn to "swing the handle" (the grip) in order to establish what you really want the club to be doing during the backswing, impact, and follow-through. For the greenside flop shot, working the handle works wonders!

We all know that when we push the hands ahead of the ball at address, we de-loft the club, thus making the flight of the ball lower. The ball can also jump off the face more quickly. Yet not many golfers have ever tried the opposite trick, of laying the handle behind the ball, resulting in a shallower, more lofted attack into the ball.

For many years I have been amazed at the constant instruction telling golfers to put the ball a little farther back in the stance, followed by the request to hinge or cock the club up abruptly in the backswing. If you truly understand the ballistics of a strike that produces a soft-flighted, soft-landing shot, you know immediately that this age-old advice cannot promote the ball flight described above. When taking your setup with any chip or pitch, do not jam the ball back in your stance, since the contact will become too sharp and violent.

A really good way to view the clubface in many of the shots we play in the short game is merely as an extension of the right palm. You'll notice that as you lay the handle of the club slightly back behind the ball (to be felt in the right palm), the clubface automatically lies back, too, thus putting more loft at your disposal. The second benefit gained from laying the handle back a little is in the creation of a shallower arc through the impact area. The flop shot needs this bunkerlike angle of attack to ensure that the bounce of the club glides through any grass it may encounter. The only other aspect of the setup I need to mention is in relation to the sternum: As in the majority

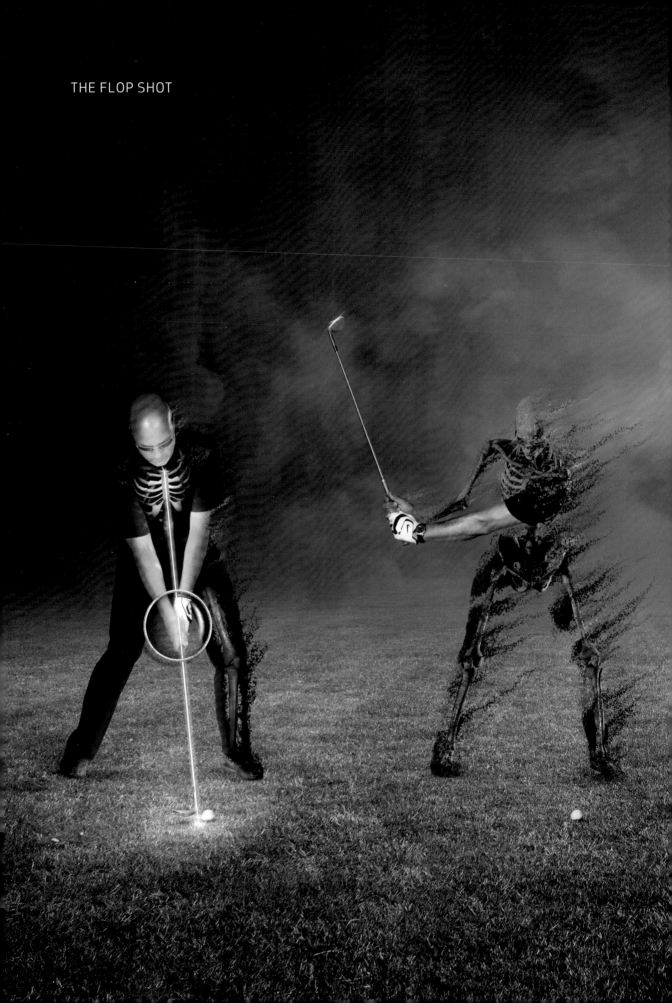

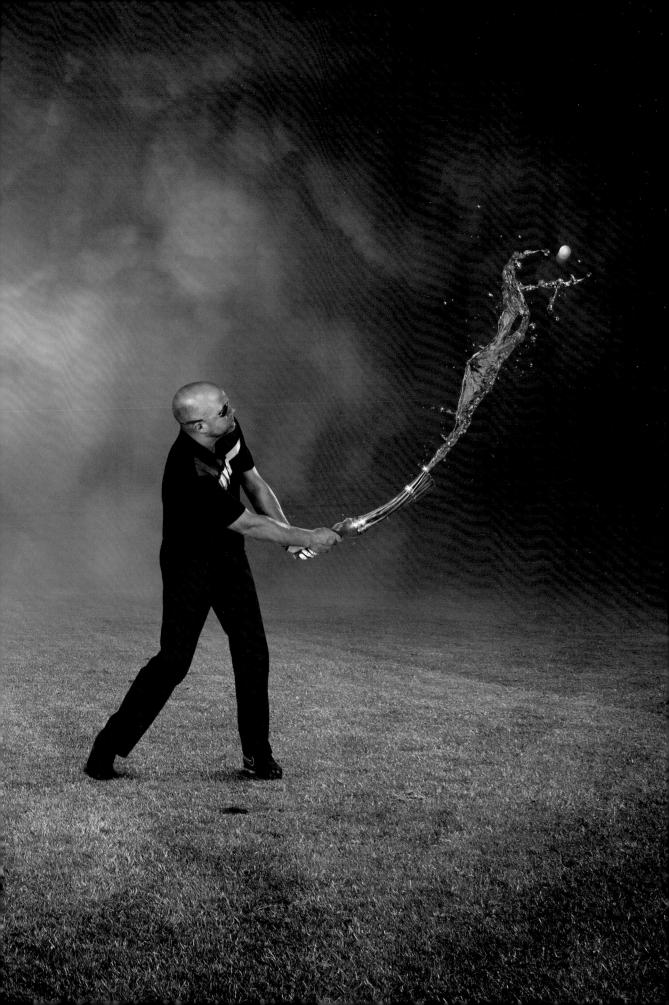

of short-game shots, it should hang directly over the ball.

Your objective, to pull this shot off with success, is to work the right hand aggressively under the ball. As you become more competent at the short game, you will come to realize that the soft shots are actually played aggressively. This comes from the fact that everything in a soft shot is weakened at the address position. When playing a delicate shot with a deft touch, this weakening allows you to make a committed pass at the ball. Look at Phil Mickelson the next time he plays a touch shot; he will play these shots aggressively.

While this may appear to be a high-risk shot, sufficient practice at it will work wonders and give an extra dimension to your short game. Get the *sternum* ahead and the *handle* behind for the flop shot, and who knows? You may get a reputation as a Little Pro at your club.

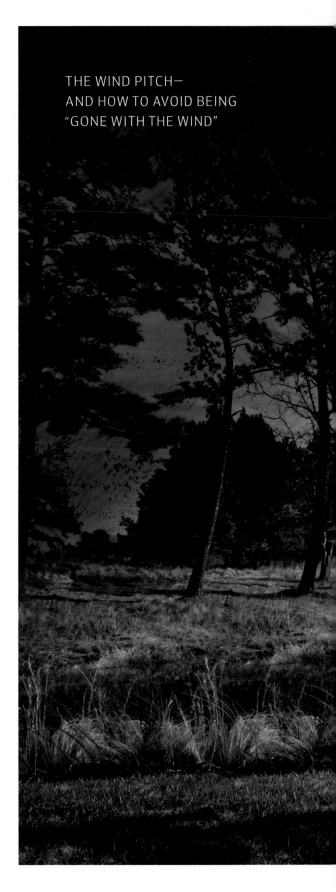

The Wind Pitch—and How to Avoid Being "Gone with the Wind"

I don't know about Clark Gable, but I see many players, amateur and professional alike, allowing their pitch shots to be "gone with the wind" when in for a chance of a solid up-and-down. I can sense that golfers almost fall asleep on these benign shots, forgetting the first part of an age-old process: seeing the shot happen before it does. When you have wind from any direction, the effect on a pitch shot can be dramatic. In the example and image here, I am obviously facing a crosswind.

The ballistic component we have to factor in here is that the velocity of the ball is

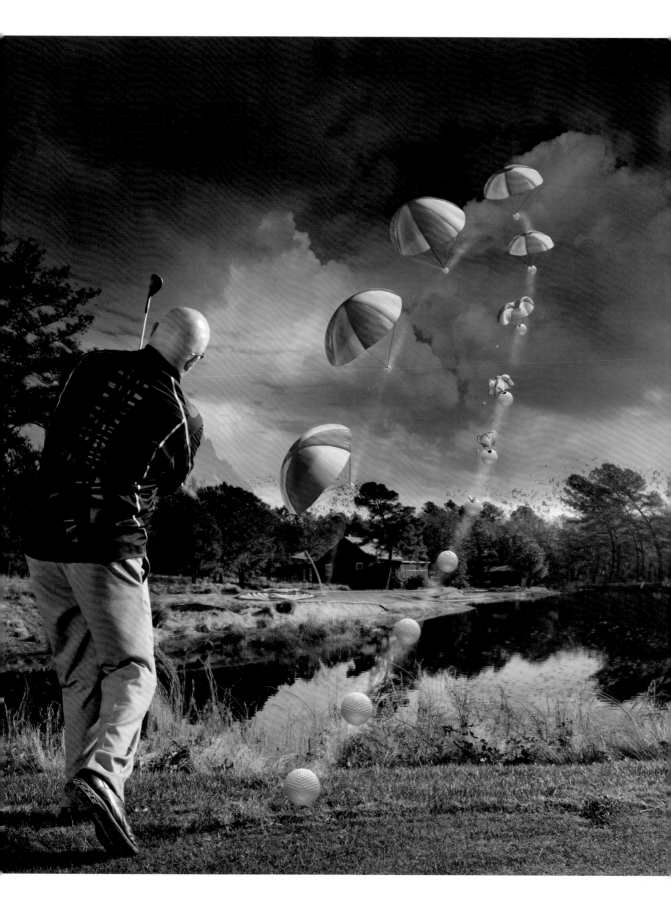

nowhere near as fast as it would be with a driver or even a mid-iron. This is why the wind, unless it is severely strong, will not cause the ball to deviate too much with a longer shot until the last part of its journey; hence, the ball cuts through the wind. The pitch has slow ball speed, especially as it reaches the apex of its flight, because this is when the backspin rate really slows down. Any outside factors—in this case, wind—now really override its flight. We can see that the apex of the flight is critical, so let this be the first port of call in picturing your shot.

I have always liked the notion of working out how many yards of drift the wind may create *plus* the amount of ball push the drift will contribute when the ball finds the green. This is the picture that you are after! So really take the time to stand behind the ball, sensing the strength of the wind, remembering that the flight will significantly change *after* the ball has reached its highest point.

Since most amateurs underestimate the wind, this image of the parachute should work well. When I was a kid, I had one of those toy army guys that you could wrap a plastic parachute around and throw high into the air. If you threw him up on a windy day, the wind would catch his parachute and carry him in its direction. This is the same effect you will face here.

Building Layers of Feel with the Ego

Hindsight in golf is a wonderful thing. The "what ifs" and "if I'd justs" ring out from every golf club in the world every day. The question is, can you develop a way to create hindsight, or get as close to it as possible, to preempt any

"Duh!" moments during your round? Well, the answer is yes, you can get pretty close to the perfect shot by way of the perfect rehearsal.

I first saw layers of feel in action when I saw Seve Ballesteros win the 1988 Open Championship at Royal Lytham & St. Annes. After a good old dingdong battle with the two Nicks—Faldo and Price—Seve hit his second shot on the 18th to the left of the green. I can see the close camera shot now: Seve with his wedge in his hand, eyes out and into his target. Then back down again, still making practice swings but this time keeping his head quiet and down. The ball landed on the green, checked, released, and eventually horseshoed out on the right side of the cup. In his prime, few were better at this hindsight programming feat than Tiger Woods; how else can you explain his incredible extrasensory perception when he needs a putt to win or to get into a play-off? It happens too frequently to be just luck.

In building layers of feel, you must really allow the mind to register and then judge the practice swings you are making. In some genres of golf psychology there is a belief that no practice swings should be rehearsed, that one should just go ahead, look at the target, and pull the trigger. This method works well on the practice area, since the mind has time to register previous attempts, make corrections, and then adjust its feel. It also requires a huge amount of trust to pull this off in tournament play—hitting shots so spontaneously.

With all shots in golf, you need a visual cue first, so before you start to apply layers to your feel, create a clear picture of your intentions for the ball. In a bizarre sort of way, we are now going to work *with* the ego to gain layers and, thus, insight. Just as Seve did, first make a couple of practice strokes with your eyes fixed on the point where you want the

BUILDING LAYERS OF FEEL WITH THE EGO

ball to land. Once done, make another couple, but this time do not peek, keep your head down, and simply hold the finish position.

The amount of feedback from your practice strokes should be enough that you can ask yourself, "Was that close to what I want?" Seek your own counsel when developing touch for a shot, and build layers on top of your first attempt if not satisfactory. This is the opportune time to maintain stillness (keeping your head and your eyes quiet) and listen to what your body and judgment are telling you.

One final but critical note: When your head is down and you listen to the feeling of

your practice strokes, let your eyes look down to the right as you hold your finish position. This eye position not only stores the feelings you derive in your kinesthetic brain bank, it also recalls them immediately. This almost insignificant detail can add another beneficial dimension to the building of layers of feel in your short game. Look at the image. The blindfold that I am wearing literally forces a unique link between the kinesthetic sensory system in the brain and the feel of the shot ahead. Much of this has to do with memory, but nonetheless, close your eyes and seek your own counsel.

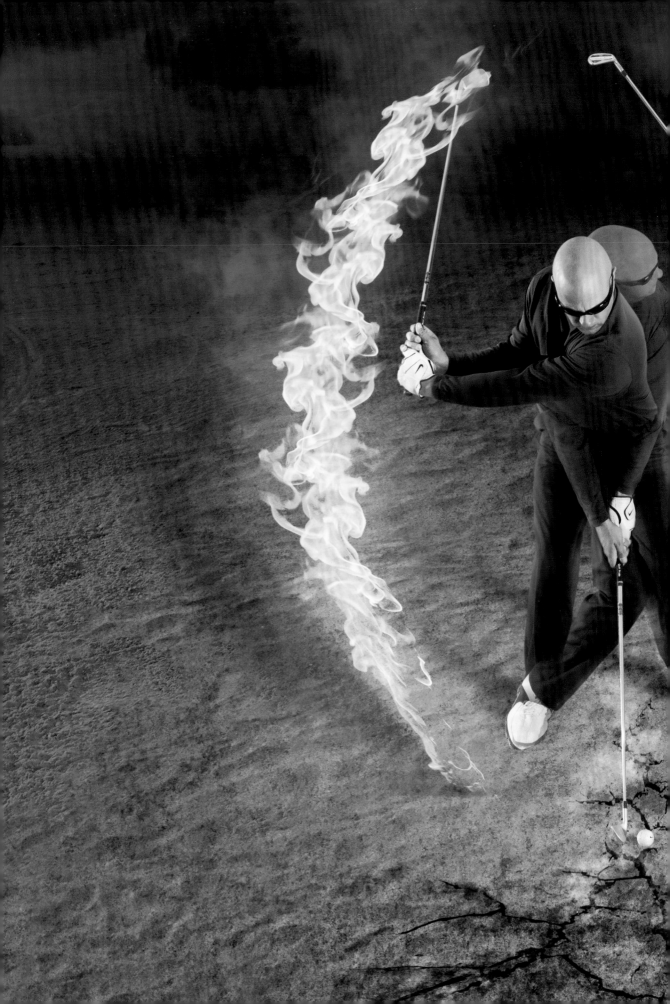

IMAGES OF
SWINGS

The Left-Hand Grip

THE GOLF SWING'S GENESIS MOMENT

It's tough to argue with nature; it is what it is. It's tough to argue with fundamentals, too; they are what they are. The question is: *Why* are they fundamental?

Golf fundamentals are in alignment with the body's natural physiology and motion. Until nature changes the fact that we have two arms, two legs, a spine, and a head, the body will always move in certain ways and with certain motions. You can cite some players throughout professional golf history who have done well with fundamentally poor grips: Lee Trevino, David Duval, Paul Azinger, José Maria Olazábal. Julius Boros won two U.S. Opens, one in the 1950s and the other in the 1960s, with interlocking and overlapping grips. So there are exceptions to nature's laws of golf fundamentals.

Using a fundamentally poor grip does come with a price, though. You would have to practice extensively to develop a compensatory movement in your swing to deliver the clubhead consistently to the ball. Since compensatory motion is rarely in alliance with the body's biomechanical preferences, there would be a premium on your speed and reflexes to time the hands with the body and the face of the clubhead with the hands. You see how it can get busy!

When you stand with your arms freely hanging down, you will notice that your palms naturally point inward toward your thighs. This inversion of the hands forms the basis of a fundamentally sound grip, in that the left hand will feel slightly turned right when on the handle of the club, and the right hand will feel slightly turned left. You could say that they equally oppose each other. For the majority of golfers, this will visually correspond to the two green knuckles you see bursting through the glove. However, even this is just a reference point and not gospel, since people's hands differ in size (mainly width), but it's a good starting point. This is true not only from person to person but from hand to hand. When it comes to the grip, you certainly don't want to be any weaker than the two knuckles visible in the picture. With the correct left-hand grip, the handle should feel more on the base of the palm (certainly if you have had less than one knuckle showing as you look down on your grip). A good pincer formation should be visible as you look down between the left index finger and the thumb.

Get this foundation correct, and you can build a golf swing that will be completely functional and repetitive over a long period of time.

Pincer Pressure

THE FINGER ANCHORS OF A GREAT GRIP

I believe that the grip pressure used by our professionals today has changed in the past twenty or so years. Twenty to thirty years ago, when we played with balata balls (they were like squash balls, for you younger readers), wooden heads, and heavier, less dynamic shafts, it was up to the golfer to generate the speed and explosive hit on the ball. This was accomplished by lagging the handle of the club (using very soft grip pressure) in the backswing and the downswing. This wave-like motion, also seen in casting a fly rod

in fishing and cracking a whip, increases the downswing leverage in the wrists and ultimately generates more clubhead speed. Compared to today's clubhead, ball, and shaft technology, the clubs of yesterday were essentially dead.

Nowadays, materials and club design are at a new level of assistance and performance for the golfer. Since the club and ball hold the dynamic keys to the game now, the golf swing itself can be much more static and economical. If you were to combine the softness and lag of a swing from thirty years ago with today's equipment, ball flight and yardage would be hard to control.

The pincers formed by the right and left index fingers and their adjoining thumbs are critical to creating and maintaining a great grip. I often see golfers who have placed the hands on the handle pretty well, yet in the process of settling over the ball, the hands seem to fall apart as all pressure disintegrates. The two pincers of the left and right hands are the finger anchors that hold the hands in consistent position through the swing itself.

The crab claws you see in the image really do illustrate the hooklike look the index fingers take on when placed correctly. Vital to the formation of this hook is the short thumb, where the tip of the thumb is roughly level with the knuckle of the index finger. It is virtually impossible to have one without the other anyway, but the short thumb is still a great reference point.

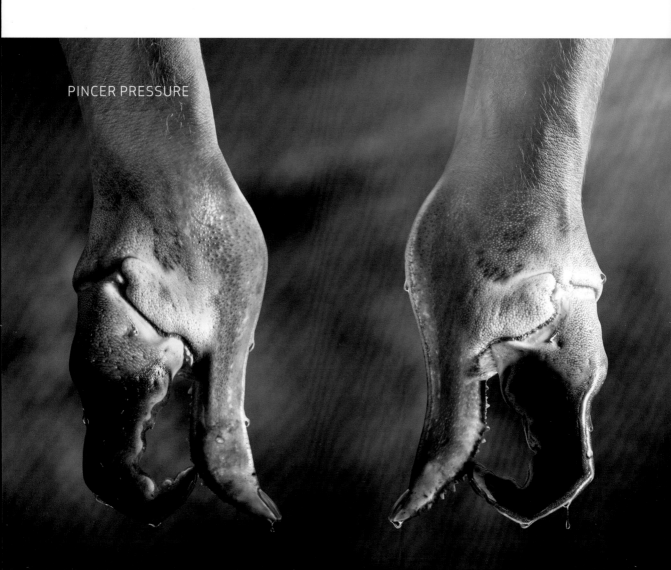

PINCER PRESSURE

The Short Left Thumb: Torque Up Your Grip

This image was inspired by Ben Hogan's left-hand grip, yet there are plenty of other world-class players out there with these curly thumbs, I can assure you of that! Hogan is said to have had double-jointed thumbs, which would have contributed to the amazing amount of lag during his swing.

A left thumb that is poorly extended down the grip is rarely associated with a good pincer formation between the thumb and the index finger. The long thumb, when lying virtually flat on the grip, has the effect of softening the tendons in the left forearm—like a series of elastic bands that have become slack and saggy. When this change in physiology happens, a certain torque is lost within the left hand and the club starts to move in a very unstable way. Typical symptoms are looseness at the top of the swing, exaggerated clubface rotation, and weak shots to the right. In bad cases, tendonitis will result from the left arm and wrist repetitively meeting impact with a less than solid physiology; each time that ball is hit with a divot, it's similar to someone twanging those slack and saggy tendons like guitar strings. Inflammation will occur at the tendon sockets, and golfer's elbow will be the final outcome.

The beauty of the short thumb position is twofold. First, the short thumb allows you to hinge your wrists on the backswing with torque. What do I mean by this? Because the left thumb activates certain muscles and tendons in the left forearm, you have the ability not only to hinge your wrists, but to hinge them *with torque*. In essence, you will be pulling back the wire of a bow and arrow as you hinge and cock your wrists during the

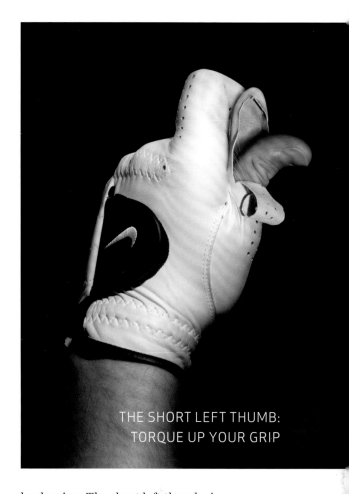

THE SHORT LEFT THUMB:
TORQUE UP YOUR GRIP

backswing. The short left thumb gives you mobility *with* torque buildup. Also, although we are hinging the wrist during the backswing, the short thumb position acts as a governor of motion. Your backswing will never get floppy and loose in the hands as long as the short thumb and the pincer are present.

As always, I'm going to say that your grip is a work in progress. Because it is! I want you to really work hard on your initial hold on the club, since it sets the golfing wheel in motion in the right direction. Chip away at the correct positioning of the glove hand, the pincer formations, and the short thumb, and you will soon have physiology and history working for you, because all great players in the future will have great grips!

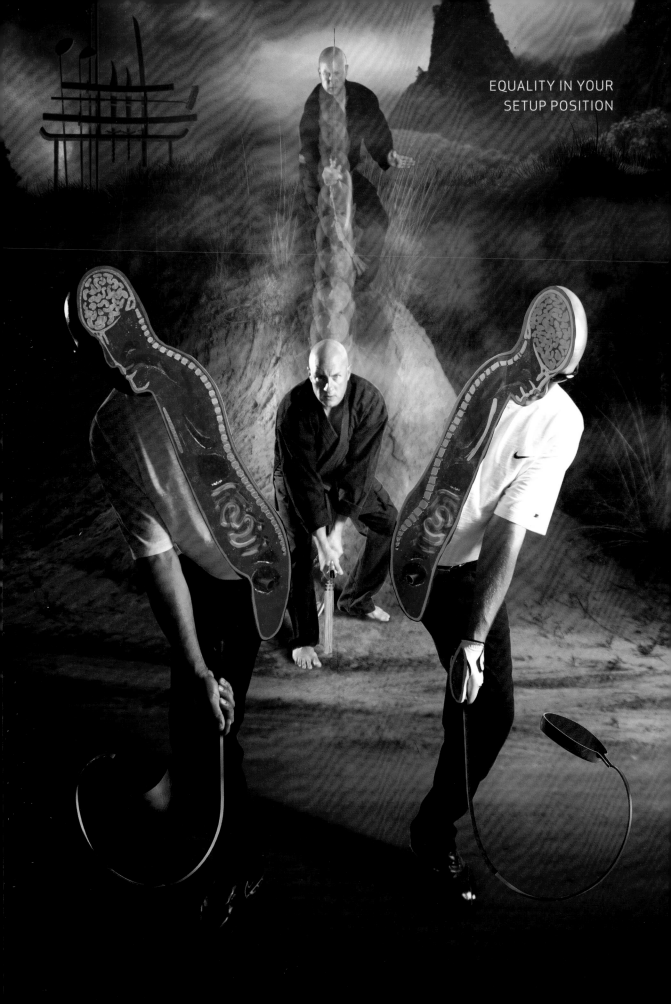

EQUALITY IN YOUR
SETUP POSITION

Equality in Your Setup Position

When we talk about balance in the game of golf, our thoughts immediately turn to the motion of the golf swing. Rarely do we look at the balance between the right and the left sides of the body when standing over the ball. This overlooked aspect of the setup has its roots deeply embedded in the quality of the grip, so as long as your hold on the club is neutral and balanced, we can start to create symmetry over the ball.

Let me start by saying that there are subtle differences between the three different genres of clubs in the setup from this face-on angle, but a basic equality over the ball will serve you very well. Let's take a moment to investigate those small nuances among the clubs.

The setup with the 8-iron through to the wedges should have some DNA of an impact position. The swing used for this group of clubs will inevitably be shorter and slower than with a driver, for example, so in that regard we do not have the time or the speed to pass through the three main qualities of impact in a very dynamic fashion. These qualities—*weight into the left side, sternum over the ball* with the chest open, and *right knee fired* into the ball—are the key ingredients that all great ball-strikers have at the moment of impact. Because of the lack of speed and dynamic with these clubs, we have to assume a sort of watered-down version of these qualities when standing over the ball. Remember, you only need a *small* sense of these qualities to get what you need, so don't OD on these feelings.

As we hit the midrange of clubs (7-iron to 4-iron), we assume the most neutral address position we can, working with the type of strike we need with these clubs. *Relatively level shoulders, weight caught at fifty-fifty* between the right and left foot, and the *butt of the club looking directly at your navel* make up the address position for the mid-range irons.

As we move into the 3-iron and upward, we once again consider the implications with these clubs at impact; we must start with the end in mind. The *weight slightly favors the right side*, especially with the woods. The *spine and sternum are slightly tilted away* from the target, creating the correct angle of attack, and the *hands feel slightly behind* the clubface, too.

One vital piece of information: Unless you are trying to play a shot that's especially low, you must never shove the handle of the club forward and ahead of the ball so that your arms look like a reversed letter *K*. Apart from breaking the symmetry we need over the ball, this also creates huge strain on the performance of the club itself. The club doesn't want to sit on its leading edge, it doesn't want to be de-lofted, and it doesn't want a sharp *V*-shaped entrance into the back of the ball and into the turf. It's not designed to behave like that. Keep another symmetrical shape going at address: the letter Y, formed between the arms and the club.

Use a mirror to gain this balanced symmetry between the right and the left side of the body. You'll cut a fine figure over the ball.

Spine-Wrecking Posture

I'll make this as clear as I can. Your posture over the ball (including your grip) will entirely dictate whether you are in freedom mode or recovery mode during the swing. Let me explain. There really is no one way to swing a golf club; one only has to visit the World Golf Hall of Fame, just south of Jacksonville, Florida, to see that there are many ways to get it done. However, each of these golfers, each with his own individual style, had rules he had to follow while standing over the ball, based on his technique and physical attributes. Working with some of the best physiotherapists in the game, including the late Ramsay McMaster, who tragically passed in 2011, has taught me that many of these Hall of Famers would have had even more stellar careers in terms of longevity and performance if they had had the conditioning and the knowledge we now have about the body and golf. This takes nothing away from them. If anything, it further elevates their accomplishments.

What you see before you is a heinous posture that is likely to induce major structural, ligament, and muscular damage. For the sake of this instructional offering I just want you to consider this: In what other form of physical human endeavor would you see someone so limp, so unready to move and perform an athletic motion? The leopard poses and *then* springs, the boxer takes a stance and *then* punches, and the golfer structurally assumes a position that respects the shot ahead and his body's needs. It is in this last aspect that we will find the next huge jump in golf technique and performance—how we structurally set ourselves up for the very best pass at the ball we can muster.

It's easy to imagine the huge physical jarring that would occur if you asked this guy to suddenly swing an object around his body at about 100 mph. This jarring and dynamic motion doesn't really occur until the change of direction between the backswing and the downswing. Still, it's when many of the body's muscle groups are recruited to engage and fire into the ball and beyond. If you prepare your body over the ball before this happens, ball striking can be a joy. If you have little regard or awareness of structural necessity, you will be moaning about soreness very soon.

My advice here is twofold. First, look at the image and take note of the roundness in my back, the overly flexed, saggy knees, and my chin—which looks as if it is tucked into my chest. Take your regular posture and look for any of these classic traits of poor form over the ball.

Second, I sometimes refer to the spine and other bone structures we possess as the body's coat hanger. This term has more significance to it than my throwaway moniker might suggest; I would encourage any regular golfer to seek out a reputable osteopath or chiropractor and believe the adage that an ounce of prevention is worth a pound of cure. Don't wait until something goes wrong (especially with the spine!) before you visit a good specialist. Our bone structures are essentially jigsaw puzzles that serve our muscles best when they fit together properly.

Respect the ball, and respect your body, with better posture than the hideous image you see before you!

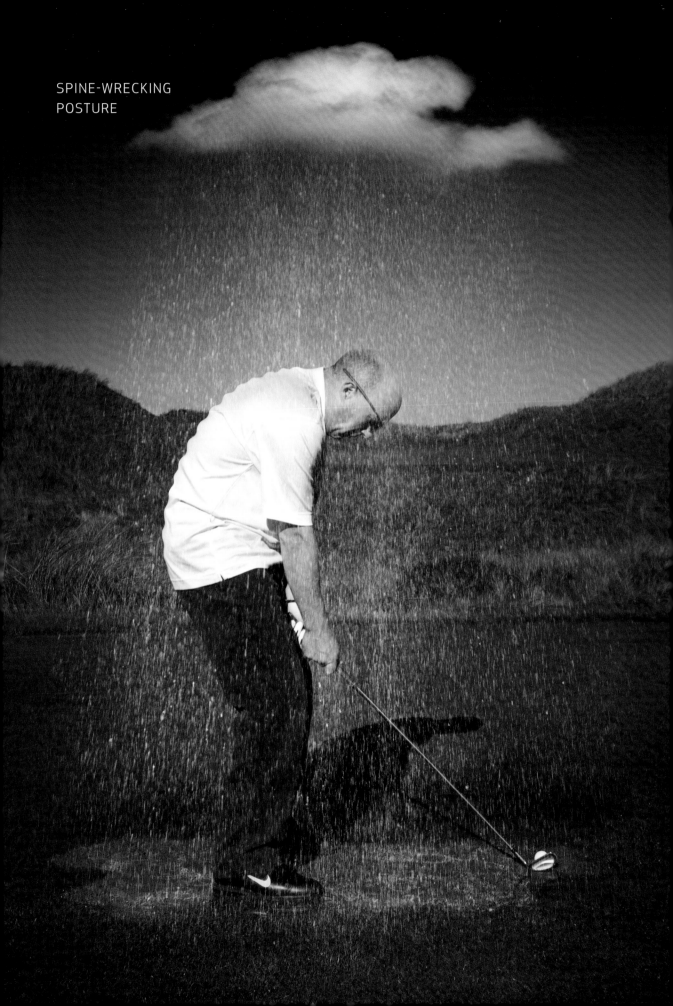

SPINE-WRECKING
POSTURE

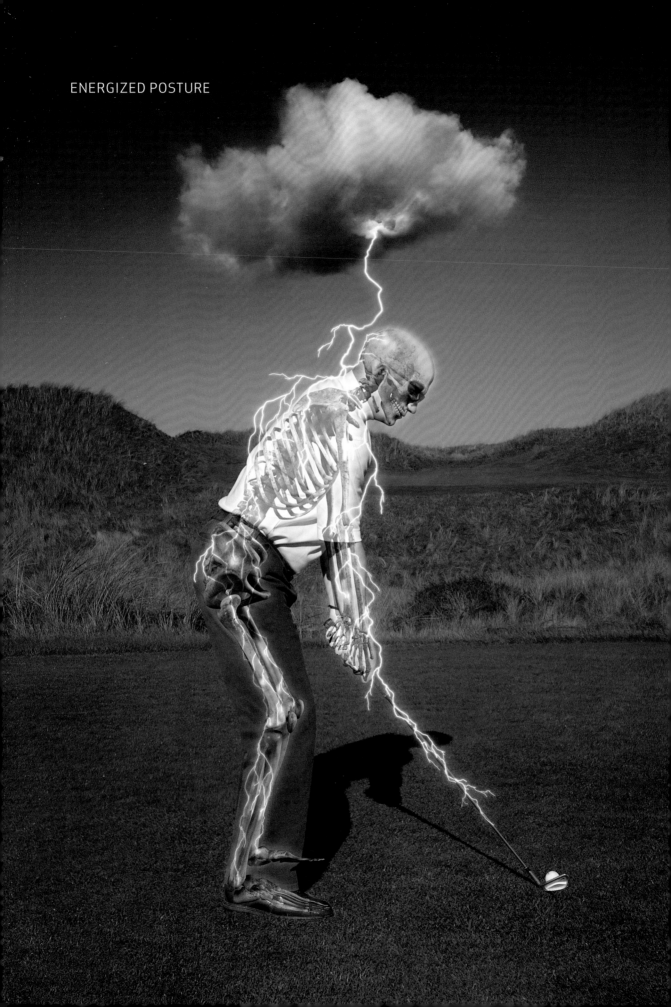

ENERGIZED POSTURE

Energized Posture

In my experience, the posture that a golfer assumes over the ball resembles the posture he normally has walking down the street. In this respect, there is an element of who you are and the energy you carry day-to-day that determine the quality of pose in your golf game. Most of us need to work continually on our posture, and the good news is that most of us can. There are well-known adjustments that position people into better posture immediately: Keeping your chin up, pushing your shoulders back a little to open up your chest, and not slumping forward from the waist all have the effect of creating a better frame in which to live, move, and operate.

Prevention is better than cure, but don't wait for your back to get better on its own if you do get aggravation from it. Seek a qualified back specialist at once. Not many of us are going to incur an injury while walking down the street, even if we do have poor posture. You will, however, increase the chances of an injury if you try to swing a golf club at 100-plus mph looking as if you've been carrying two water buffalo on your shoulders for the past twenty years. And you are asking for trouble if you go from a totally undynamic state to an explosive motion in a split second; there is always motion *before* the motion when performing a golf swing.

Apart from generating the correct energy over the ball, good posture punches in certain coordinates the body can operate under. Biomechanically, we want to use the posture we assume over the ball to *house* the golf swing itself during motion, so knee flex, spine angle, and general physiology play an important part in the bigger picture.

Allied to good posture is good balance. I'll address the in-swing foot grounding a little later, but suffice it to say we must start with the proper sensations when over the ball. A useful analogy for this foot anchoring at address would be a sprinter with his feet locked into the blocks. Imagine the sprinter with his weight loaded into the heels as the gun fires; there would be some serious compensation and time-wasting going on to gain any sort of explosion from that dead start. Golf is no different. We must prepare the ground for athletic movement before it happens. The weight needs to favor the balls of the feet (as in most dynamic activity) as you look, and sense your posture, down the target line. From face-on, a slight squeezing sensation on the instep of each foot will assist in keeping the coil and wind of the body inside the boundary of the stance, giving you more torque and kinetic potential.

Use this image to first imitate and then apply to your own golf game.

The Relationship Between the Inclined Spine, Trajectory, and Ball Position

Until quite recently, there have been two schools of thought on ball position. The first was the variable ball position, in which you moved the ball backward and forward in the stance according to the club you were using: farther back in the stance for shorter irons, forward for the longer stuff. The second—and my preference—would be a constant position, in which the bottom of the arc (which falls

opposite the left armpit) signifies the placement of the ball. Apart from its reliability, the bottom-of-the-arc method encourages a full release of the golf club, which returns the shaft back to 90 degrees and, in doing so, presents the correct loft and angle of attack into the ball.

Be aware that the right foot will complement and adjust according to the spinal angle. The driver swing, for example, which creates the most acceleration and dynamic motion in golf, needs a wider (lower) center of gravity (COG) to provide stability and balance. So the right foot will have to widen to provide this stability. Allied to this, the spine drifts back a little, creating the slight ascending blow we need to maximize the club's effectiveness.

Now you can see the parallel between the ball's initial launch angle and the slight backward tilt of the spine (A). Some players drive the ball exceptionally well when they feel that the shaft is actually matching the incline of the spine (hands slightly behind the ball).

With the mid-iron, everything levels out and "trickles down" from the driver. Unlike with the driver, the right foot is drawn in a little, and the spine is less inclined from the ball; it's virtually upright (B). This doesn't suggest that the club still ascends through impact à la the driver. Even though this still resembles a sweeping setup, since it appears very level, we definitely need to take a divot with the mid-iron. The divot is taken by the combination of weight shift and the open chest

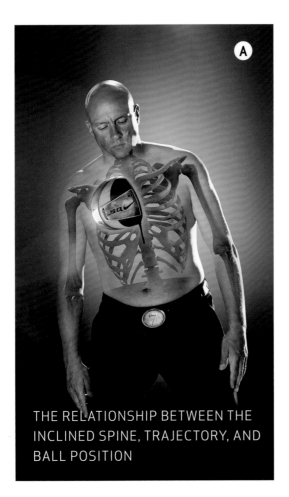

THE RELATIONSHIP BETWEEN THE INCLINED SPINE, TRAJECTORY, AND BALL POSITION

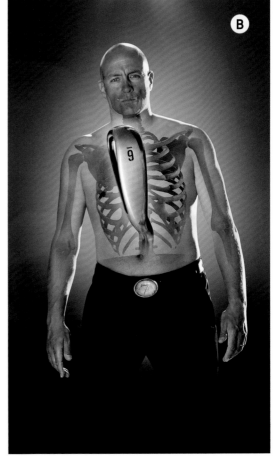

positioning the sternum on top of the ball at impact, inviting a great vertical swing plane. You can start to appreciate why the right foot would narrow with the shorter irons when you grasp the fact that the profile of the strike and launch is largely determined by the angle of the sternum. If we take too wide a stance with a short iron, we can get the rotation of the body, but we will struggle to make the strong move (weight shift) to the left side to get the sternum over the ball. Conversely, too narrow a stance will encourage a premature weight shift left, which, when hitting a club like the driver, would be disastrous.

The last image (C) shows the proper alignment for using the short irons to wedges. Unlike the other two categories of club, where we have ample speed and momentum to find impact, we have to create a mini feeling of impact at address with these shorter clubs. The right foot now narrows to the point where the middle of the foot is under the right hip joint; anywhere inside this point, and we start to risk a lateral shift instead of a wind. The sternum is without question at 90 degrees to the ground (and with some wedge shots slightly ahead of the ball) and the shoulders marginally open. All that's required is for you to make a powerful and compact backswing and then collect the ball on the way through.

Study the relationships among club, sternum, and right foot. Adopting this system will greatly improve your ball-striking consistency.

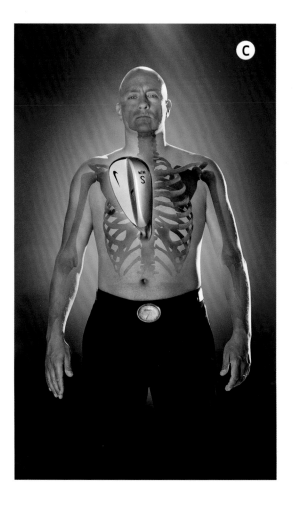

Body Alignment

At times I observe a new student hitting shots and initially all I see is the kind of body alignment that would make a contortionist look good. When adjusted, the student looks in complete disbelief at the quality of the shots he is suddenly hitting. I'm not joking when I say that I have even experienced resentment from students when the cause of their frustration was so simply fixed and corrected. "No!" they say. "It must be way more technical than that!" Well, it can be, but not in the case of misaligned body parts!

I think the following image (p. 114) captures and helps the imagination "see" what you need to look like over the ball. Good alignment is tough, because you're asking the body to feel something it can't actually see. It's like sticking the pin in the donkey's ass with the blindfold on: You know where it's meant to go, but you can't see it. The trick is to have the

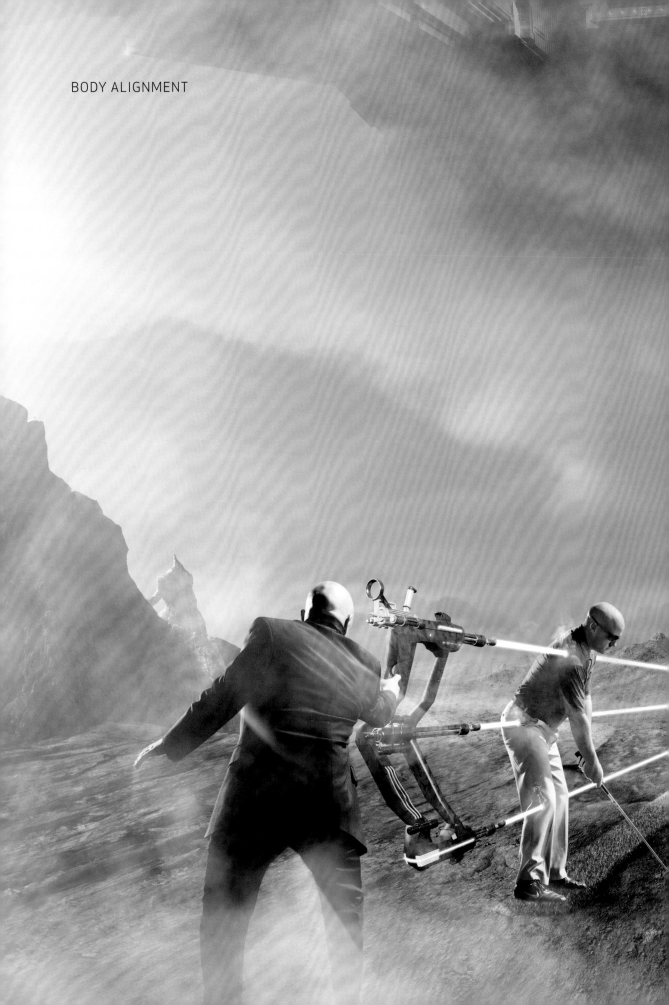

eye-and-body-feel relationship working harmoniously; this occurs when your perception of correct targeting (what you see) dials in to where you place your body in relationship to it.

The first step in mastering alignment is working with the clubface, and since this is the only part of you or the equipment that touches the target line, it had better be correct. Many golfers—Tiger Woods, Greg Norman, and Jack Nicklaus, to cite three—use an intermediate target.

Jack often says that it is easier to align to a target one foot ahead of you than one 200 yards away, and this of course is true. So all these golfers pick a leaf or a divot just ahead of the ball, in line with the intended target, to which they align the clubface. Take your time with this and ensure that the leading edge of the club is at the correct angle to the target line.

It's interesting to observe golfers at local driving ranges and Tour events. They will make their way to the left, middle, or right side of a driving range depending on their alignment tendencies. For example, hookers or drawers of the ball will always stand to the left of the range and aim right, because that is how they want their swing to feel when hitting the ball to the target, and will feel very uncomfortable standing anywhere else. The same is true of the faders or slicers. These guys will err to the right side of the range and aim left, since that way their swings feel good to them. Do me a favor and try to head to the middle of the range, pick a target dead ahead, and practice away.

Look at the image and see how everything centers on that initial relationship between the clubhead and the target; everything else is parallel left to that.

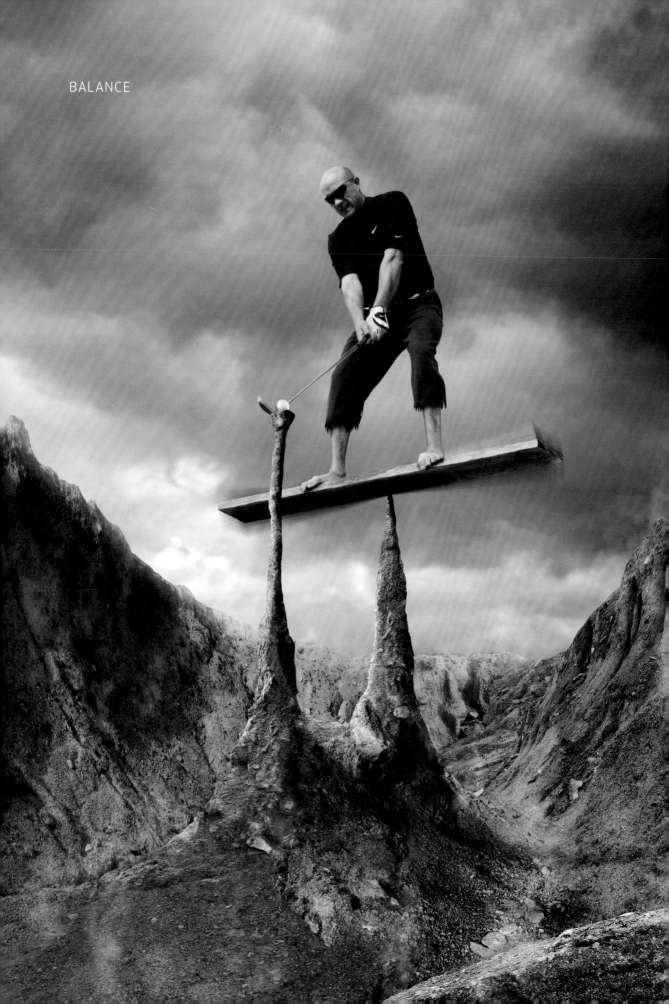

BALANCE

Balance

STAY WITH ME ON THIS ONE!

I don't think there is any serious golf instruction literature in the world that does not mention balance at address and during the golf swing. Probably the key dynamic in a powerful golf swing, your relationship with the ground determines potential power and released power. The "stay with me" subtitle of this section refers to the attitude shown by most golfers (and Tour professionals) toward the subject of balance and foot grounding.

Imagine a ballroom dancer who is obsessed with the way his upper body looks during a routine. Try as he may, he can generally get the form looking pretty decent, but the flow eludes him; there never seems to be any oil in his action that ultimately blends all the individual pieces. This dancer also becomes baffled by the inconsistency of his positioning when the movement speeds up; when posed in his mirror, he is pleased with what he sees. However, with music and thus speed, the efficiency of his mirror work disappears.

I see many golfers practicing in exactly the same way. You could have the armswing of a Nick Faldo, but if your lower body is unstable and not grounded, you will be prone to fluctuations of form at best. To be centered at address and at the same time ready to move is to be prepared to swing with discipline and speed.

The image is pretty apt at conveying this. If you were to be in this situation, there would be two points of focus that would seriously help your centeredness and readiness. The first would be your center of gravity, and the other would be your constant feeling or sensing between left and right. If you were to step into the stance of a Tour player, you would immediately be struck by how much knee flex you feel. Your center of gravity is located between the bottom of your rib cage and the mid thigh. This middle ground should always fall between the insides of your feet when looking at yourself face-on, which is why, when we take a particularly narrow stance as we would do in chipping, we anchor the weight on the front foot. Try pushing a top golfer over when he is addressing the ball, and it might be a little more difficult than you think. The key is to feel heavy through your stomach and your rear end (gluteal muscle group), not high and floaty as if a strong wind could blow you over.

When the center of gravity is firmly planted, certain muscles need to fire in preparation for movement. This motion (often seen in tennis players, too) takes the form of a jockeying between the left and the right foot in which you sense an equality of balance. What this accomplishes is to get two sets of muscles firing at the same time, which counterbalance each other (and thus produce balance overall): the gluteal muscles and the front thigh. It's a bit like crushing grapes, only in our case the stamping is lighter.

Finally, practice taking your address position with your eyes closed and gently rocking from side to side and from heel to toe. This will increase your sensation, awareness, and knack for gaining perfect balance over the ball time and time again.

The Two Roles of the Right-Hand Delivery

If you struggle to consistently place the left hand on the club in good form, your first step is to look at the routine that shapes it. It's virtually impossible to get the club into the left hand without the right hand assisting in some way, so that seems like a logical starting point. Think about this for a second: First you draw the club out of the bag, normally with the right hand, and then somehow deliver it to your

about 45 degrees. The same can be said when each hand is lifted about waist high, too: They still maintain that inward turn toward each other. What this is telling us is that these are the unforced positions of the hands according to natural law. With this natural constant in mind, we should always get the golf club to fit the hands, never the other way around.

Look at the image and see how my right hand is introducing the grip of the club at an angle that complements the natural inward turn we talked about above. The left hand does not need to turn or twist; it can simply retain

left—again with the right hand—so the question is, can you remember how you made this key introduction between the handle and your hand? It's an important question, because this is a chain-reaction move from which quality will either follow or dissipate.

With your hands hanging naturally at your sides, peek down and observe how the palms appear to be "looking" inward at the thighs; to be more specific, they turn inward

its natural form in front of the body as it accepts the handle of the club. The other benefit of this routine is that it allows you to fully observe the quality of the grip in front of your face. A grip that is taken when both hands are down by your thighs will be visually obscured, thus jeopardizing the quality of the club/hand relationship. So get this in-your-face grip routine integrated as fast as you can, and it will pay huge dividends in consistency.

As we already discussed, it is better to locate the handle of the club toward the base of the palm and into the fingers. This hold biomechanically enables the wrist to move with the freedom that produces power and good clubface control. Once the glove hand has initially closed itself around the grip, the right hand can provide its second key service for us. You can see in the image how the right hand is pulling the shaft toward my chest, almost like a bar worker would pull a pint of beer. The grip on the club starts to maneuver and slide toward the base of the left palm and the fingers when the shaft is pulled in

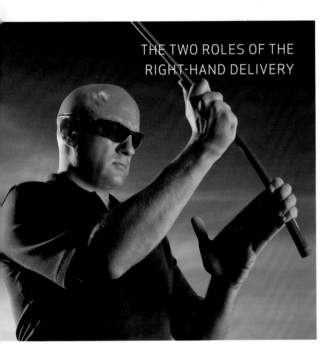

THE TWO ROLES OF THE RIGHT-HAND DELIVERY

this fashion. As soon as the fingers sense when to grasp the handle, pressure will be directed into the little finger and ring finger of the left hand, thus securing the club during motion.

In what could possibly be the most important routine in golf to develop, allow the right hand to play matchmaker and instigate the proper marriage between the glove and the handle throughout your golfing life—you won't regret it.

Driver Setup

AN IMAGE FOR THE SLICERS AMONG YOU

Slicing the driver is the common cold of golf. This unforgiving weapon will send your ball spiraling into the rough before you can sneeze if certain elements are not respected.

Slicers *really* need to pay attention to the points I cover here and replicate the image on the next page. Slicers and drivers are like oil and water—they don't mix well. Unfortunately, this relationship always seems to get off on the wrong foot, starting from the address position. Understand that the driver is the Polaris missile of your golf set: potentially effective when respected and controlled, yet absolutely disastrous when misguided. The slicer steps up to the driver as if he's slapping a Doberman across the chops—no appreciation of the beast he's dealing with!

This face-on angle provides the slicer with most of the qualities needed to significantly improve his ball flight. Rather than focusing on what the slicer should avoid, I want to narrow in on the qualities that make great drivers of the ball.

Let's skip the grip! If you are new to the game and you slice the ball, I suggest you nail this component of your swing as soon as possible. If you are not new to the game, slice the ball, and have not reviewed the most basic fundamental in golf, then what can you expect? Get to it!

Let's start from the ground up. Look at the stance width: From my feet to my knees, I have the look of the Eiffel Tower in Paris. A great reference point is that each hip joint falls directly over the middle of each foot. This ensures that the stance never gets too wide for us to rotate and shift our weight into the feet.

There are also a few subtle points I'd like you to adopt right from the start.

First, build a stance that creates stability in motion, yet can harness windup and torque. My right knee falls and feels as though it's slightly inside my right instep in a somewhat pinched position. This small detail gives my body the opportunity to store its coil within the stance. While the knee will rotate in this position under the influence of the torso turning, the knack for the knee is to retain its starting position at address. This small detail critically influences the hips from this face-on angle, which in my opinion, aside from the grip, is the most important aspect of the driver setup for the slicer.

Secondly, as a slicer you may be used to having your back foot (in this case the right) square, pointing straight out ahead of you at 90 degrees to the target line. If you do, I'd like you to change to having that *right foot fanned or splayed out a little*. By having the right foot too square at the address, you encourage the right hip to float in a high and outside position, rendering it almost impossible to get behind the ball and make a decent backswing.

Take a look at my hips and my spinal angle; notice how my left hip is subtly higher than my right. Also, look at the cohesion between the *shaft* angle, my *spine* angle, and my *nose* bone; all three components form a linear relationship with one another. Apart from being pretty, they actually serve a huge purpose, since they dial the angle of attack into the ball that ideally suits the driver. Start with the head: Most slicers of the ball will look at the ball with their right eye—that is to say, both eyes will actually be pointing to the left of the target from a view down the line. It's like putting; ideally, of course, we need the eyes to be directly over the ball and parallel to our target line. With the driver, it

is preferable for the slicer to sense that he is actually looking under the shot, so that the face of the club will deliver a better starting line.

Next, we come to the spine angle: Any student of mine will know the importance I place upon its positioning relative to the angle of attack you want and the trajectory of the ball flight; this slight rearing back of the spine will also have the effect of shifting a little more weight onto the right foot.

Last, look at the shaft of the club: Can you see how the handle appears to be hanging back a little, giving the impression that the shaft is matching the spine and nose bone? The biggest effects this has for the slicer are grip pressure and better positioning in the first part of the swing! With the grip pressure automatically softer in this hands-back setup (particularly in the glove hand), there will be less inclination to roll away and open the clubface. The desired effect is to have the face looking at the ball for longer in this initial stage. Remember this if you slice!

So if you slice your driver, use this image and replicate my key points. Also, using a mirror to do this will speed up your recovery process from the driver blues!

Connection to a Bigger Mass

THE SWINGWEB

There are only so many real guarantees in golf—the rest, if you lump them all together, are a myriad of old wives' tales, fables, and throwaway pop junk. But the guarantees come in the form of scientific laws backed by

hard evidence. The very best golf swings are founded on these principles.

Core stability is a common term in golf. It mainly refers to the consistency of the speed-motion variable that every golf swing has, located between the mid thigh and the mid rib cage. This nucleus, aside from the grip, is the single most important aspect of the swing to train, since unless this hub of motion behaves itself, it's unlikely that the spokes of the swing will hit the same spots consistently.

If the torso is the biggest mass we can work with, it makes sense that working *everything* off this will give us the best chances of swing success. Since the arms really do have the capacity to float around during the swing (because they carry little mass), it is essential to train and discipline them to work closely with the larger mass of the torso.

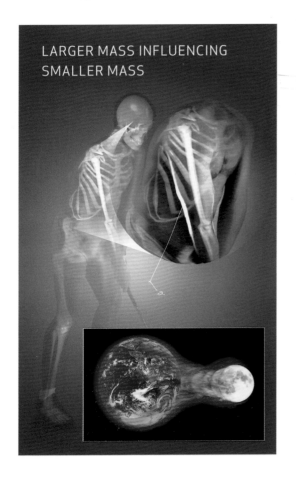

LARGER MASS INFLUENCING SMALLER MASS

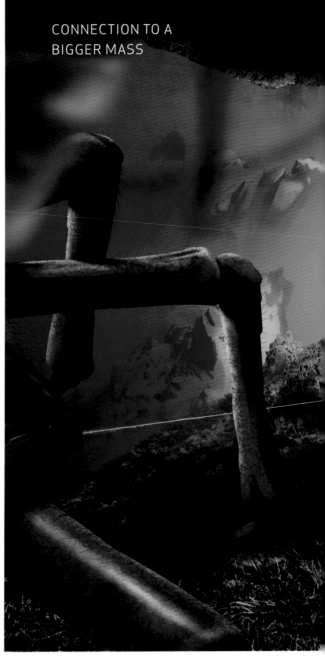

CONNECTION TO A BIGGER MASS

If you are hitting shots off every conceivable part of the golf club, I suspect your swing plane is jumping all over the place as you swing at the ball. If this is so, your first priority is to recruit a governor of motion into your swing; this will immediately start to discipline and tie your arm motion into the bigger mass of the torso.

As the image suggests, this sensation starts at the address position when your upper arms

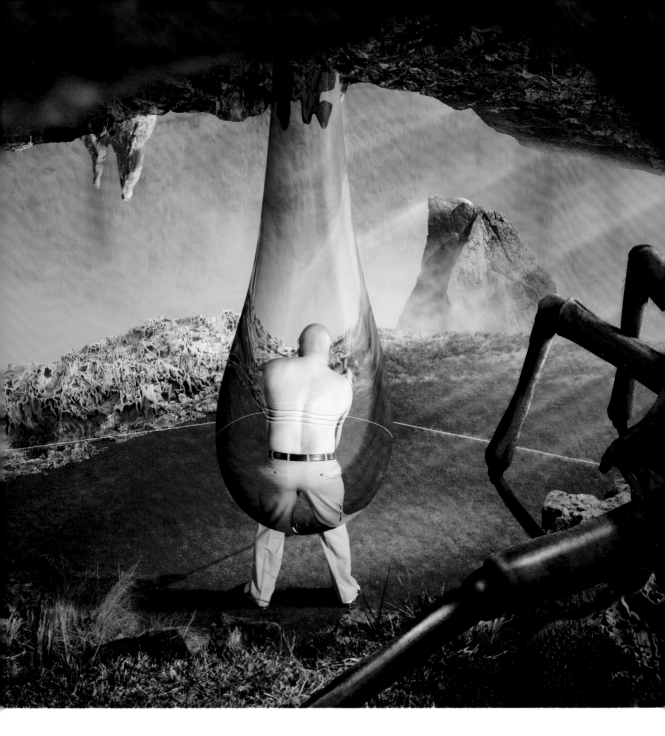

impose a slight pressure onto the rib cage. As you start to make your motion, try to maintain this pressure, at least until the swing makes a motion halfway back and halfway through. The two spiders and the webs they've spun mesh the arms and the torso together. While the arms will separate a little from the body during the swing itself, it's well worth trying to keep this bond for the sake of consistency.

A really easy way to grasp this is to hit shots with a towel under each arm. All you need is a 9-iron, a couple of towels, and a bucket of balls to sense the connection between the smaller mass of the arms and the larger mass of the body, feel this link to the torso, and acquire the discipline that your armswing is begging for.

The Zip Grip

In Ben Hogan's *Five Lessons*, published in 1957, the opening picture by Anthony Ravielli shows Hogan at impact. Ravielli drew what looked like a generator whirring inside Hogan's body, linking the brain, the stomach, and the hands. Within the hands is a switch, rather like the one you would see in a Frankenstein movie; the switch has been flicked on and there is electricity flowing around Hogan's body.

Ben Hogan's understanding of the quality of the grip, the potential power the grip could provide, and the subconscious awareness of the mind placed on the grip was ahead of its time. Initially a hooker of the golf ball, Hogan would have experienced times when his mind unwittingly drew his attention to the left side of a hole more times than he'd like to remember; he would also recall how his mind would start to compensate by adjusting his alignment to fit his fault. In what became a famous grip change, Hogan shortened his left thumb and then significantly weakened both his hands, which put the clubface position and the mind at one with each other.

To get the hands at one with each other, we initially have to work with the inside of the grip, the part you can't see from the outside. As you know, there are three common ways to link the right and left hands together on the handle of the club. The first is the interlocking grip, as used by Tiger Woods and Jack Nicklaus; then there is the Vardon or overlapping grip, used by most touring professionals; and last we have the baseball grip, in which all ten fingers touch the club. *None of these methods of linking the hands is as important as the "docking" connection.* Look at the smaller image and see how the curvature of my left thumb matches the line (the lifeline) that sits just under the fatty muscle of the right thumb; it's as if they were formed from the same cast. It's this inside relationship that continues when the grip is completely formed around the handle of the club. I'd like you to learn and perfect this docking system, as it forms the most important link between the two hands at address, and repeat this until you really sense that your left thumb is neatly nestled or, in this case, zipped into that pad.

This invisible link between the two hands manifests itself in the way the outside of the grip now looks. Bad grips always appear to be splitting apart, and the right hand often looks slack and without sufficient pressure. The result of this is a grip that breeds independent hand action and inconsistency of motion. A great grip looks neat, symmetrical, and embodied by authority, like the one you see here with the hands appearing to have been sewn together from the inside. The appearance you want is that there is only one join marrying the two hands together, in this case the zipper. Remember, the better you have your grip looking, the quieter your mind and the better your shots and your scorecard will be.

The Pivoting Motion of the Body

FIRING THE RIGHT KNEE

It must appear to be some sort of black art to amateurs who watch Tour pros hit the ball a mile down the fairway with a controlled flight. We all attempt to hit the ball hard at some

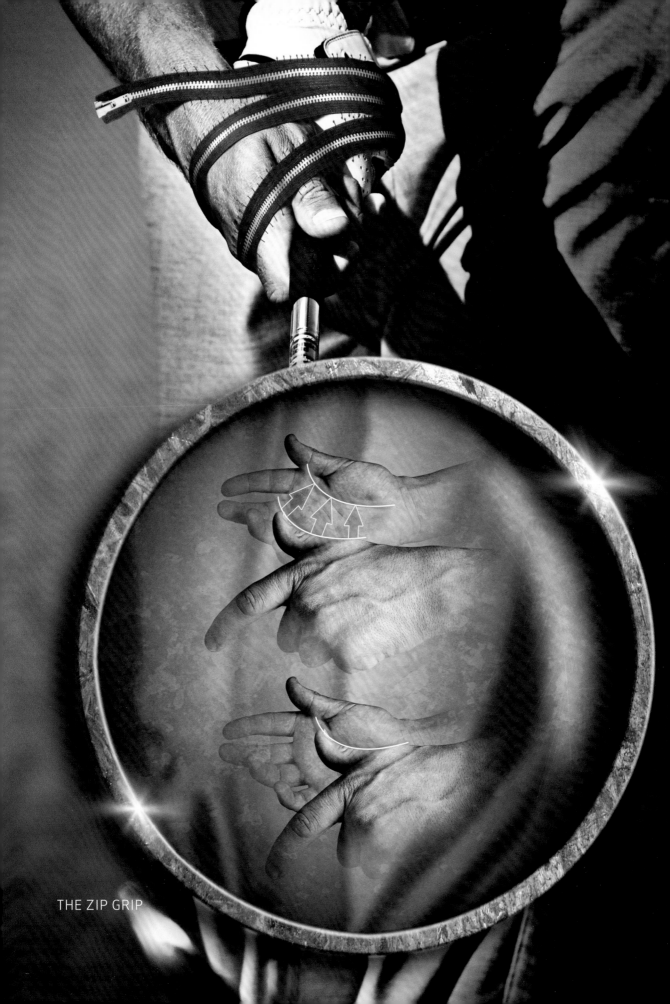

THE ZIP GRIP

point in the round, but we usually have to pay the price of quality to do it. When things speed up, our sense of timing between body and club must be synchronized fairly well to get the most out of hitting the ball harder. There's no point in hitting it 300 yards into the middle of a jungle!

Apart from the timing element the right knee creates between the body and the club, which I will elaborate on later, its involvement during the downswing also promotes organized body planes and dynamic balance to the end of motion. In most sports where the body is called upon to create torque and speed, you will often see a "going to the ground" move, in which the pressure to move explosively is initiated. Examples of this are throwing the javelin, karate, pitching a baseball, and boxing. As the downswing initiates and the right knee drives toward the ball, the initial posture you took at the address is

slightly exaggerated and compressed groundward, developing the spring you need for speed. Tiger Woods provides the best example of this move in modern golf.

Imagine a bow and arrow, if you will. The arrow is the ball you propel and the bow represents the winding action of the body. As the arrow is drawn back, the wire becomes stretched to the point where it has to be released. The wire, unhindered in its release, will fully recognize and reflect the buildup of torque by shooting the arrow way into the distance. Imagine the power lost, though, if part of that wire were to be held back or snagged during its unloading process; it would simply jam up any full release of power, sacrificing both accuracy and power. If your right knee does not fire effectively during the downswing, you will be robbing yourself of vital power and control as you hit the ball.

THE PIVOTING MOTION OF THE BODY

The powerful strike that retains and harnesses control, too, involves both body and club. A downswing that simply thrusts and unwinds the body at the ball will leave the club behind. Conversely, swiping through the ball with just the shaft and clubhead will have none of the body's mass behind the strike. The optimum goal, therefore, is to combine the two.

I'd like you initially to practice this blend of body and club by hitting a series of mini pitch shots. *The sensation, and the goal, is to have the right knee and the club shaft pass through the ball together.* Start off slowly, giving yourself the chance to coordinate these two elements, and then, when ready, gradually build up speed. So long as you are working both club and body (right knee) through the ball together, your chances of a controlled and powerful strike are good.

The Three Points of Resistance

THE CHAOS THEORY OF SWING

There will be times in your golfing life when aspects of your swing get so out of kilter that order must be restored sooner rather than later. You could say that the golf swing has its own chaos theory going on when nothing seems to be working. When faced with swing chaos and confusion, you must go back to a system that creates neatness and economy. Having successfully diagnosed golf swings for the best part of twenty years, I use a system that cuts to the chase pretty quickly when things start to go awry. Order of mass is the order of the day when the chips are down. Big mass will always control smaller mass, and so our sequencing of diagnosis and then cure must also follow this physical law.

Certain aspects of the swing are most definitely dependent on others. A simple example of this is the grip, since a substandard grip will always produce substandard shots. So until the grip is correct, let's not bother talking about swing plane—get the idea? I'm assuming at this stage that you will run through all the obvious setup checks for me before I go on.

The three points of resistance refer to three major joints: your knees and your neck. When instability occurs in these three variables, the body will generally dominate and steal the show. Since the armswing is largely dependent on the body motion, we must discipline this bigger mass first.

Take a look at the image on the next page and the sensation you can derive from it. Set yourself up without a ball initially, and close

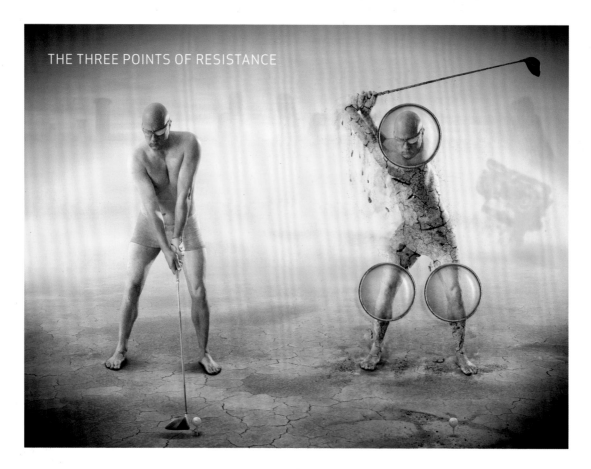

your eyes. Take a moment to visualize unbroken brickwork stabilizing your head and your knees—let your awareness drift onto these three areas one by one.

Just by focusing your awareness on these three points, you will automatically become aware of any excess motion occurring during your backswing, but by going one stage further and feeling these areas resisting, you will prevent the head and knees from over-rotating and allow yourself to begin to achieve the objective of restoring order to your golf swing. Now, with the body under control and not in chaos mode, you can start to work on your armswing.

The Right Knee

YOUR SWING'S ANCHOR AND BATTERY PACK

During the late 1980s, there was a huge emphasis on the role of the right knee during the backswing. This emphasis came out of the need to move away from the 1970s method of swinging a golf club with a wide, one-piece action and the body turning as much as possible. With the use of video becoming more popular during the 1980s, the inefficiency of this method began to show up biomechanically, and thus a "less is more" philosophy was born.

For a while, though, many golfers had the wrong notion about maintaining the flex in the right knee. They would stand over the

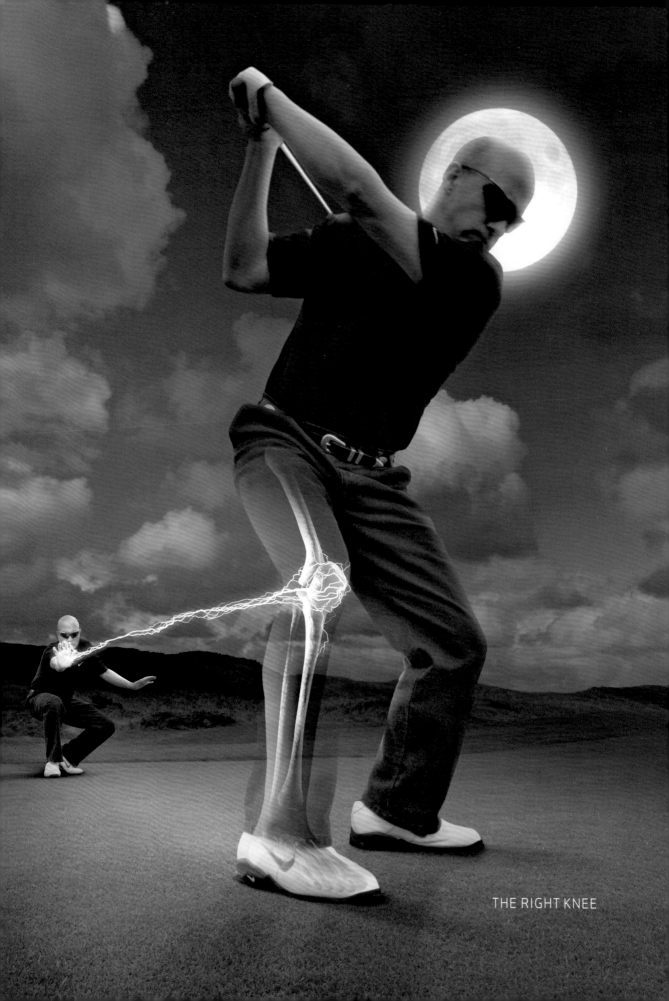

THE RIGHT KNEE

ball, lock the right knee in position, and wonder why their distance and quality of strike started to evaporate. Locking the right knee in a fixed position in hopes of creating stability and power in fact induced the opposite effect. Everything in the midsection of the body became logjammed; there was no wind and no potential to coil.

The role of the right knee can be seen in the image on the previous page. Although the knee has maintained its initial flex, some qualities have to be respected. The knee acts as something to wind into, not something to make everything else static around, so when the tummy starts to move around, the knee complements the motion rather than fighting it. As the tummy moves to the right, the knee does so with it; you could say that the right knee travels with the turn a little. This isn't to say that the weight moves to the outside of the right foot as this subtle rotation occurs. This never happens. In fact, the weight should be felt predominantly in the toes and ball of each foot, ensuring good hip plane and an authentic wind of the trunk. The role of the right knee is not to stay rigid at the address and during the swing; it is to be wound and turned, making possible a *re-flex* action that fires during the downswing.

I have witnessed both amateurs and pros develop ligament damage through the over-resistance of the right knee. It should be a buffer, but not a barrier, to great motion.

Kinetically Flowing for Power Blowing

Kinetic chain is too fancy a term for the creation, movement, and delivery of power from point A to point B. This type of energy flow is found everywhere. Look at the actions of a whip or of a fly rod being cast: The energy travels upward from the ground, into the

tip of the whip or the rod. The energy starts from a body source and moves to a smaller source—the tip, the fly, or in this case the clubhead.

What we are doing is moving energy. The images here show the very genesis of this transference of energy from the body to the clubhead in the golf swing. You could use the term *tempo* to describe this energy transfer, and indeed it's a good place to start. When I

see students suffering from a lack of dynamics and flow between the backswing and downswing, I may go to a drill I call the "step in." In simple terms, their tempo will change from a one-two to a one-*and*-two. The *and* is what I want you to experience here as you look at and replicate these images.

The first image (A) relays a sense of motion into the downswing before the backswing has fully completed. The rod is still

downswing by allowing those leftward tassels to get going early!

The second image (B) is the rest of the body's response to this initial move. I call this the "shuttling," since there has been very little unwinding of the body at this stage—it's just been a shift! The tassels are now fully flowing with speed and direction; you are now fully in the *and* part of the tempo.

The last image (C) is a rotated finish. My

traveling back as the fisherman steps forward; the whip is still traveling back as the left foot is planted. We can even see this chain of energy events unfold in a sport like the javelin throw. In the golf swing, this is the left knee's response to a shift in weight onto the left foot. Look at how all the tassels are still moving backward, yet the left knee has already started to move forward. This is the start—it's the *a* of the *and*! Practice this initiation into your

right knee has fired into my left leg, my belt line is horizontal with my stomach and chest, facing left of the target ahead. A classic way to end your swing.

Practice this drill like the images. With your arms behind your back, really sense that you get the one-*and*-two feel going as you make the change from backswing to downswing. You will now be able to transmit the energy the body has created in its wind into the tip of the club.

SO WHAT IS THE FIRST MOVE DOWN?

So What Is the First Move Down?

Somebody once said, "Walking is a fall that is under control." Technically, a good downswing is actually the same! In both walking and the downswing in golf, there is a lateral shift from the back (the right foot) to the front (left foot) into the finish.

Is this open to confusion? Well, you'd have to think so. Many actions have been used as a trigger to start down, but the question is, "What actually starts it?" Pulling the ball, spinning the left hip out of the way, sliding your knees, and trapping the ball with your chest have all been in fashion at some point. What we can say without argument is that the initiator, the instigator, the facilitator of your downswing comes from the ground upward, with the primary focus on the left foot.

I want to clear up some areas of confusion straightaway. The *firm left side* and *posting around the left leg* are two terms that you may have read about or overheard in the locker room. Both ruin the chances of golfers ever making the best first move down possible. They refer to the straightening of the left leg, which for 80 percent of golfers would lead to the loss of certain disciplines on the way to hitting the ball. The left leg should straighten, no question, but only at the very tail end of the swing.

The telltale sign that you need to focus a little more on this first move will show up in your ball flight and your contact. If you lack the ability to compress the ball into the ground, which maximizes the club and ball performance, then this image is great for you. Also, if you have a combination of scooping the ball into the air while having your weight hanging back on the right side, this will drive some new sensations your way.

If you can't seem to make this aggressive move to the left foot, you will probably have to examine the quality of your backswing—more specifically, your belt line. If your weight is on the outside of your right foot with the right hip riding high (belt line tilted), you will not be physically dynamic enough to make a good move.

Finally, I doubt you will be able to find a willing rabbit to assist you with this feeling! So just get a bag towel and put it under your left shoe. The awareness that you have something under your shoe will define exactly where you drive your weight during the transition from backswing to downswing; it will give you a direction to your movement.

The Combination Lock of a Great Follow-through

START WITH THE END IN MIND

The business and personal growth guru Stephen Covey has a great saying that basically sums up the images that follow: "Start with the end in mind."

When I was learning the golf swing, I would often hear teaching pros, usually of a certain age, say, "I would like you to just focus on your backswing and everything will be better!" Purist teachers in those days thought that if they fixed the backswing first, the follow-through would arrive! As time has passed and experience has grown, I've learned that working on the form of your follow-through can seriously influence the events that precede it.

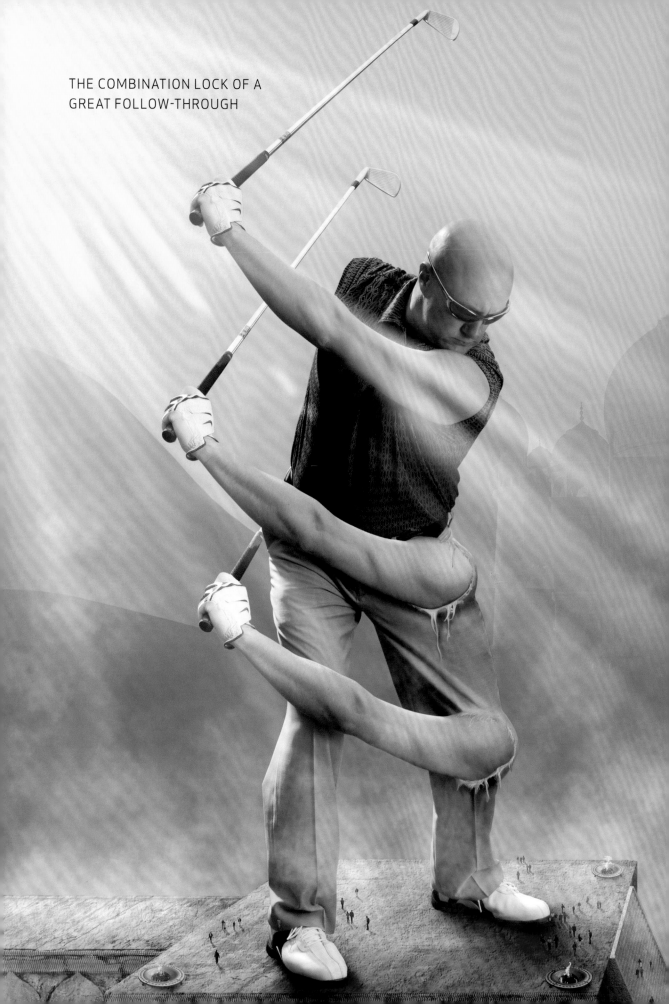

THE COMBINATION LOCK OF A
GREAT FOLLOW-THROUGH

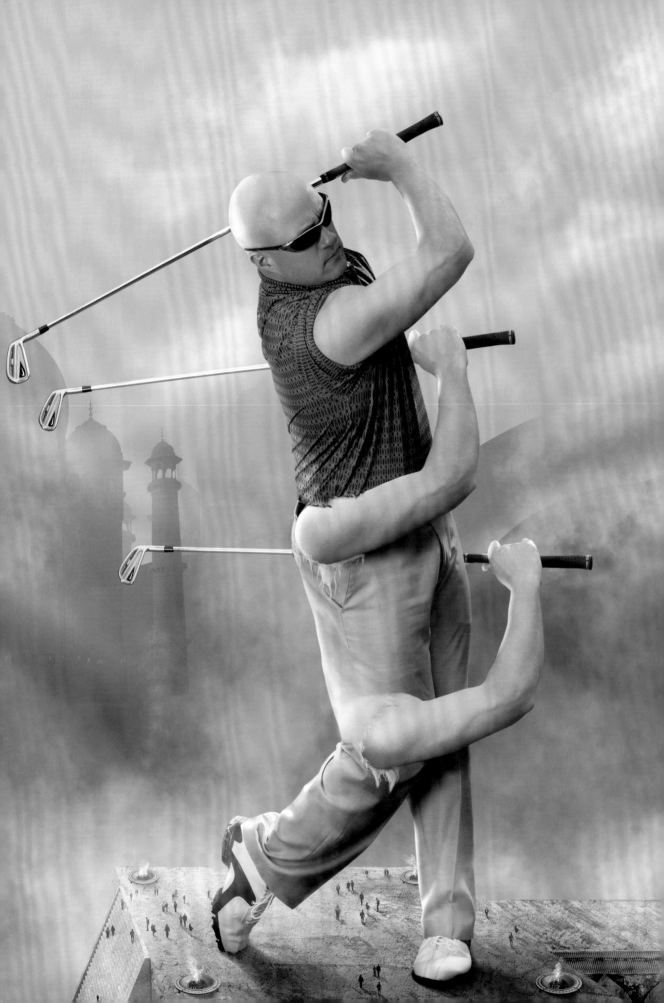

JUSTIN ROSE'S SWING BIBLE

You have two images here, one of me and the other of Justin Rose. When I first started working with Justin in May 2006, a key area that had never been properly addressed was the plane of his arms relative to his body. This is one of the pictures I created for him in what we called our bible. In reference, he could really see how the plane of the right arm in the follow-through wasn't separate from the body or something that just happened, but something consciously planed into. Using the bible consistently allowed Justin to reach his career high of sixth in the world rankings. In developing this image further, I saw how the arm-swing was relevant not just to the shoulder plane, à la Justin's picture, but to all the body planes—in particular the shoulder, hip, and knee planes. For example, you couldn't possibly have the backswing plane of Ben Hogan and then the follow-through plane of Jack Nicklaus. One is very shallow and the other very steep! Well, you could, but I wouldn't recommend it!

So how do you use this image? First, take note of how each one of the arms sits slightly above the corresponding joints. This is a desirable image and position to feel in both the backswing and the follow-through, since uniformity in motion will start to develop. If you are a golfer who makes an in, up, and over-the-top motion, then obviously your arms are all over the place in relation to your body. By simply focusing on having your arms and the club hit the same spots on each side of the swing—à la my image here—you will develop the symmetry that is evident in all efficient golf swings.

If, for some bizarre reason, I had to hit the ball with my knees, according to this image my arms-to-knees relationship would be in the perfect plane to do so. The same can be said for my hips. Relative to my hips, my arms would be in good shape to make a great pass at the ball, back and through! And so it is with the real swing. With the arms floating just above the plane of the shoulders, *on both sides of the swing*, you can see how the combination of arms and body develops a beautiful symmetry.

So work hard on the positioning of your left arm on the backswing and right arm on the follow-through. Relative to your body, they want to be mirror images of one another, back and through.

Ground-Pressured Power

If there's one word in golf that has been overused, misinterpreted, and ruinous to many players, it would be the *T* word. No, I'm not talking about *tempo*; I'm talking about *turn*.

Simply turning the body during your backswing adds very little value to the overall quality of your motion. Turning will drag the club too inside, de-sequence your swing, rob you of power, and usually have you slicing the ball within seconds. Yes, the body does

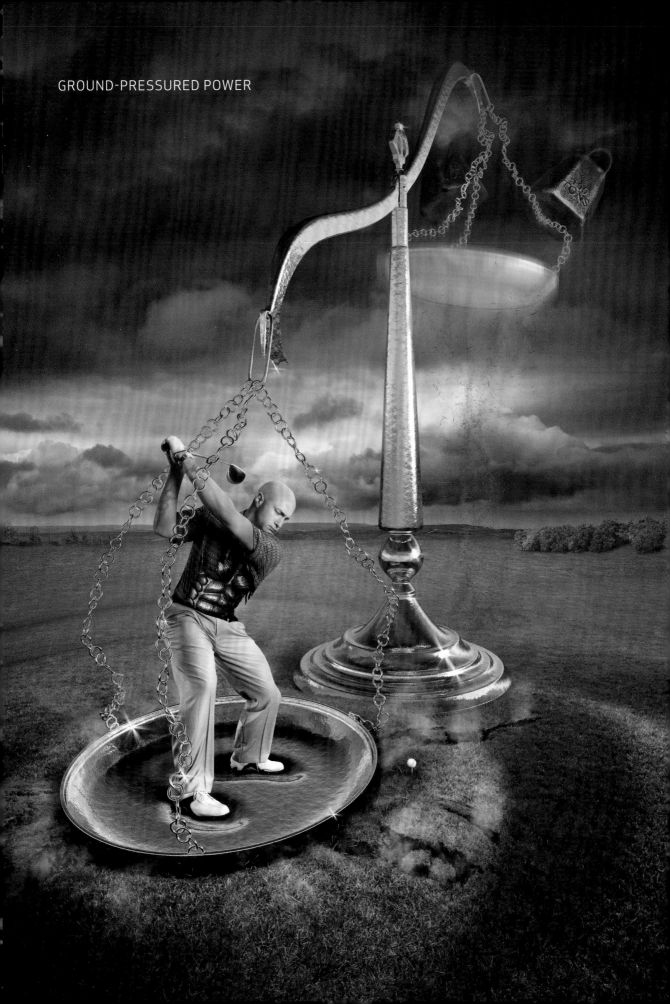

GROUND-PRESSURED POWER

turn, but it does so on the angle created by the spine at address. The turn is also governed by another *T* word, a word that is of much benefit to you as a golfer: *torque*.

Torque not only creates a boundary to your motion, it also lets you know if you are building up power at all, because if you are not—you can't feel the torque! Torque is *tension around a fixed axis.* Torque is felt first through your thighs, then your abdominals, and finally (the least subtle feeling) in your back. So where do we have to place your awareness to gain torque? The image gives you all the clues.

Your biggest source of torque buildup will be derived from the fixed platform that you stand upon every day—the ground. The ground, if used well, can be regarded as the most consistent element in your golf swing. Why? Because it doesn't move. It's always there. That's the first good reason for you to create a strong association with it in your golf swing. Secondly, because you are standing on it, you can regard it as being part of your body. You are attached to the earth from the soles of your shoes down. It is the governor of motion.

The image shows me loading up the weighing scales beneath my feet to the point where my ground-force dynamics snap the chain. By going to the ground during my backswing—a small but significant lowering of my frame as I swing back—I then recruit Mother Earth to wind the turn against, thus creating torque.

I would recommend that you kickstart your ground-pressure feeling by hitting some regular 7-irons. When you're ready, subtly sense a small compression feeling in your thighs as you make some swings. Without doing anything other than this, your clubhead speed will start to respond to the more potent stretch, coil, and torque the ground is providing you. Try it. You won't have to be a swing model to *torque up* your body!

Boundary of Your Swing

Golf is a game of precision. The clubhead sits behind the ball with the sole intention of being reunited with that exact spot again with great speed. For argument's sake let's call this sitting position behind the ball ZERO, and its corresponding impact position the very same. *Any motion that now moves the clubhead away from this ZERO position during the backswing has to be replaced in order for it to get home, back to impact and ZERO.* The more efficient your backswing, in terms of synchronization and shape, the better your chance of hitting that magic ZERO again. In contrast, the backswing that goes around the houses and on some sort of Magical Mystery Tour has little chance of rendezvousing with its original startup position. This swing to me is always in recovery mode.

This explanation alone should tell you why good players find the ball with the clubhead more often than the weekend warriors do—it simply goes back to my opening line: Golf is a game of precision.

This image gives a few boundaries that must be respected during the swinging motion of the golf club if we are to make consistent and repeatable passes at the ball. Firstly, observe the triangular aspect that lines upward from the feet to the hips. It's accurate to say that the only time it is permissible for the weight to move predominantly onto the outside of any foot during the swing—or during the short game, for that matter—is on the completion of the motion itself. In this instance it is the outside of the front foot (for right-handed players, the left foot). However, at any other time during the swing the weight would never breach the boundary

of this pyramid structure that clearly runs up and down the outside of each leg; the wind of the body should be felt to torque up within this shape, thus not jeopardizing the afore-mentioned ZERO relationship formed at the address position. So if you top the ball or hit the ground before the ball, this lower-half boundary and governor of motion is a great starting point in moving away from recovery.

Moving up to the top of the triangle, we have the head. Much has been written about the head motion during the swing, from the wrongly documented head turn of Jack Nicklaus to the compensatory actions of David Duval and Annika Sörenstam. What we can say is this: If you were to shift your head to the right (for a right-handed golfer) during your backswing, you had better shift it back to its

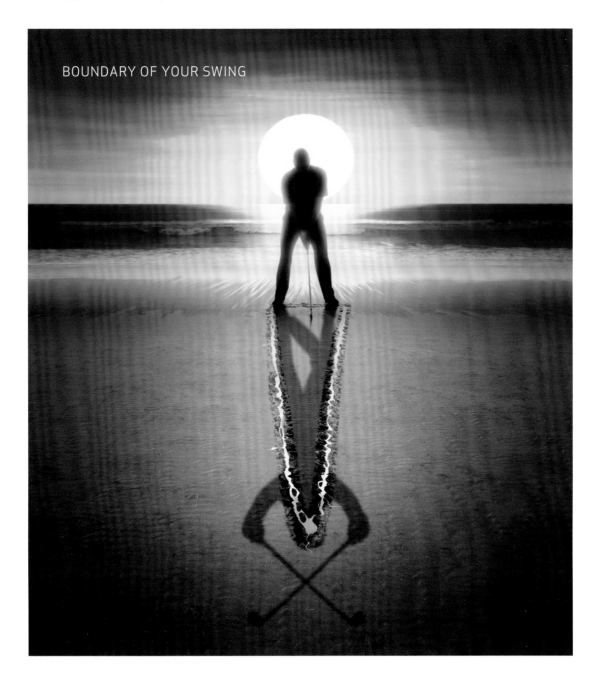

BOUNDARY OF YOUR SWING

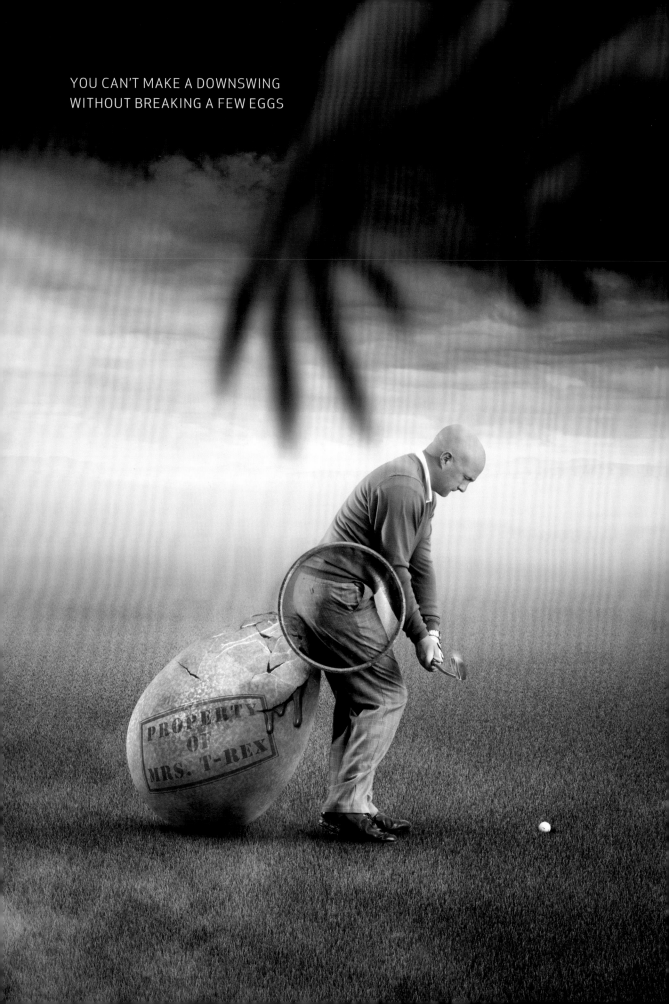

YOU CAN'T MAKE A DOWNSWING
WITHOUT BREAKING A FEW EGGS

original position by the time you get to impact. Or, alternatively, shove your knuckles forward and down at impact, since this will be the only way you can attain a strike into the back of the ball—not a great recipe for success. Conversely, you should never allow the head to move grossly ahead of its original position, either.

So between disciplining the lower body and head motion, you avoid this possible collateral damage and inconsistency from happening regularly. When you find yourself at the range or on the course, please just take a moment to close your eyes and see in your mind your head wedged into that narrow triangle at the top, where it is best to remain during your swing.

Lastly, look at the length of my armswing. You can see that there is symmetry to my motion and an efficiency of length. Ponder again the premise that we must return back to ZERO, the place where we started from, and again you will see that an armswing that flails around and travels too far will give you little chance of returning the club back to impact. The good news is that if the body and the head are disciplined within the pyramid structure, then the arms also have a great chance of being schooled into a disciplined motion themselves.

Set these basic boundary rules for your golf swing and, in doing so, ZERO out the need for recovery in your technique.

You Can't Make a Downswing Without Breaking a Few Eggs

The change of direction from backswing to downswing has been called many things, but I believe Ben Hogan had it right in his first book, *Power Golf*, when he said that the downswing is like a crossroads: You either make the correct turn or you don't. The golf swing is just a sequence of events, good or bad. This is the crossroads!

I'm sure that many of you have the Ben Hogan book *Five Lessons* tucked away in your collection somewhere. In it, Hogan gives a very clear description of how he felt his downswing and yours should look and maneuver, starting down and through the ball. Like several aspects of Hogan's book, this section was written very much with his feel in mind. Hogan started his career mainly as a drawer/ hooker of the golf ball; his swing was incredibly long, with tremendous lead lag resulting in a hanging-back of his body, waiting for the clubhead to play catch-up. Anytime you hook the ball, there has been more tilt and pitch with the body than there has been rotation. This is why Hogan was such an advocate of turning the hips aggressively through the impact area. He wanted to feel pure rotation with no feeling of being underneath the shot at all. So were Hogan's feelings true to his actual motion? The answer is . . . not entirely. Before Hogan rotated his midsection through the shot, a move he suggests happened immediately, he went what I now term "down three floors"; this is what you see in the image.

Hogan's downswing suggestion isn't good for everyone; in fact, it isn't good for the majority. Since most golfers have a slicing profile, any form of early rotation exacerbates the slice they already have. So turning and spinning the hips as your first move down will be anything *but* an antislice move in your golf swing.

What *will* help anybody with a slicing profile is having the body go "down three floors," which is what Hogan really did during his downswing. This image of me sitting on the egg as I start my downswing really captures

the sensation you must acquire *before* you start to turn the hips out of the way. Go online and look at these golfers: Moe Norman, Tiger Woods, Jack Nicklaus, Ben Hogan, Vijay Singh, Gary Player, and Christy O'Connor. All are considered among the best ball-strikers in the game. Stick an egg under where the sun don't shine with these guys, and they would crack it wide open, too!

GOOD BODY MOTION IS
SHEER MAGNETISM

Good Body Motion Is Sheer Magnetism

The genesis of this image came from coaching women golfers in my formative years. I was always fascinated as to why women golfers had an increased tendency to tilt their hips during the backswing. This, coupled with the palmy grips they always seemed to show up with, didn't bode well for a power-hitting session! Women's hips are generally wider than men's, so in coaching women we must always be on the lookout for this naturally induced golf swing fault. But the rocking and tilting of the hips also happens with men. Fortunately, in both cases the remedy is the same.

The first area I'd like you to look at, if you feel or have been told you are what John Jacobs used to call a "rocker and blocker," is the width of your stance. When the space between your feet is narrower than the points of your hips, you are asking for trouble. Since a narrow stance creates no boundary for the stomach to rotate inside, it's highly likely that a sway will develop, since the weight is already on the *outside* of each foot. So the first criterion is to build a stance that looks rather like the Eiffel Tower—wider at the bottom than it is in the middle and the top. As a general rule

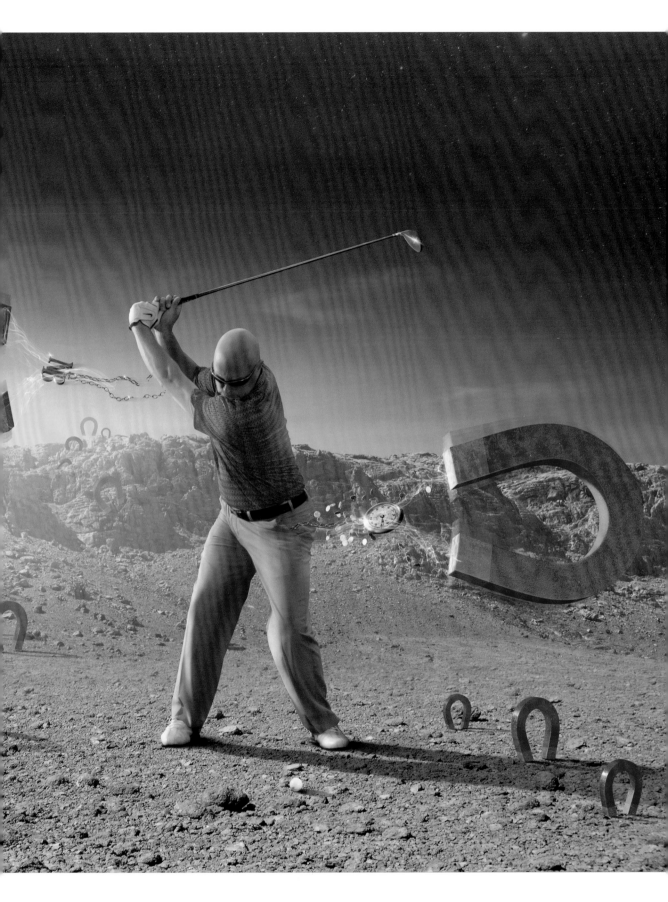

of thumb, have the *middle* of each foot hanging directly under the hip joints for any full shot, and then gradually widen until you reach the driver.

Now that you have your stance foundation cast, we can start to move with discipline inside it. When a golfer tilts, it's as though the upper and lower halves are glued together. This is an oversimplification, but when you tilt, every part of your body sways laterally to the right from the navel—there is *no* disassociation between the upper and lower parts of the body when a sway occurs. It's as if somebody pushes your hips from the side and your midsection buckles sideways.

Creating disassociation in the golf swing is essential. The stretch and the wind you see in this picture have come about through my moving my body in two different directions. This is the *ultimate* way to eradicate any form of destructive tilt. Great exemplars of this lower and upper body separation are Nick Faldo, Tiger Woods, Moe Norman, and Padraig Harrington. All of them demonstrate this slight pulling in different directions of the lower and upper body, which sets up the all-important kinematic sequence vital to timing and power. In the case of Nick Faldo, an over-turning issue with too much disassociation between his upper and lower body later became a fault on which he had to keep his eye.

So if you're rocking and blocking the ball out to the right, hitting fat, smothered shots that go dead left, or, more important, your back is hurting, then start to blend this upper-lower body separation into your swing with the help of this image. Feelwise, your backside errs toward the target and your chest shadows over your right thigh.

Athletic Foot Grounding and Dynamic Balance

Next to *turn*, *balance* is probably the most overused and mysterious term in golf. Where does balance go? Where does it come from and when does the balance shift? No, they tell you—"You just have to have BALANCE!" Balance isn't static. Well, not in the golf swing, anyway. Balance is what you need on a unicycle, walking the plank, or spinning plates in the circus. The balance we need during motion is dynamic balance. Michael Jackson had good balance, but it was constantly adjusting to the way he danced. What came first, though? Was it the way he moved his body that dictated the balance patterns of his feet, or did he learn from the ground upward, setting the

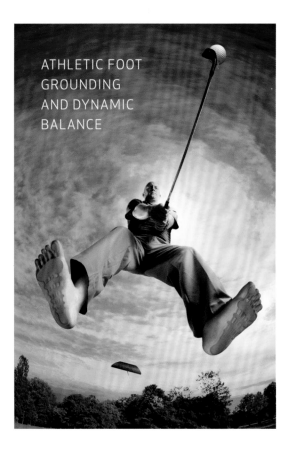

ATHLETIC FOOT
GROUNDING
AND DYNAMIC
BALANCE

parameters within which his body was allowed to move? The same question can be asked of the golf swing: What comes first? The disciplined body motion or the fancy footwork? In a nutshell, if the feet set the rules, the body has to follow.

If you have been guilty of undisciplined body motion, then working to these patterns of dynamic footwork will certainly give you new feelings of power and control. Modern golf shoe design reflects how foot grounding is a critical element in the transference of power from the ground to the clubhead. One of the first golf tip books I ever read was by Gary Player, who wrote many times about "golf swing power leaks," citing aspects such as letting go less of the club at the top of your swing as examples. By learning the balance patterns you see here, you will not only minimize the chance of your own power leak (weight

moving to the outside of the right foot during the backswing is the killer!); you will also recruit some serious ground-force dynamics.

It's the body's center of gravity (COG) we are trying to control here. We don't need your COG floating around everywhere as you're trying to hit the golf ball—that's like rearranging the deck chairs on the *Titanic* as it's going down. The COG in your swing should not move a great deal—in fact, if you take a look at the COG pattern in the image, it pretty much stays on the insides of each foot. This is how Jack Nicklaus was originally taught footwork by legendary teacher Jack Grout. Nicklaus was schooled from the age of ten always to swing from the insides of his feet, never to the outsides. You can see from the pattern of movement here that good COG moves in a radial, almost semicircular, pattern from the balls of the feet to the right inside heel, back to the

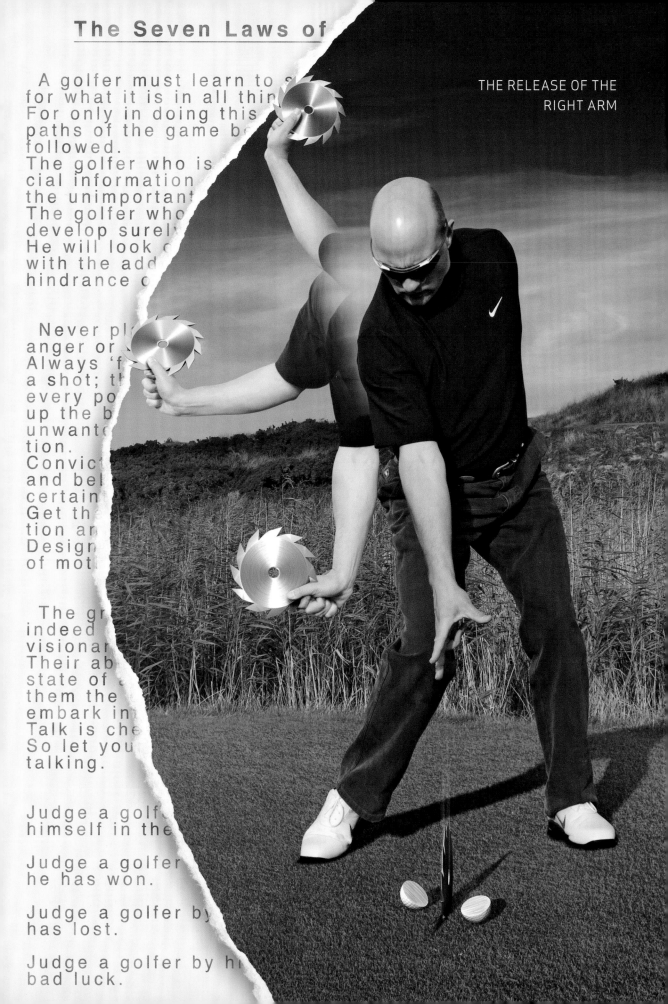

The Seven Laws of

A golfer must learn to s
for what it is in all thin
For only in doing this
paths of the game b
followed.
The golfer who is
cial information
the unimportant
The golfer who
develop surely
He will look
with the add
hindrance o

Never pl
anger or
Always 'f
a shot; t
every po
up the b
unwant
tion.
Convict
and bel
certain
Get th
tion ar
Design
of mot

The gr
indeed
visionar
Their ab
state of
them the
embark i
Talk is ch
So let you
talking.

Judge a golf
himself in the

Judge a golfer
he has won.

Judge a golfer by
has lost.

Judge a golfer by h
bad luck.

THE RELEASE OF THE
RIGHT ARM

balls of the feet, and then to the inside of the left heel. You could say that just as the club travels on an arc around your body, so does your COG, but *within* the boundary of your stance.

Grab a wedge and make some swings, focusing on the soles of your feet. It would be a good idea to close your eyes as you do this, to gain a heightened awareness of feel. Picture the pads of your feet lighting up just like the ones in the images on pages 144–45 as you move through your backswing and downswing. Keeping your eyes closed, sense the relationship between your upper body motion, as your swing is working, and the movement of weight within your stance. They are not separate; they work together.

The discipline the feet provide is built upon their relationship with the ground you stand on. That discipline gives your body permission to wind and unwind with speed and control.

THE CLUB, THE ARMS, AND THE HANDS

The Release of the Right Arm

Consider this: Looking at a golfer face-on, like the image you see before you, the club would be sitting at 90 degrees to the ground, straight up at twelve o'clock. Even if the club is offset (head set behind the shaft), the shaft still sits at 90 degrees. This is the natural design of the clubhead/shaft, the way they want to sit at address. In this position the bounce (sole) of the club can work, and the authentic loft of the club is presented to the ball at address and then again at impact. Forget any notion of consciously pushing the hands ahead of the ball at address or during impact to create compression on the ball. The compression you are after arrives through body positioning, the load/unload of the shaft, and an unconscious, reflexive positioning of the hands relative to the ball. Starting the shaft at 90 degrees, and then returning it to 90 degrees from face-on, will seriously improve the profile of your ball flight.

How does the role of the right arm fit into this need to start and return to the same point? Well, more specifically than the right arm, we are talking about its corresponding wrist and elbow joints. Picture a baseball pitcher loading up his arm by closing up those joints and then releasing them fully to the point of letting go: The joints close (fold), then they open again (unfold). Boxers and karate fighters also draw the hitting arm back, closing down the elbow joint and wrist joint to fully extend and release the leverage created. This isn't just about the joints, of course; it's about the stretch/release of the ligaments and the recruitment of the responding surrounding muscles. All I need you to appreciate is that those right arm joints close and open again during the backswing and downswing motion.

What are you like throwing a ball with your weak arm? If you're like me, getting it out of your shadow is a problem. That whole ineptness is born from the weak arm's inability to reopen as you try to release your throw. The body lunges, the arm stalls, and both distance and direction are pathetically lost! If you slice, your right arm probably works in the same way: While everything else unwinds and starts to release into the ball, your right arm remains in its closed and folded position.

Like the weak-arm throw, your right arm gets jammed and trapped behind your body and comes over the top with no speed whatsoever to offer the ball. So if you are a slicer, you need to sense your right hand bleeding away from the right shoulder ASAP in the downswing. Look at the image and see how the right arm gets longer and expands from the top of the swing. It's releasing and unfolding, in turn creating the *free armswing* that you need to get speed, and thus a better direction to your downswing.

How does this closing and opening of the joints relate to the chapter heading on the previous page? For the better player it is more the unloading of the right wrist, rather than the elbow joint, that will be important. Because better players will create a more dynamic motion during their swings, a characteristic called lag will be evident during their downswings. Lag is literally when the club lags behind the body turn, creating huge leverage between the shaft and the right wrist. The problem arises for the better players, however, when the lag created is not unloaded at the time of impact. This means that the 90-degree shaft angle they formed at address (with the correct loft on and the right amount of bounce presented to the turf) will not be present at impact. Instead, better golfers will have the handle of the golf club way forward of the head with the right wrist fully hinged back on itself. The club is therefore de-lofted, the ball flight will be low-launch, high-spin, and the leading edge now becomes a digging implement.

If you are a better player experiencing inconsistent trajectories, poor distance control, and exaggerated sidespin, it's highly likely that you really need to focus on opening out the right elbow and wrist during your downswing and getting that shaft back to

its original position of 90 degrees. You will always have lag and leverage, so do not be fearful of losing this advantage. The point is that you have to release the club, all of it, by the time you reach impact. Even Ben Hogan, with his double-jointed thumbs and tremendous dynamic lag, had the club back to its original starting point. Working the right arm down and widening it lets the release of the club happen with an increasing force that builds and crescendos at impact. Much of the work I did getting Kevin Chappell onto the PGA Tour was in lag reduction. On his first visit to me he warmed up through the bag, eventually starting to hit his 5-iron. When I asked whether he was trying to hit the ball on all of those different trajectories, he realized the effect of his hyperlagged delivery into the back of the ball.

The hyperlagged release explodes into the back of the ball with an inconsistency that can spin it a hundred different ways. That's why the long-driving champions are great at what they do, but sadly not great at golf!

Releasing the right arm during the downswing has the rare distinction of really benefiting both the good players and the bad. For one golfer it stops the slice; for the other it stops the spin!

The Feeling of Mid-Plane in the Club and the Arms

There is a great video clip of Ben Hogan appearing on *The Ed Sullivan Show*, in which he gives the American audience a very solid three-minute golf lesson. He also, uncharacteristically, mocks Ed Sullivan's swing by producing a rather comedic impression of it! The

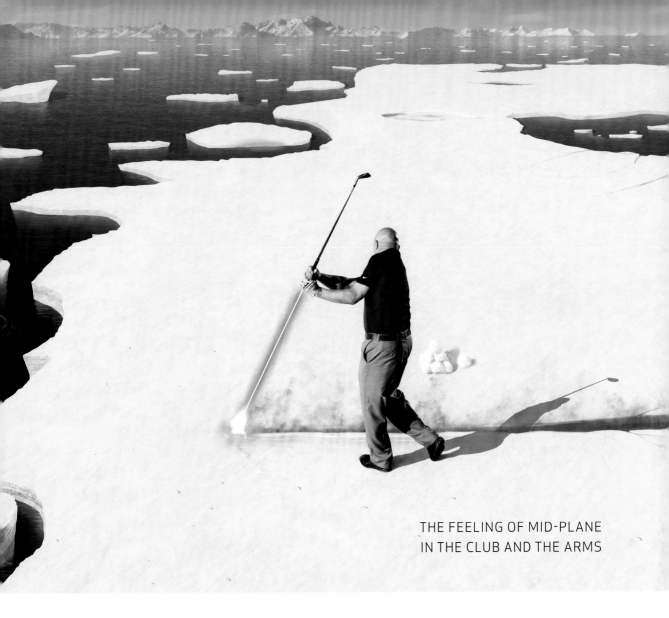

lesson Hogan gave is the image you see before you. He addressed the audience and showed them the basis of motion in the golf swing and how, after only a relatively short period of time, you could develop an action that resembled a powerful and neat-looking golf swing. He did this by making a small backswing and through-swing while keeping his upper arms joined to his torso, effectively his rib cage. As he continued, the club started to naturally hinge and rehinge around his body, creating some swish and speed in the motion; it now started to look like a golf swing. Finally, as he grew his motion, the upper arms started to slightly separate from the body until you had

the full-blown Hogan golf swing so admired in the world of golf. It was such a simple process that followed most of the natural laws of a solid, repeatable golf swing that it was bound to be effective. It kept the armswing close to the center of gravity, and it had the club hinging and rehinging, promoting good positioning through good synchronization. Easy!

In general, golf swings are becoming smaller and faster than they were some time ago. In fact, smaller swings have made a comeback. Just take a look at the swings of Bobby Jones, Gene Sarazen, Byron Nelson, and of course Ben Hogan—all were compact, small, fast wheels around the body. Then Jack

Nicklaus came along. Jack's arms were short relative to his height and body size. Also, given that his torso was a little on the large side, he sometimes had to create space for his arms to swing during his backswing. Jack went wide from the start, floated his right arm, and lifted his plane steeper than most would do. He was strong, though, very strong! Interestingly, Jack's worst year on Tour was 1979. At this stage he was lighter than he had been in the 1960s. The reason for his poor play? Lifting his arms way above his plane and getting too steep and disconnected from his torso, something that he didn't have to do with his tidier frame. After he and Jack Grout ironed this out in 1980, Nicklaus went on to win the U.S. Open and the PGA Championship. During the 1960s, many people who had neither the build nor the strength or talent to make it work as effectively copied Jack's example. Nick Faldo reintroduced and popularized the arms-to-body tie-in as he successfully (to the tune of six majors!) went from the wide Jack model to more of a Hogan method. And then, of course, there was Tiger Woods. Where was his action in the grand scheme of things? Well, Tiger actually followed Faldo's journey. Tiger was hugely influenced by Jack's career, so it's no surprise that when he first hit the Tour his action was wide, cross-line, and shut at the top—it was cross-line and shut, as opposed to Jack's action, because Tiger has much longer arms! Tiger's swing now doesn't resemble his 1997 Masters-winning swing at all, other than that it's the same person. Tiger has gone to the body as Hogan and Faldo did before him.

Look at the image here and copy it. See how the upper arms have hinged and folded into the body on both sides of the swing. As the swing lengthens beyond this point, the arms will break away from the torso, giving you that stretch to the top you need, coupled with good

arm plane. Start off like Hogan, make some swings in the garden or yard, and just have the arms hinging and folding, letting the body motion respond in tandem. Allow the wrists to freely hinge back and rehinge on the way through as you build and grow your motion. Listen for the swish, too; you will recruit good leverage when you do this. It's the motion from which every good armswing is born.

The Radius of the Swing

Let's get this clear from the start. There is a huge difference between the swing *radius* and the swing *arc*. This huge difference is simple: They are not the same thing! The swing's arc is the channel or pattern the clubhead scribes

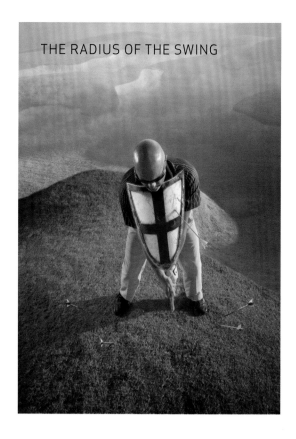

THE RADIUS OF THE SWING

during the swing. A swing arc can be narrow, wide, or conceptually uniform. It's basically a 3-D circle that is drawn by the clubhead in motion. The swing's radius does not refer to the clubhead at all; it refers to the armswing. More specifically and basically: It is the maintenance of the triangle (the shield) formed by the arms, shoulders, and hands. Fortunately, the images below reduce the concept to one simple form.

When standing to the ball correctly, the hands should hang directly under the breast-bone or in between the two shoulder joints. Either of these will be correct—in doing this you have created the radius of the swing. In a perfect world, this formation between the arms and the shoulders would not vary during the swing's motion. Since it is primarily the wrist action during the swing that generates *leverage* and thus its *angular momentum*, the radius really can take on the position of a static constant; it's a controller, not a provider of power.

Take a look at these images. They will give you a great visual to work from. Incidentally, there are many great radius swings on Tour, but in particular look for Steve Webster on the European Tour. Steve is only about 5 feet, 7 inches tall, but pound for pound is one of the longest players on Tour. Since the radius of Steve's swing is very controlled, the huge amount of leverage he employs during his swing is housed and harnessed beautifully within the radius. If you have been guilty of altering your radius during your swing, you will also notice a dramatic improvement in your wedge distance control when this aspect is worked on. Since controlling your wedge distances well requires a harmonious relationship between body and club, working on this feel using the images before you will really improve your performance from short range.

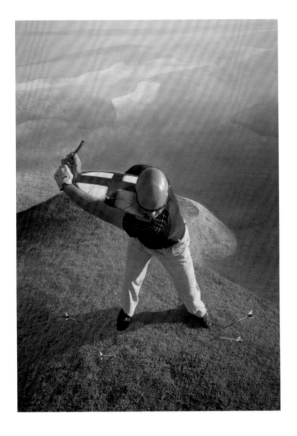
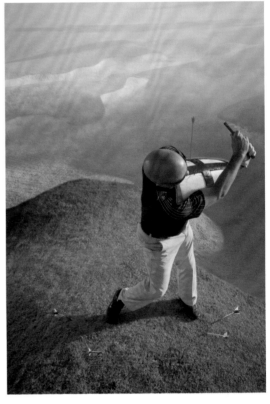

Swing Synchronization

GREAT CIRCLES OF FIRE

If you're a golfer who finds yourself very position-oriented, yet can't seem to find the shape you desire, you may be putting the cart before the horse. Trying to position the club at various stages of the swing *without* syncing up your motion is liable to cause you frustration. It's like constantly adjusting the hands on a watch face in hopes that they will point to the right place at the right time whenever you look! The golf swing is the same. You can't just position your way through motion, you have to *swing* through it.

Good positions throughout the swing manifest themselves when certain elements are working in the correct order. The hands on your watch only point toward the right numbers (positions!) because the insides of the watch are syncing up together; positions are vanity—syncing up is sanity!

My image here gives you the easiest and simplest way to visualize and work on your sync. It's a smallish, uniform circle scribed around the body. Interestingly, you will almost always feel a shift in the rhythm of your swing when you work on this sync. In *The 7 Laws of the Golf Swing*, I talked about the ratios of the backswing and downswing speeds; in that section I noted how the best

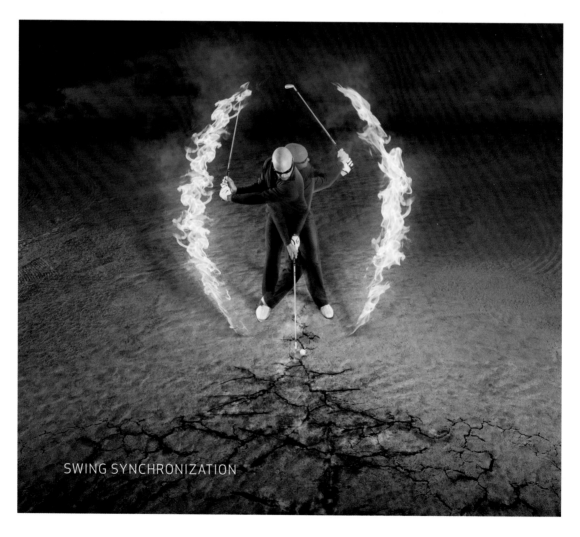

SWING SYNCHRONIZATION

swings showed a pattern that kept both sides of the swing closely knitted together, in terms of tempo. For example and hypothetically, it would be erroneous to have a backswing that moved at 20 mph and a downswing that moved at 95; the change of direction and control would be off the charts. But time and time again you hear golfers saying, "If only I could slow down my backswing!" No, buddy, you have to speed it up, because then your downswing won't feel as if you've just been shot in the back!

Sync has to do with tempo and rhythm, too. Getting slightly more technical: The clubhead has on average about nine feet to cover during the backswing move, with probably another twelve through the downswing and finish positions. The shoulders probably have proportionate distances, but in *inches*, the hips even less, and the knees virtually zero. So you start to appreciate that if everything moved at the same speed, the body would finish its backswing way before the club even got halfway. This is fuel to the fire for any slicer. Therefore, as a very simple rule: See the clubhead orbiting faster around your body than the body moves itself. Or, visualize the clubhead moving at 100 mph and the torso at 30 mph.

Either way, you'll start to light up those positions you've always wanted in your swing!

Drag It, Lag It, WHACK IT!

Lag is without question the invisible crown jewel of the golf swing. Invisible? Yes, because the ingredients needed to obtain lag are invisible to the naked eye; all you do is see the

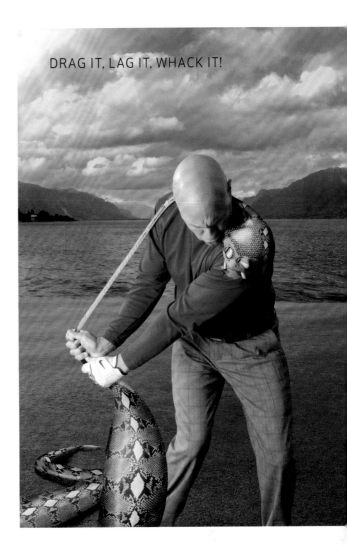

DRAG IT, LAG IT, WHACK IT!

motion, hear the ball, and watch its powerful flight. Quite how it's done is often a mystery!

In describing lag, I would say that it is a power accumulator. When you have it, you can turn up the volume of your swing to the power of ten. Lag turns you from Bruce Banner to the Hulk, from Clark Kent to Superman. So I'm guessing you're wanting to know how to get it now, aren't you?

When the club lags, you reduce the angle between the left forearm and the shaft; lag is increased leverage, nothing else! It's similar to holding a plastic ruler and bringing both ends together so it really bends in the middle; the closer you get these ends together, the more it will become spring-loaded and repel outward

faster. This analogy couldn't be any closer to the reality of lag in the golf swing. The image (p. 153) also gives you the visual cue you need in keeping the shaft (or the snake) close to the right shoulder during the downswing. So what's the secret?

The secret to gaining lag is invisible because its presence is largely created through your physiology. It's not a position, it's an ingredient within you that creates a position. The golf club has two states. One state is when it is still at address; this is referred to as its *dead weight*—it's not moving. The other state is called its *swing weight*—it *is* moving. When we increase the club's swing weight, we create the effect of lag and gain that extra leverage; the ruler analogy is in full effect.

Okay—here's the secret sauce! To increase or decrease the club's swing weight, you merely have to adjust your grip pressure accordingly. Sergio García's swing pattern goes wide and tight on the way back but narrow and slack on the way down. So do Vijay Singh's, Bubba Watson's, and Kevin Chappell's swings; all these guys move it out there! Through having soft and slack grip pressure, the club takes on a heavier state. Try it! Conversely, if you strangle the thing and bend the shaft under the grip, the club will feel extremely light, and thus you will throw or cast it out during your downswing.

The place to train lag is on the chipping green. Simply take a 9-iron and start to make a chipping action with your awareness firmly focused on your grip pressure. To *overdose* lag and really get a feel for it, have your grip pressure so slack that you drag the handle back first, leaving the clubhead at the ball for a second. Then, as you start down, create that same feeling of the handle of the club leading all the way. For some of you, this may feel a little out of control, especially if you have been

controlling the club through a tight, viselike grip. You will immediately experience a new kind of pop from the clubface, as though there is more behind the ball than usual. Take these baby steps first and then graduate slowly into your full motion.

Decrease your grip pressure and increase your lag leverage; it's all in the wrist, you know!

Disciplining Your Armswing at the Top

To coach a Tour player at an event, you ultimately have to know what that player is looking for. In twenty years of coaching these guys (and gals), I can boil it down to three basic needs. The first and most obvious is that your recommendation must be effective. The second is that it be easy to use, and last, you must be able to make them feel or picture it. It has to be a large and *tangible* sensation/image.

The toughest and most *intangible* playing thoughts/images/feelings are nearly always directed at the arms and the hands. Trying to guide these babies through your backswing and downswing is tough—you can move your arms okay, but you're not 100 percent sure of where they are and where they are going. That's why they are best thought about and trained *away* from the golf course and trusted to behave when playing. Incidentally, the most tangible images/feelings you can play with are nearly always body- and torso-focused, since the brain can distinguish the bigger mass over the smaller mass more easily.

Controlling the space between your elbows during the backswing and downswing is a very simple way of inducing the most basic

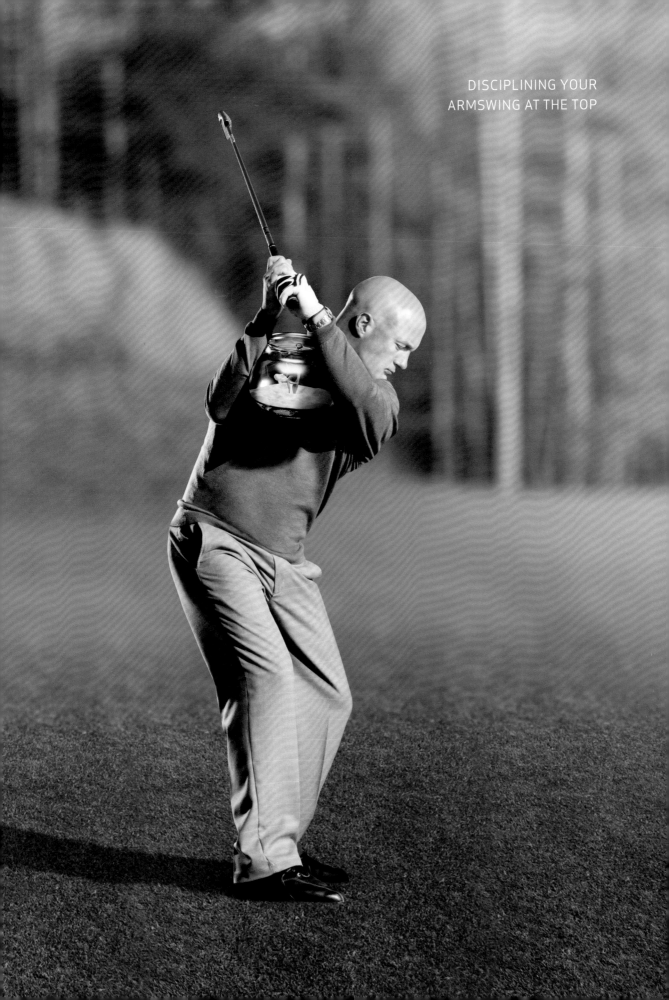

LIBERATE THE MOTION
OF THE CLUB

good form to your arms. If you take it that at the address position your elbows are roughly twelve inches apart, a nice consistency to strive for would be maintenance of this relationship through the swing motion. The reality of this will be a little different, owing to the forces that are imposed on the arms by the speed of the swing, but as a goal or an ideal it is nonetheless a wholesome one.

It may prove a little impractical for you to use a fishbowl, so I would recommend a partially inflated balloon or a small Nerf (foam) ball. Simply wedge it between your arms at address and then make some swings; you will soon know if you have been guilty of an inconsistency with your armswing at the top, since you will either let the balloon or ball go (elbows getting wider) or you will initially feel physically challenged. Through just a small number of repetitions, you will gain a neater feeling, a neater pattern, and a better look of your arms at the top.

Two notes: First, look at the image and observe how the right forearm is at the same incline as the spine, and second, see how my elbows and the butt of the club create a triangle that is in balance, as opposed to being tilted one way or the other. These two reference points will give you vital clues to the quality of your backswing move.

Liberate the Motion of the Club

I conducted an experiment recently in which I took four people who had never touched a golf club before and in four weeks had them looking as if they had played for ten years. A critical aspect was to give the budding golfers

mental permission for the freedom that is facilitated through good motion and technique. What do I mean by this? If you look at the majority of golf instruction, most of it is *don't*-oriented. A "Don't do that or this will happen" sort of conversation is quite common on practice areas all around the world. And so instead of a flowing athletic motion with a clear directive, the beginner often ends up looking pokey, static, and wooden because of this avoidance concern.

When I think of a golfer who has totally liberated the club during the swing, I think of the 2009 Masters champion, Ángel Cabrera. His hub (torso) stays relatively still, while his arms work around his body like two pieces of cooked spaghetti. The clubhead speed he generates with this action derives from the fact that his physiology is not tight; it's supple and fast-moving. Think of it like this: The arms can either resemble a towel or a whip that can crack the clubhead at velocity, or they can resemble two pool cues—heavy and cumbersome.

This image will liberate your golf swing. By simply touching each shoulder with the shaft of the club on both sides of the swing, your physiology will *have to* adopt a much softer and thus speedier state. Your initial response to this (especially if your tendency is to overcontrol the club) will be an uncomfortable sense of letting go, as if you have just switched to autopilot. This is fine and should be embraced! The black belt of the drill is allowing the shaft to bounce from each shoulder joint, just like what the image is showing you, while generating a loud, audible *swish* at the bottom! Also, don't be afraid of the left arm bending a little. Like Cabrera, you will gain an extra lever and increase—not diminish—your capacity for speed. More power to the elbow!

KINETIC GOLF

THE PUCK RELEASE

The Puck Release

The "puck release" is a term and clarification that I introduced to simplify and communicate the correct way the clubface should be felt through the ball after impact. It matters not whether you look at Ben Hogan, Nick Faldo, Jack Nicklaus, Tiger Woods, or Colin Montgomerie—you will see the puck release used. For some, this explanation has caused controversy, since in many pictures of top professionals at impact, the left wrist bone appears to be slightly high and bowed. Let us understand that the upwardly bowed position the left wrist assumes at impact is a *reflexive* occurrence as the body prepares itself to impact something. You wouldn't hit a punching bag with a floppy wrist, would you? The body would *instinctively* clench the hand to prevent any injury from its impact with the bag; the same reaction is seen again as we hit the golf ball. So this pronated position is never something you have to work on. In fact, trying to create it only reduces your swing speed and induces cartilage issues. Ben Hogan wrote in *Five Lessons* that he wished he had three right hands through the impact area. This quote should have received a bit more attention than it did, since it really does expose the truth behind the real release of the clubhead post-impact. Jack Nicklaus has also said that all he wanted to do during the downswing was to "fully release" the clubhead through the ball. So I guess this doesn't mean consciously arching the left wrist at impact, then!

Let me ask you a question. Would you ever, when hitting a golf ball, try to deliberately hold the clubface open so that it pointed right of the target at impact? I'm guessing a resounding "*No!*" is forming in your mind! In that case, why would you try to turn the clubface over so that it pointed left of the target?

Yet this is the way many golfers perceive a release: a spinning over and turning of the clubface through impact. Neither of these is correct, of course. Let me ask you one more question. Would you prefer a release that kept the clubface square to the plane and arc for the longest period, didn't deny you speed and power, and returned the proper loft back onto the club at impact? Hard to pass up, isn't it?

The initial reaction to the puck release is that it looks like a scoop! Technically, you can only scoop the ball if your COG (sternum) backs away from the target at impact. You can scoop chips, bunker shots, putts—in fact, *any* shot in golf can be scooped by backing away from the target.

Conduct a small experiment the next time you are at your range. Take a 9-iron and make some practice swings using your right hand and arm only; grip down the club a little to make this a bit easier, too. Initially have the club in motion using a small swish of the shaft in front of you, nothing more than what you would consider a chipping action. As you do this, start to feel the right palm working slightly skyward at impact and beyond. When you have that motion down (you will feel that Hogan was right in how much you can really swish the clubhead fast), place a ball down, and start hitting in the same fashion. Maintain the sensation of the puck and you will see how the ball flight takes on a very consistent pattern—it won't really start right or left of your target, and its sidespin will be virtually gone. Having a passive clubface through impact and beyond is critical, since the clubface is 85 percent responsible for all directional influence on the ball. Yes, 85 percent! If you get the concept of clubface control wrong through impact, you're going to make some *big* numbers.

Use the image to foster the feeling of pucking through the ball. Use your chipping action to train and develop your feel around it. If we want the clubface to remain square to the arc of the swing, there is no finer way than to puck hard through impact, just like Hogan and Nicklaus before you.

The Club's Initial Path and Motion from the Ball

A significant percentage of the quality found in the initial move away from the ball is mainly setup influence. Any indiscretion in these early stages can usually be traced to the grip, arm configuration, or posture over the ball. Strong grips tend to roll the club early, weak grips tend to drag. With the weight too far forward, it's likely the club will shoot inside; with the weight back on the heels, the swing will counterbalance and lift the shaft high and away to the outside. You can see that attention must be paid (as always) to your form over the ball. So assuming you have this in check, let's look at the clubhead's first move away and how it should feel.

I hope the image conveys a couple of simple messages. As you can see, there is no sweeping motion inside that would scribe an aggressive backswing arc—a mistake made by many slicers in the belief that this will assist them in delivering from the inside. And conversely, the club doesn't lift away to the outside, ruining any good relationship the arms may have had with the body at address. So use the image and create a gentle arc back from the ball—best initiated by the body, arms, and club working in unison.

Finally, it will do you no harm at all to hit a few chips with this image working for you. Why

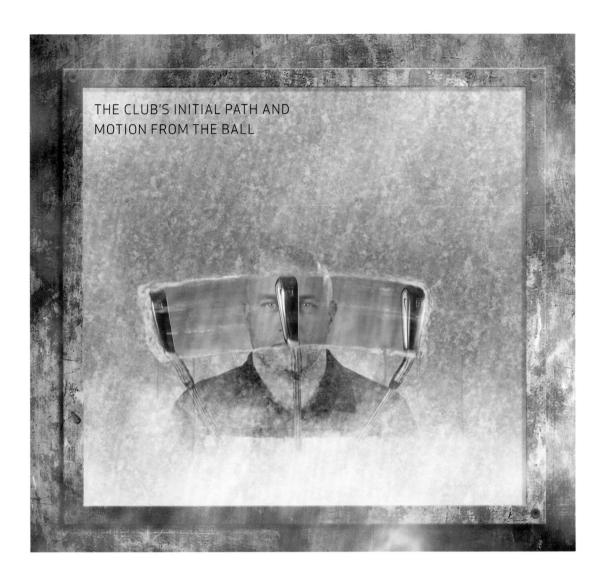

THE CLUB'S INITIAL PATH AND
MOTION FROM THE BALL

not practice the full swing's initial start away while working on your short game? They are inextricably linked and are virtually the same anyway! A gentle arc, not an aggressive curve!

To Invert Your Mid-Plane

I was once asked by a plane-obsessed instructor at the Orlando Golf Show whether I believed in a "one-planed" or a "two-planed" golf swing. "Neither," I said, "just *on*-plane."

On-plane refers to many things in the golf swing, but if we are just referring to an on-plane golf club, then we mean its position relative to the ball and to the working planes of the body (shoulders, hips, knees). I don't like the phrase *on-plane*, anyway; it should be *linear-planed*. All swings that demonstrate great club plane have been linear relative to the other, more dominant planes. The dominant planes are the torso planes, because unless the torso planes are consistent during the swing (they are the bigger mass!), the club itself will have little chance of orbiting consistently around the body. If you want good club plane, start with the body.

TO INVERT YOUR MID-PLANE

If you suspect your backswing plane is too flat, then you need to look at this image. Normally caused by a faulty grip, a flat and deep backswing will be rolled away from the ball, where the hands blow outward, toward the toes, and the shaft and the clubhead scoot inward and behind the heels. (Raymond Floyd's swing is a perfect example of this tendency—you can view his swing on YouTube.) Complicated, eh? I call this a convex backswing because it's too rounded, curved, and arced.

To invert your backswing plane from the one described above, we need to focus on the relationship between the clubhead and the handle of the club. Look at the image and see how I'm maintaining the initial relationship of the clubhead and the handle as it was *set down at the address*. I'm moving that handle back and keeping the clubhead *outside* the grip of the club until at least belt height.

Bodywise, your focus is firmly placed onto the left arm and the glove hand. Both will feel *underneath*, as if they are turning under your shoulders as you look down. Your left biceps will feel a lot closer to the left pectoral muscle, while the glove and the handle of the club will have almost a dragged-inside sensation—as though they were moving toward the right pocket. The benefits of this feel and image will be found in a clubface that won't spin and roll from your swing's arc in a heartbeat: a more stable relationship between the clubhead and the rest of the club. And, finally, your plane and arc will contain fewer variables; the swing will feel lighter, balanced, and smaller.

Remember, everything and anything in the golf swing can be overdone or never experienced; while this may feel like an exaggerated move, it's probably just bringing you back to neutral!

To Rotate and Round Off Your Initial Plane

Jim Furyk joined the PGA Tour in 1994. It's fair to say that when he did, he created quite a stir, not because he won precociously early, but because his swing was probably the most idiosyncratic action since Irishman Eamonn Darcy graced the fairways. People—and indeed many pros—were at a loss for words in trying to describe how the clubhead ever got back to the ball after it tracked a route that went farther than most of us go on vacation! The interesting point to make here is that in the eighteen years Jim has been out there, his swing has tempered and become more uniform. Put the 1994 model and the 2013 model together and you'll see what I mean: Today's version contains far fewer moving parts. Jim's swing, much like Nick Price's, has the club and the armswing inverted (pointing inward), with the club steeply positioned halfway back. Both players have developed a strong move in the downswing that shallows the steepness they developed. Needless to say, this type of correction/compensation in the club takes timing, talent, and repetition—even for these guys—to pull off.

In rounding off this discussion of steep backswing, we need to foster a feeling of rotating—not tilting—as we start the club back. Focus on three main components that are interlinked: your left forearm, your glove hand, and the clubface. In a nutshell, these three components need to rotate and turn clockwise as you look down on them from the address. This gentle rotation ensures that the clubface, and indeed the left arm, stay square and true to the arc of your swing. Remember, the arc of your swing is nothing more than a circle on its side. It's a tube, a

STRETCH YOUR WAY TO THE TOP

tunnel, or a drainpipe that the clubhead travels *within* around the body, so ideally we'd like the clubhead to be square to this arc all of the time.

One of the first sensations that may come through to you will be via the left shoulder. It will feel higher and more level as this forearm rotation occurs. Another—and a feeling that I'd actively encourage—is found in the right arm folding earlier. This complements the rotation we are trying to install in your swing, so let the right arm fold and let the face of the club rotate.

Lastly, you can round off your swing while hitting some shots with the ball above your feet. This incline will automatically encourage the arc and plane you are looking for; you will slowly change the profile of your swing from a tilter to a turner!

Stretch Your Way to the Top

I want to start this section by writing a little about stretching in general—the purpose of it and the danger it poses to good golf technique. The main purpose of stretching is injury prevention, not technical improvement; technical improvement is a bonus gained from stretching out the right areas. Golfers will generally have one or two physiological areas that they need to monitor: Ligaments, tendons, and muscle fiber will get tight and, if not attended to regularly, will start to structurally affect the body. When your structure (skeleton) gets misaligned, injury and nagging sensations always follow. I have had many players ask me about the benefits of activities like yoga. While I

believe that the breath control and discipline yoga induces are very beneficial to playing well, I am in total disagreement with any activity that can potentially *over*stretch the body for golf and make you *hyper*mobile. The golf swing is an organized sequence of events that are best performed tightly—not in the physiological sense, but as in knit together. For the majority of golfers I coach, professional and amateur, I am more likely to want them to economize their action through a "less is more" philosophy. Learn your body's needs and stay on top of your specific stretching exercise, but don't become an Indian yogi!

The image you see creates a great stretching feeling to the top of your swing, with the added bonus of inducing some sound technique. Creating kinetic power in the golf swing often requires you to work the right side of the body against the left and vice versa; this is what you actually see here. With the feet and knees providing a stable base, we have the opportunity to stretch the *right hand* away from the *left foot*, creating a stretch in the back, left lat muscle, and thighs.

This concoction of power sources has come together through a combination of *discipline* (in the lower body) and *mobility* (in the upper body) to give the swing a pull-and-release effect similar to that of a bow and arrow; the wire (the torso) gets stretched against the bow (leg stability). So now you can understand why I'm not a big fan of overly stretched golfers, since there is always the possibility of too much slack and not enough torque; the stretcher unwittingly removes all the explosive recoil that a tight wind produces.

To experience this stretch, buy an isometric rubber band from your gym and train

with it in exactly the same fashion as I'm doing with my snake friend. Hook it under your left foot (keep it hooked or it will smack you in the face!) and then grab the other end as you would grip a club. With a little slack in the band, start to make your backswing, maintaining the relationship between your eyes and where the ball would be. You will immediately start to flick the right buttons, allowing your body to know where and how you are meant to be feeling torque!

As a Rule, Get Some Leverage

I'd be the first to admit it (closely followed by family members!): I wasn't a grade-A student. Most of my time in class was spent daydreaming, scribbling down new ideas, and thinking about James Bond or golf! One knack I did have down pat was breaking or snapping rulers; I'd bend them in boredom while looking at my teacher who was talking about algebraic equations. Little did I know that I was unwittingly conducting an experiment in applied

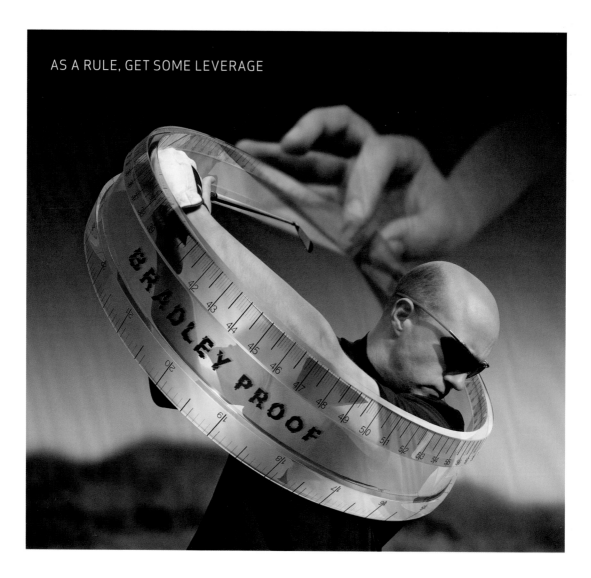

AS A RULE, GET SOME LEVERAGE

leverage; the closer I brought the ends of the plastic ruler together, the faster they repelled when I let go—there was snap and there was speed!

Your golf swing works in exactly the same way as the ruler. The closer you can bring the clubhead to your left shoulder, the more leverage you will generate in your swing. You can now see the importance of a good grip—it would be impossible to create this motion *and* have the clubface in a decent position relative to your left forearm if your grip was in any way substandard. Any golfer, amateur or professional, who has generated significant clubhead speed has a great system of leverage in his or her swing. Some golfers who would be familiar to you would be Sergio García, Ben Hogan, Anthony Kim, Michelle Wie, and Bubba Watson. All display an acute angle between the shaft and the left forearm, either at the top of the swing or on the way down. This, more than anything, illustrates the importance of grip pressure throughout your swing motion. It is the pliability of a whip bending that brings the two ends of it closer together in its change of direction, and there has to be some amount of slack for this to happen. If you feel that you are guilty of a tight hold or even the cardinal sin of casting the club from the top, then you need to foster a new feeling of softness, initially through your chipping action. Take some balls and hit chips to the point where you literally feel the grip of the club moving around in your hands; the club must feel heavy throughout the motion. This is the catalyst and the training ground for your lag/leverage development.

I suggest you take this image and initially imitate its look using a mirror or a window. You will feel how your glove hand almost stretches outward as the leverage starts to take place. When you have the look down, let your awareness focus on your grip pressure, since this gives you a physiological road map of how to feel it get there during motion.

The Plane's Line of Fire

One of my traits as a coach is having my students maintain—or even build—their golf swing away from the golf course. This can take place in the garage, living room, or bedroom; taking the result of the ball flight temporarily out of the equation frees the student's learning process dramatically. One of the toughest areas of the swing to maintain can be the armswing, owing to its mercurial nature of disappearing from sight as you make your move back.

I found a great training aid, which I now sell on my website, called the Laser Trainer. This device screws into the butt of your golf club and emits a red laser beam, letting you know where your club is during your backswing and making this a really great way to train with little chance of making a big mistake. You simply drill your backswing and through-swing planes by monitoring the path the laser makes on the ground. The image you see before you gives you the blueprint to make this training possible.

You could probably count on one hand all the successful pros who have "crossed the line" at the top of their swings. *Crossing the line* refers to when the shaft and the head of the club point to the right of the target as the backswing completes. Yet many pros have played from an on-line position (club pointing parallel left) and also a subtly laid-off

THE PLANE'S LINE OF FIRE

position (club pointing slightly to the left of the target). The preference for the slightly laid-off position is twofold. First, you have already positioned the club into a natural shallowing position with respect to the original starting plane. Second, the shaft (and most notably the butt of the club) is still relating to the target line. You can see from this image that the club has continued to relate to the target line by virtue of the fact that the butt has carved out its line of fire along it. You can practice this classic backswing look by simply placing an object such as a coin or another ball somewhere along this backward-extending target line; all you have to do is create the sense that the shaft and the butt of the club hit that point time and time again. For golfers new to this sensation, the immediate "WOW!" feeling will be found in the left arm rotation to the top. This feeling will also create a sense of the armswing and the body motion planes calibrating and matching more efficiently on the way back.

Work on your swing's line of fire, and start to burn a better backswing.

IMAGES OF
MOTIVATIONS, ATTITUDES, AND AFFIRMATIONS

A Round of Golf?
No, a Round of Life

Have you ever noticed how your attitude—and even your persona—changes during a round of golf (*persona* meaning face)? If you start off badly, your tendency at some point will be to let go or give up. You'll place a different mask on your face, and ironically, you'll start to play more effectively, displaying a freedom you didn't have earlier. If you start off well (and most great rounds have been stumbled into), the mask can often become egoistic, letting you believe you are ten feet tall and bulletproof, taking on everything and anything with a flag on it. These rounds can leave you thinking, "Where the hell did I let that one go?" when you blunder back into the clubhouse with a 75!

There is a distinct relationship between your persona and the amount of time a round of golf lasts—a hidden momentum, if you will, that has seldom been talked about. Since a round of golf is a journey that a good course architect designs around flow, strategy, and climax, it is imperative that your attitude toward the course align at the right place and at the right time. A round of golf passes through three distinct areas of momentum:

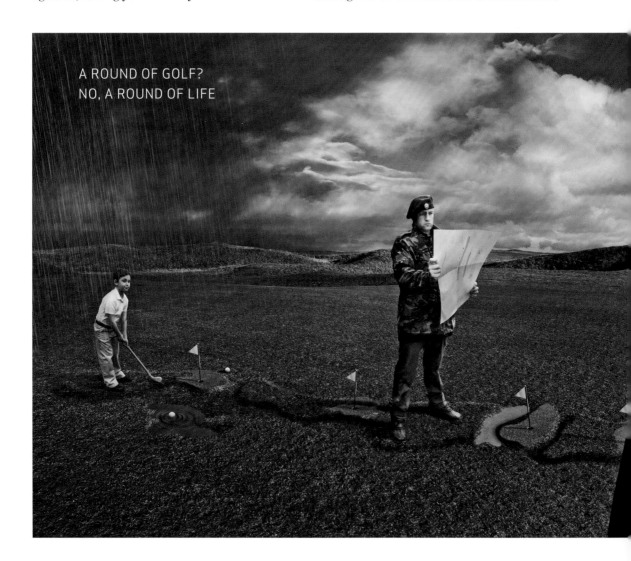

A ROUND OF GOLF?
NO, A ROUND OF LIFE

simply put, a beginning, a middle, and an end. The typical persona for the weekend golfer is a starting attitude: "I'm full of expectation!"; an "Okay, where am I?" attitude in the middle; and an "I see the finish line in sight!" attitude in the home stretch.

THE CHILD

You must treat the beginning of your round like the beginning of your life. You're a child with little expectation. Your main focus is to have fun in a carefree manner, and if you mess up—which you may do—you merely try again. The golf course at this stage is a clean sheet of paper that should be mirrored by your

mind. So for the first six holes at least, your persona should be childlike (in your outlook) but not childish (in your actions). Have fun and see what comes your way! With the all-too-common attitudes of *over*-expectancy and self-importance, you do yourself no favors at all, piling a load of pre-round conditions into the mix. Lighten up, smile, and enjoy this first part of the journey.

THE ADULT

By the time you reach the 6th or 7th hole, you should have an instinctive awareness of how you are playing. This is the time to slowly morph from the childlike persona to the role of strategist—similar to life, really. You get to your twenties and thirties and you are certainly more aware than you were in your teens; your round of golf is the same. So during this portion of the round, you work with what you have that day. If it's obvious to you that you are all guns blazing, displaying a controlled ball flight, then you should honor this by turning up the volume a little and taking on some pins when it's strategically right to do so. But if you are hitting a push, pull, slice, or whatever, you should realize that now is not the time to be playing swing mechanic, and you should plan your shots around what you have that day. Do not develop the mentality that unless you're on your A game, you cannot score! Bruce Lietzke won millions playing a slice; Lee Trevino won millions playing a push; and Ian Woosnam won millions playing a hook. Strategize and be smart. You're more mature now, so play with what you have!

THE SAGE

As you get to your 14th or 15th hole, you either have a great score going, you're hanging around par, or you have a potential train wreck on your hands. The closer you get to the

18th green, the smarter you have to become to deal with any one of the above possibilities. This is what I call the sage persona—old enough and wise enough to deal with anything and never get flustered. This is really when mind, body, and soul come together in a great golfer. The sage can control his mind to bring a good score home, never letting his ego override his strategy. The sage can control his body through breathing techniques and swing/short-game awareness. And finally, the sage keeps his emotions under wraps as the 18th green approaches. Whichever of the three scenarios above he is dealing with, he will always be like a pilot landing a plane—totally under control.

So, *write* the three stages of life on your glove and let them play out. The right kind of momentum can build this way, and build at the right time.

Confession Time

LET'S BE HONEST

One of the attractive aspects of golf is the responsibility that each and every player has for his or her own play. Unless you allow someone else to get into your head, the final result really is down to you and you alone. Even when you have been psyched out by another individual, you still have the ability to quash and dampen their actions.

An aspect of competitive golf I relay to my younger players is about whom they are actually competing against. We know by now that this is largely a game in which you compete with yourself, but aside from that, what and whom do we then have to beat?

A PGA Tour player's career is defined *not* by the people he beats, but by the golf courses he successfully dismantles. This line is worth rereading, because it is actually irrefutable across the board, no matter the standard of player. Ultimately, it is the maneuvering of your ball across the course that really, when we see the truth for what it is, counts.

The original meaning of the Greek word for sin (*harmatia*) has little to do with religion. To sin translated means to err, to miss the target, and in this instance I want to talk with you about the golf course you may play every week or one that you might face soon with which you are unfamiliar. To miss the target here means you have not learned enough about the challenge ahead of you.

My diary always gets busy around October 1. I get calls from young, aspiring Tour players who want to prepare for their first Tour school. So I get to work on these guys, doing my best to read their situations and develop a plan around their needs and wants. Without fail, the very last subject I will talk to them about before they leave my office is fear. While nerves are a natural phenomenon in golf, or any other competitive endeavor for that matter, fear is a totally different animal altogether. Nerves dissipate and eventually your performance and skills kick in and take over, but fear can literally ruin careers by totally sabotaging the mind.

Fear in golf is derived from a feeling of the unknown. "How am I going to hit it? Are these players better than I am? Am I going to look like a fool?" There are many reasons to feel fearful in golf, but the single biggest instigator of fear is a lack of knowledge about the course you are about to face. There are three aspects I want to cover with you.

At the pro level, the focus from the moment you arrive at the venue is to create on

the range the shots that the course will accept during play. Once I speak with the young pros about this aspect of their preparation, much of their fear about the pending visit to Tour school is over. They walk the course, their caddies learn the course, and if done correctly, the two of them will sit down Wednesday afternoon and finalize the lines and green complexes before play starts. The player must have the shots down and the caddy must have the battle plan mapped out. The fear of the course has largely gone now.

For the amateur, who generally plays his own course every week, there are always the same one or two holes that seem to get the better of the scorecard. Approaching that hole, the player knows that his nemesis is looming, and without prompting, the heart

rate goes up, the eyes narrow, and the adrenaline starts to flow. What is it about this hole that provokes such a bodily response? It's simple. You don't have the technique or the strategy with your *current* game to play it and tackle its design. And my advice here is simple, too: Buy a course planner and relearn the golf course that you play week in and week out. This can be an enlightening exercise when you actually sit down and work out some of the carries from the tee boxes, where the hazards really are, and—probably the most important—where to miss the ball if you do hit a poor shot. Look at these trouble holes with fresh eyes—you may just see the answer.

When you visit a course for the first time, rule number one is to have looked at the

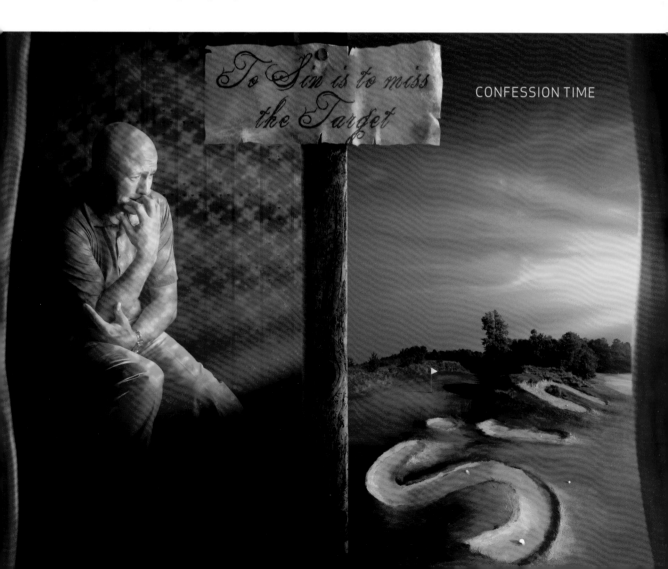

To Sin is to miss the Target

CONFESSION TIME

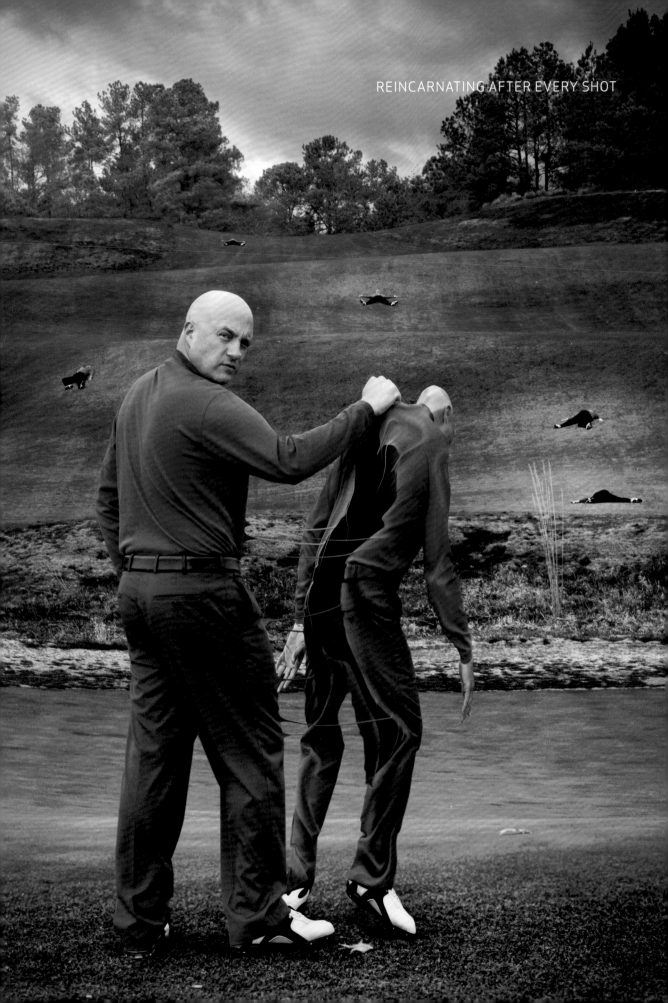

REINCARNATING AFTER EVERY SHOT

course planner before you step to the first tee. I have no sympathy for the pro or the amateur who blindly pulls the driver from the bag on the first hole and then proceeds to hit the ball through the fairway into the hazard beyond. Learn the exam ahead of you, because if this does happen on your first hole, fear will almost certainly manifest itself. Secondly, trust the yardages. Why? Because to the naked eye a new course may completely skew your perception of distances, owing to its unfamiliar design. So no matter what your heart thinks as you look at a shot ahead, just make sure that you have the yardage crystal clear in your head. This is what counts!

Reincarnating After Every Shot

Having baggage on board is a good metaphor to describe the thoughts and the drama people, rightly or wrongly, carry around with them. When it comes to golf, the only baggage you need is the bag containing your fourteen clubs. Anything else is surplus to requirement.

It is often said that successful sportsmen, and indeed businessmen, have very selective memories when it comes to success and failure. If this isn't the case, how can we explain their ability to put bad situations behind them and move on to better things? Part of this could be put down to an ability to erase what has gone before, but more likely it is a certain perspective or lens that they have developed to maintain perspective on past, current, and future events. I have written about the journey you take during a round of golf, and how the people you successively

become mirror the flow of a round of golf. A round of golf is not a static event; situations change and you have to be flexible in your perspective and not allow any one situation to shift you sideways.

Reincarnating after every shot simply means that you have the following perspective on golf: Since you will rarely get the same shot twice, and almost every shot is different, how can you possibly go into every shot as the same person? If you had to be a deft putter on the last green and stroke a twenty-foot putt downhill with several feet of break, how could you have the same persona two minutes later when you want to smash a drive down the fairway? You couldn't!

Let me give you another example of the flexibility you must develop to become the best golfer you can be. Imagine you approach the hardest tee shot on your local golf course. You pull out your driver, make a good swing, and pump it down there about 280 yards. You strut down the fairway, delighted with yourself. You stand confidently over your approach, living off the adrenaline of the drive you have just hit, and proceed to carve the ball into a deep greenside bunker. All of a sudden you have gone from being an athletic, all-powerful smasher of the golf ball to a golfer involved in crisis management. A different feeling coursing through your body? A different person now? You bet!

So being able to reincarnate or "shed your skin" from shot to shot is really a key skill in golf and a perspective you should learn. Staying in the present is one thing, but arriving there with a fresh persona ready to face the next challenge is another.

It's You and the Golf Course, Nothing Else

Despite the leaderboards you see every week displaying the 150-odd different names, golf is not a mano a mano sport. While the net result may tell us that Player A beat the rest of the field, he did it virtually without paying attention to that field. There is no theory in golf that suggests that because Rory McIlroy birdied the 16th hole, some other person will double-bogey the 10th; it doesn't work that way.

A European, LPGA, or PGA Tour player's

IT'S YOU AND THE GOLF COURSE, NOTHING ELSE

thoughts in regard to competing. They did not see it as a battle between golfer and golfer; they saw each golf course as a different exam that was to be taken. Think about the way Jack Nicklaus used to talk about Augusta National or the way Nick Faldo talked about St. Andrews during the 1990 Open Championship. Neither of them ever said, "Yeah, I've got to take this or that guy down."

You need to rechannel any competitive feelings you may have toward another player onto the golf course that you play or might be playing soon. This is directing your precious energy to the right cause. Getting your strategy dialed in for the golf course based upon your current game is *exactly* what you should be doing a day or so before your game. Most golf course websites nowadays will have a course planner or hole-by-hole preview of the layout. Better still, the pro may give you a hole-by-hole rundown of the course. This is fantastic preparation. If you have been a member of a course for a while, it may be time to dig out the course planners you used to study when you first became a member and reinvent or reenergize the way you view and play your local track.

The true role of a Tour caddy, apart from issuing the correct numbers and advice on the day, is to break down the golf course so clearly that both caddy and player have this intimate "I've been a member here for twenty years" mind-set. That's why it's a rarity for a player to win the first time on a course he's never really seen before. "Horses for courses" definitely applies in golf, but there the horse must have run on the course a few times before.

career will not be defined by the other players they beat. It *will* be defined by the golf courses he or she dismantles. You just have to think of interviews with Bobby Jones, or Ben Hogan's famous "I brought this monster to its knees" quote about the 1951 U.S. Open at Oakland Hills to see the direction of their

It's not you and the other guy. It's you and the golf course. That's all!

The Memory Chip

Do you think our memory has much to do with the way we play golf? The more I investigate how memory works, the more I am convinced that we seriously underutilize it, especially when training the swing and the short game.

First, I'd like to discuss the pattern of a typical range session for most amateurs—and indeed for some professionals—who spend too much time on "Misery Hill." The first ten minutes of a range session typically starts with the wedges. During this time you are observing what the strike of the ball is like and getting reacclimated to feelings you may have had the previous day or week. It is at this juncture that memory will start to influence the moments shortly to follow. If your last ball-hitting session was successful, you will know exactly what to do and what you should expect to feel, based on your previous experience. Interestingly, this initial stage then becomes the acid test for how consistent and repetitive the technique you are currently using is. You really make a couple of conscious decisions at this stage, number one being: "Am I liking what I am doing here and getting the desired, expected result? If not, what do I pull out of the memory bank that may work in this situation?" You see, this is why the Tour players have their coaches with them a lot of the time. Why waste time searching on the range, when a guy or gal who knows your game well can supply the feel or image you need? Either way, by this stage of the training/warmup session you will have arrived at a conscious thought that you will probably use for the rest of the day.

Good, bad, or indifferent, you will almost certainly move up to a longer club, and the session will enter into a rhythmical-flow stage. Armed with your thought for the day, your mind and body will start to make things

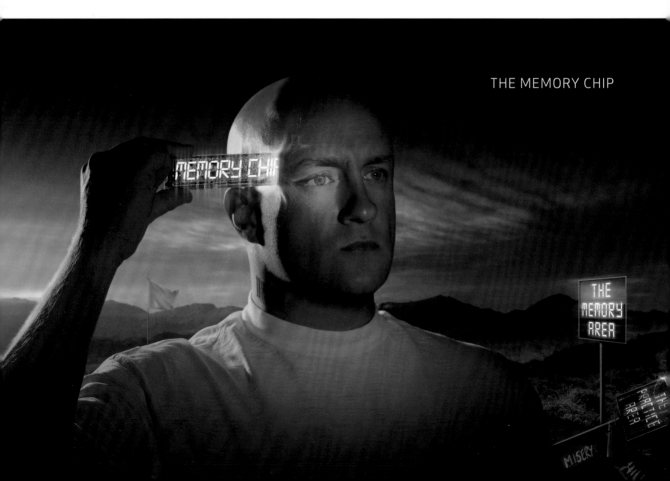

work whether you are swinging well or not. Remember, the acid test for your technique is the magic three-minute walk between each shot. Will your flaky technique need another ten balls before it can time a decent shot, or is your technique solid enough to hit the next shot with just one swing?

So in this rhythmical period of the range session, you will hit decent shots, they will be well struck and fly in the general direction that you want. Unfortunately, this is where the trouble can start . . .

As you start to hit the ball better and better, the tendency is to hit it harder and harder, which will strain your technique. You must have the ability to recognize this change in rhythm and speed. I'm not sure whether the added aggression is owing to ego or the body's craving for physical excitement. What I do know is that it is imperative to monitor its rise. If you allow it to continue, your shots will become loose and your strike inconsistent, and you will then start searching for a new answer.

The memory chip is a metaphorical discipline for knowing when enough is enough. Withdrawing the memory chip doesn't just apply to the long game; it applies to almost every aspect of your golf. When you have arrived at a point of stability and function, STOP and move on to something else. In doing so you will preserve the memory of everything that was positive, and not give your memory a chance to introduce an immediate negative into your next session or round. Maybe this is the true definition of a selective memory, insofar as you have the ability to select the exact time you want to quit to preserve the right feeling or image for next time.

Too Excited and Fired Up

Bobby Jones was 100 percent correct when he said: "Golf is a game played on a five-inch course—the one between your ears." As a young man, Bobby had a fire in his belly and yet was also susceptible to chronic nerves; we can only surmise how well he overcame these mental challenges by the way he filled his trophy cabinet in his mid to late twenties. Looking at those two raw emotions—hypertension and hypercompetitiveness—we come across Mother Nature's own version of a triple espresso: adrenaline.

The first point I would like to make on the subject of adrenaline is that you would not be much of a competitor without it. It's a primal natural mechanism in your body when you are under threat and an acute, narrow focus is needed. Without adrenaline there would be no such thing as excitement or the ability to react under pressure. The critical question is: How much do we actually need? Too little and we fall asleep not caring about bogeys, too much and we look like the image you see here before you (p. 184). Adrenaline is liquid energy, and when it is present it has to be channeled. If this liquid energy is not channeled, you get what is known as an adrenaline rush, followed by an adrenaline/energy crash.

If you feel that you are susceptible to this rush, I want you initially to try to identify what grabs your attention enough to provoke such a bodily response. Is it everybody watching you on the first tee? Is it a particular golfer whom you are always trying to catch? Is there a low score that you desperately want to shoot? As you can see, there are multiple reasons why something might pump you up.

TOO EXCITED AND
FIRED UP

This surge of excitement can also happen midround. I got the idea of this image from the movie *Finding Nemo*, when the Aussie shark, Brucie, caught a whiff of blood, arousing him and making his eyes fully dilate. Do you get aroused after you have made a couple of birdies and then smell the blood of another? Does every flag look like a winning lottery ticket after you have experienced a run of good holes, encouraging you to shoot the ball at some impossible pin positions?

Arousal and adrenaline are constants, they are always with us. First you must learn to sense this change in your body chemistry as adrenaline enters your bloodstream and mind-set. Once you have defined and identified what may trigger this Hulk effect, you must learn to temper it through breathing and, most important, to stick to the game plan and not take on impossible shots. Slow, deep breaths can regulate your blood flow, heartbeat, and thought process during these pumped-up moments, so start to practice these disciplines. Making birdies doesn't have to engender a do-or-die perspective.

Aggression

By now you should know that I am not a great fan of emotional golf. In twenty years of coaching and instructing tournament players, I have seen more cuts missed and tournaments lost through impulsive play than I'd care to mention. When I was sixteen, I chose to learn from the best course strategists who had played the game, the most impressive, for obvious reasons, being Jack Nicklaus. Even if Jack wanted to play aggressively, he played with what he called "intelligent aggression," which meant that even if the shot didn't come off he could still play the next one from a decent position. Jack

AGGRESSION

factored in possible misses as well as successful outcomes.

Blind aggression simply throws caution to the wind and pays no mind to what might happen if something goes wrong. Look at this another way: The golf course just sits there—it doesn't care if you are excited, down, elated, or despondent. The golf course just lies flat, doing and feeling nothing. Your goal is to match this flatlining persona of the course with your own mental state. The more you move away from the strategy and the truth of the golf course you are playing, the more likely you are to make aggressive and nonsensical decisions.

The good news is that playing in this psycho mode is easy to spot. If you suspect your aggressive play is holding you back, take a look at your scorecard. Does it read like a telephone number, or does it display some uniformity? There are plenty of numerical peaks and troughs to spot when somebody is playing angry golf! It can take a Tour player many years to discover that great play isn't arriving on the first tee with fourteen weapons of mass destruction in his golf bag. Try to maintain an emotional equilibrium throughout the round, and kiss those anger-management issues good-bye.

Tiredness

Your body and your mind only work well when they are sharp and energized. Look at it

TIREDNESS

OCTOBER

this way: Every morning you wake up with a certain quota of energy. This reserve may be topped up to the max, so that you're fully alert; or, if you have been on a relentless treadmill, you may wake up totally tired and depleted. Once predetermined, it's actually very difficult to alter this initial balance in your energy bank. So the key with a big game coming up is to try to slowly wind down, get the occasional earlier night, and make sure that you have things in order that might otherwise sap your reserve of energy.

A great analogy to use for this mind/body/energy ratio is to imagine that you have a car antenna or aerial sticking out the top of your head. When you have been resting and playing a sensible golf schedule, this antenna is extended to its maximum length, allowing you to consciously and subconsciously pick up on many aspects of your life easily. Essentially, your vitality allows you to be very receptive to and perceptive of things going on around you. These are the times when everything comes easy and you are experiencing flow.

However, when you are feeling sloppy and tired, that antenna will be at its lowest. While you will still be awake, you will not be able to function, perceive, and react with any great conviction or accuracy; you are a burned-out unit.

The amazing thing about the low-antenna syndrome is that you will not be aware that you are running on reserve energy. You often hear players saying that they will "play through this bad spell" when in fact what they actually need is to step off the golfing hamster wheel for a moment, pick up some energy time, and then return. It's the classic case of your ego knowing that it is tired yet insisting that it can handle it. It can't, and in fact, the more tired of golf you become, the more your old friend Ego will smash you for missing the simple stuff!

All I'm saying here is that, amateur or professional, you must watch your schedule. See what feels comfortable and fits in with your travel schedule or work life. Find that balance between your life and your golf, because that ratio has to be respected for you to play your best. With the proper energy, you should be looking forward to playing the next day, not thinking that you are going into a physical and mental battle. Work, rest, and play—keep the antenna *up*!

Frustration

There are two types of frustration, legitimate and unreasonable. Let's deal with unreasonable first.

Unreasonable frustration is ego-driven. Normally an animated emotion, frustration and the ego love to team up and cry out loud to anybody watching when a fifty-foot putt is missed. This is unreasonable frustration. Unreasonable frustration is usually associated with attention-seeking individuals whose parents gave them the "poor little Johnny" treatment every time the kid screwed up. It then became this two-act play in which shouting out resulted in getting attention. Not good. Firstly, if you suspect you may be a "little Johnny," consider this: People are into their own games, and to be honest, unless it's a very close friend, they really won't give two fiddles about your frustrated outburst. Secondly, if your silly outbursts continue, you are likely to get attention and, for that matter, a reputation that you really don't want.

Legitimate frustration genuinely hurts and culminates in the "Why me?" mind-set.

Legitimate frustration originates from putting considerable effort into what seems to be the right cause or technique and then being unable to make it work. This would be like Thomas Edison failing the 400th, the 700th, or the 999th time at getting that lightbulb to work. This is legitimate! But legitimate frustration can also be associated with having no clear idea of what direction you should be heading in with your game.

Frustration can also develop if you believe in luck. Ironically, both legitimate and unreasonable frustration fall into this lucking-out/lucking-in belief, even if you are playing well. For example, you hit a perfect 7-iron directly at the flag, expecting it to take its two customary bounces and settle close to the hole. Instead, you see it take a firm bounce pin-high and dive into some thick, patchy rough behind the green. You look up and say, "Why me?" For a good 90 percent of this shot, things were going well and you had done your job! The irony is that the human condition will not home in on that 90 percent; it prefers to draw your attention to the black dot on the white page and say, "Look!"

What can we learn about frustration and golf? Well, golf is by its nature a frustrating sport at every level. Some people quit because they cannot stand this constant battering from the game. Others become determined to try to wean frustration out by chasing golf's holy grail, namely perfection. The key is to learn the humility of failure and to understand that as long as you genuinely gave 100 percent to the shot you have just played, the outcome is what it is! Frustration is in the fabric of the game; how you react to it is the critical mass of the situation.

FRUSTRATION

THE EGO LOVES THE
LONG GAME BUT HATES
THE SHORT GAME

The Ego Loves the Long Game but Hates the Short Game

When I take on a new player, I aggressively listen and aggressively observe, so that I know I will have all my ducks in a row when I create a plan going forward. I call this "the player code." One aspect that never changes, though, from player to player, is the ratio of time and energy spent between the long game and the short game. It has to be one-third long game and two-thirds short game—this part of the plan brooks no compromise at all.

There is a huge problem with this fail-safe strategy: The ego and human insecurity always want to tinker with the long game. This is why we have driving ranges and not short-game stations flanking every major city in the world. I'm sorry to say that, for many people,

the short game just doesn't have the same sex appeal as the long game.

Let me list some of the aspects of the long game that appeal to the ego: hitting the ball a long way, an intellectual fascination with swing technique, acquiring a perfect strike, out-hitting your partners, the physicality of a full-blown hit—the list goes on and on. So many things challenge the little kid inside your head that it keeps going back for more and more; it virtually becomes an obsessive-compulsive disorder.

This is when the phrase *paradigm shift* can be really useful, because unless you can get your head around the fact that you need to spend at least *half* of your practice time on your short game, you will not significantly improve—FACT!

I want you to conduct a two-month experiment for me—just two months. I want you to divide your practice time into thirds. If you go to the range for an hour, only hit balls for twenty minutes, and spend the rest of the time working on your wedge play and putting. Get in a bunker

and actually learn how to play a standard trap shot with distance control. Learn to lag putt and thus eliminate the long-range putts that add up. See how much time you have to practice, divide it into thirds, and then stick to it!

When you take the obsession out of the long game, you immediately take stress away from your golf. I rarely let players see their swings nowadays, simply because to perform well they need to function kinesthetically and visually, not intellectualize the swing while playing. All of a sudden the paranoia about "How's my swing looking?" or "Am I reaching that position?" starts to fade away.

Don't worry about being the loner at the short-game area. It's far better than being with the other sheep on "Misery Hill."

Gambling

TO BE OR NOT TO BE? THAT IS THE QUESTION

The better question, actually, is to ask, "When should I gamble?" To say in golf that we should never throw caution (or the ball) to the winds and should play it safe all the time is folly. Without question, there are times when taking on a risky shot is absolutely imperative and necessary to win, *but* picking your moment is critical.

Take a tournament like the U.S. Open, for example. For 99 percent of this tournament you have to put the notion of excitement and

do-or-die shots way in the back of your mind. It's true that you will be penalized for missed greens and fairways; it is also true that you will be *heavily* penalized if you gamble and take an aggressive attitude toward this tournament. It rewards calculation, yet will dish out carnage for one swift error of judgment.

The only time to gamble is when you really have to. From holes 1 to 15, you should be sticking to your game plan for the course; in a way this is like a road map. You wouldn't embark on a journey into the unknown and, within ten minutes of leaving the house, throw the map out the window or turn the GPS off. Maneuvering around a golf course is an identical proposition to reading the map; instead of driving a car around the golf course, you are directing your golf ball according to the thought processes you put in place before you hit it.

Here is a really good barometer for those who like to gamble golf shots away on the golf course. Try to view every shot you play as a fraction of 10 or 100. For example, hitting a shot 120 yards into the middle of the green would constitute an 8-in-10 shot. However, hitting the same shot with 14 yards of fade into a flag tucked behind a bunker with only 6 yards of green to play with goes down to a 2-in-10 shot. This can actually develop into a very cool shot-making philosophy for you. Imagine if you literally carried out this judging process on every shot, with your own mental provision never letting you take on a shot with a ranking of 6-in-10 or less. All of a sudden you move from being a golfer who would irrationally take on pins Tiger Woods wouldn't even look at, to becoming a golfer who has a restraining bolt never allowing you to overstretch your imagination or your technique. Get used to creating a plan for the golf course and reduce the chances of mindlessly gambling when you don't need to. Also, use the gamble judgment process I mentioned above; give yourself some sort of platform from which to make decent decisions. Gambling is fine—but just at the right time.

Your Persona and Your Story

One meaning for the Latin word *persona* is "mask." I'm sure you can remember wearing many different masks and taking on a few different personas during various rounds of golf. The trouble with many of the guises we adopt is that, more often than not, the mask finds us. We rarely choose *it*.

If the old adage that your outer world often reflects your inner world is true, then the game of golf can act as an amazing mirror. You often see this at Tour level when a player clears the decks of certain members of a team or rids himself of any complicated swing thoughts. All of a sudden, he often wins. His inner world went on a mental diet, allowing it and thus him to operate on a higher level.

Imagine you have a collection of masks and personas that you can choose from, such as the Aggressor or the Strategist. You could choose the Grateful to Be out Here head or the Sense of Humor outlook. How cool would that be? The good news is that you can! What's preventing you from deciding who you will be or how you will act on the golf course today? Why do you have to leave it to chance in deciding the demeanor and energy you will leave the house with as you make your way to your next game?

Does the golf course you are playing next offer room off the tee and present lots of birdie opportunities? If it does, I doubt the Let's Play It Safe mask will align well with those birdie

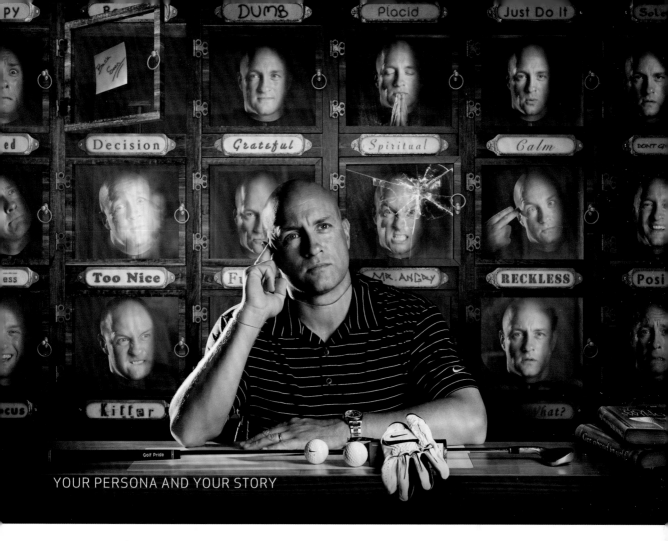

YOUR PERSONA AND YOUR STORY

opportunities! Does a course you are playing soon have the reputation of being long and tough? Maybe it's time to slip into character and become the Patient Buddhist Monk! There are countless people you could imitate to pull yourself through some challenging times.

I won't reveal the name of the Tour player, but I worked with this very talented guy for many years and he became a very good friend of mine. As a player, his weakness was a perfectionistic mind-set that led to the Self-Critic in him being very vocal and harsh. Toward the end of his playing career he competed in a major event on the European Tour and had a friend carry his bag for him. Unfortunately, the friend had been diagnosed with terminal cancer shortly before he committed to carry the bag, but carry the bag he did for all four rounds. The player in question went on to post his best-ever performance in a European Tour event, finishing second. More significant, his post-round interviews and subsequent conversations with me told a story of somebody who was just grateful to be out there in the fresh air and smelling the flowers. One mask had clearly been removed and another with a softer, less harsh nature had been adopted.

What's your story today? How are you going to behave? Who are you going to be in the face of opportunity or adversity? These are all questions that *you can* predetermine before you arrive at the course. Write on your scorecard who you might impersonate today—even draw the face—but just do one thing for me today:

Get your story straight!

IMAGES OF MOTIVATIONS, ATTITUDES, AND AFFIRMATIONS

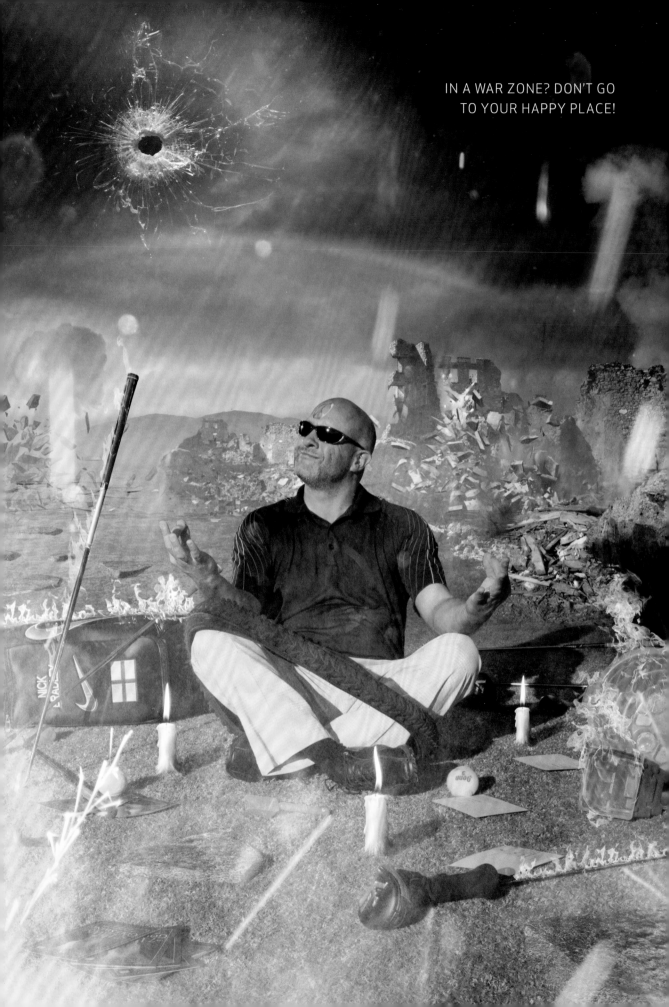

IN A WAR ZONE? DON'T GO
TO YOUR HAPPY PLACE!

In a War Zone? Don't Go to Your Happy Place!

Brutal honesty with oneself in golf is an admirable quality and one I would encourage you to adopt, since it cuts a clean path to improvement without the distraction of emotion or persuasion. I often chuckle at the golfer who believes that fundamental issues can be skipped over or brushed under the carpet, never to rear their ugly heads. Strong is the golfer who has prepared. That's all I'll say on the matter.

There are times, however, when *nothing* you do seems to work for you, despite great preparation and mental attitude. Golf can be like that, since you can only really control the process for the shot and its execution. Everything after that is in the lap of the gods. What can you really do when you give your very best effort yet continually get slapped down? What is your 911 emergency call when everything is getting thrown at you and the demons have moved in?

I personally wouldn't follow the advice of some books on golf psychology, written by people who can't break 100 anyway, who encourage you to just close your eyes and transcend to a "happy place"! My issue with this is that when you open your eyes again, read the scorecard, and look around, you discover your happy place is not your reality! Shocking, positively shocking.

When you are in that war zone, the only thing you can do is to think clearly and act decisively. If you're digging a hole, stop digging and get out! In times like this your brain will be fuzzy, your heart rate will be up, and your focus will be what is known as "narrow internal." You may as well be banging yourself over your head with a hammer when you're in this state. It's utterly useless.

Action plan number one is to regulate this internal implosion through your breathing. View your respiratory system as your body's stress controller. If you take three or four deep breaths, followed by slowly exhaling, your heart rate will immediately slow down, and your brain will relax and be able to get a better perspective on events. The "narrow internal" destructive thought process also lends itself to an obsessive mental gibberish, which continues to chastise you for making so many mistakes. I can tell you that this self-talk will continue until you eventually get a headache!

What is the answer to this internal drivel? How can you muffle its voice so you can steady the ship and get on with your life? Believe it or not, the answer lies in the use of your ears and where you place their awareness and function. In these times of inner chatter, your ears literally turn inward and pick up everything that's going on in the brain. Considering that this amounts to 200 thoughts pulsing in one second, you can start to appreciate how this can leave you seriously punch-drunk and confused!

I want you to listen to everything *around* you when experiencing this chatter issue. Pick up on the airplane above, the greenkeeper mowing up the fairway, the birds in the trees, the cars on the freeway next to you; whatever it is, direct your attention *out there*. In spinning the internal mirror in your mind and pointing it outward and away from you, you immediately shift your focus away from your mind and down the fairway. You go from "narrow internal" to "wide external" and immediately cut off the air supply to the voice annoying you.

Breathing regulates your body; it sends a biological message to calm down. Redirecting that mindless focus allows you to think with more clarity and make well-founded decisions, enabling you to stop digging and get back to playing golf!

To Marney, my consistent source of love and support in a world that is full of change.

Editor: Margaret L. Kaplan
Designer: Danielle Young
Production Manager: True Sims

Library of Congress Cataloging-in-Publication Data

Bradley, Nick.
 Kinetic Golf / Nick Bradley ; foreword by Butch
Harmon.
 p. cm.
 ISBN 978-0-8109-8360-1
 1. Golf. I. Title.
 GV965.B735 2013
 796.352—dc23

 2012028055

Printed and bound in China
10 9 8 7 6 5 4 3 2 1

Abrams books are available at special discounts when
purchased in quantity for premiums and promotions
as well as fundraising or educational use. Special editions
can also be created to specification. For details, contact
specialsales@abramsbooks.com or the address below.

THE ART OF BOOKS SINCE 1949

115 West 18th Street
New York, NY 10011
www.abramsbooks.com